Digital Exposure Handbook

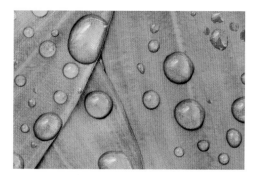

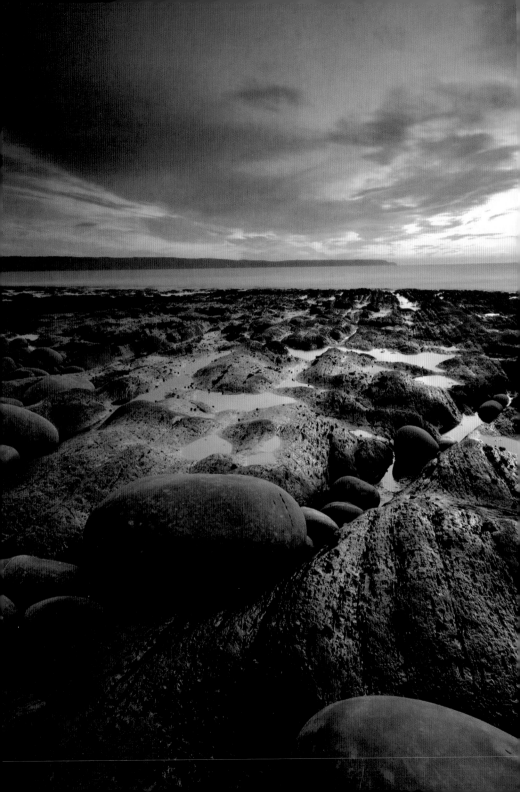

Digital
Exposure
Handbook

Ross Hoddinott

photographers'
pip
institute press

First published 2008 by
Photographers' Institute Press
An imprint of The Guild of Master Craftsman Publications Ltd
Castle Place, 166 High Street,
Lewes, East Sussex BN7 1XU

Text and photographs © Ross Hoddinott, 2008
© in the Work Photographers' Institute Press, 2008

Reprinted 2010, 2011

All photographs by the author except: page 85 and page 86
by Ollie Blayney – www.burntvisionphotography.com

ISBN 978-1-86108-533-7

A catalogue record for this book is available from
the British Library.

Publisher: Jonathan Bailey
Production Manager: Jim Bulley
Managing Editor: Gerrie Purcell
Editor: Virginia Brehaut
Managing Art Editor: Gilda Pacitti
Designer: Chloë Alexander

Set in Bliss

Colour origination by GMC Reprographics
Printed and bound in China by Hing Yip Printing Co. Ltd.

**To my beautiful daughters, Evie and
Maya – you make me the happiest,
proudest 'daddy' in the world.**

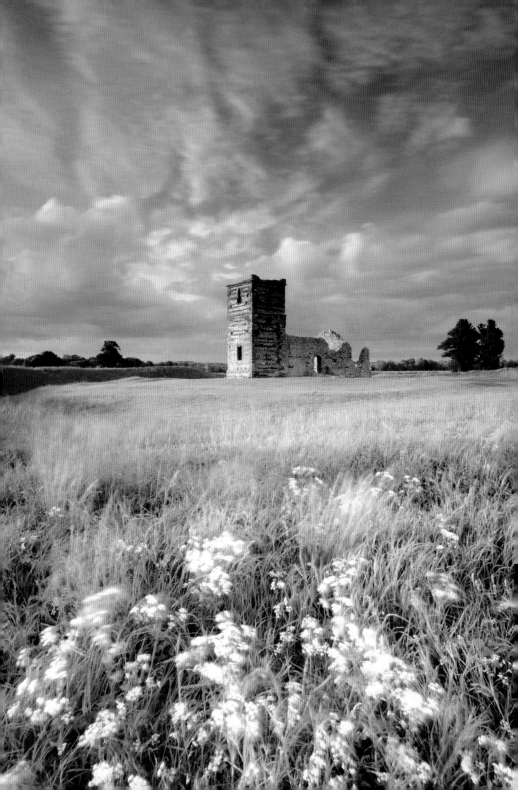

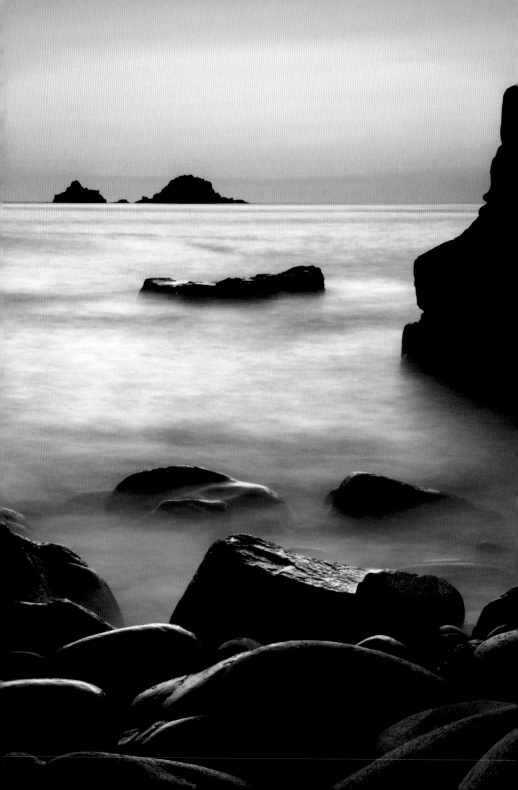

Contents

Introduction

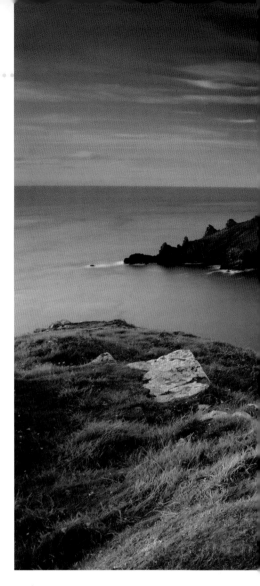

exposure / *noun.*
**The act, or an instance, of exposing a
sensitized photographic material, or the
product of the light intensity multiplied
by the duration of such an exposure.**

Exposure is the heartbeat of photography. Put simply,
it is the process of light striking a photosensitive
material – for example film, photographic paper
or a digital camera's image sensor. Understanding
and being able to control exposure is critical to
successful photography. However, it is a subject
which, at times, can appear complex and confusing
– not only to beginners, but enthusiasts as well. So
many things can influence exposure – for example,
the time of day, focal length of the lens, subject
movement, light source and any filters attached.
Certainly, when I first began taking photography
seriously as a teenager, I found the theory and
technicalities of exposure tricky to understand.
However, I quickly realized that if you try to overlook
this key fundamental, your photography will suffer
and never realize its full, creative potential.

Exposure is a combination of the length of
time, and the level of illumination, received by a
light-sensitive material. This is determined by three
settings – shutter speed, lens aperture and ISO
equivalency rating. The shutter speed is the duration
of time that the camera's shutter remains open,
allowing light to enter and expose the sensor. The
aperture – or f-stop – is the size of the adjustable
lens diaphragm, which dictates the amount of light
entering the camera. The ISO speed indicates the
sensor's sensitivity to light. At lower sensitivities,
the sensor requires a longer exposure to get a good
result, whilst at high sensitivities, less light is needed.

If the combination of shutter time, aperture
and ISO sensitivity are incorrect, the picture will
be wrongly exposed. Too much light falling on the
sensor will result in an overexposed image with
washed out highlights; too little light and the
image will be underexposed – appearing too dark.
Simply speaking, a good photograph relies on the
photographer employing just the right combination
of settings to form the correct level of exposure.
However, while this might be logical in theory,
I often ask myself: 'Is there really such a thing as
the correct exposure?' Whilst you could say that
a correctly exposed image is one that records
the scene or subject exactly as our eyes see it,

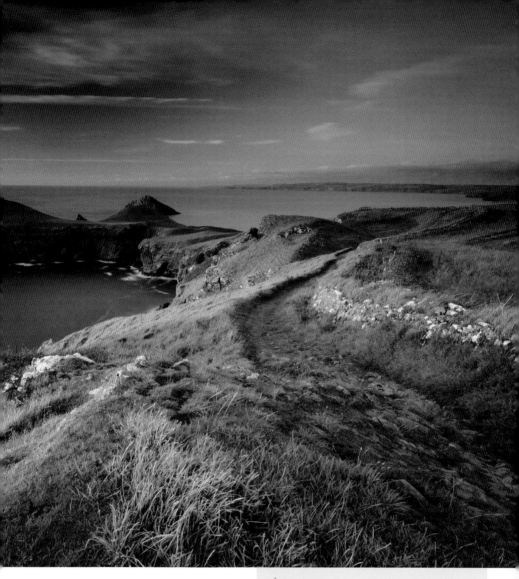

▲ *Coastline*

Every time you take a photo, you are recording a unique moment that can never be repeated. A good understanding of exposure is vital to ensure your image is compelling to others and faithfully captures the essence and mood of that particular moment.

Nikon D200, 10–20mm (at 11mm), 20sec at f/20, ISO 100, 0.9 neutral-density and polarizing filters and tripod.

photography is a subjective and creative art. There is no rule stating that a photographer must always capture images that are authentic – it is subject to individual interpretation. Therefore, arguably, a 'correct' exposure is simply one that is faithful to the vision of the photographer at the moment he or she triggers the shutter.

Today's breed of digital cameras boast highly sophisticated and unerringly accurate internal metering systems, which are rarely fooled – even

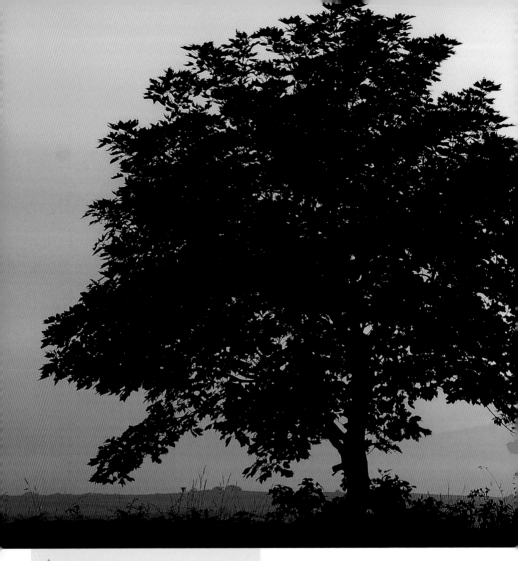

▲ *Tree silhouette*

In many ways, there is no such thing as a 'correct exposure'. Technically speaking, a silhouette is the result of poor exposure – the subject being badly underexposed. However, no one could deny that silhouettes create dramatic and striking imagery.

Nikon D70, 18–70mm (at 50mm), 1/300sec at f/8, ISO200 and tripod.

in awkward lighting conditions. They have simplified many of the technical aspects of exposure, which we should be grateful for. However, a camera is still only a machine – it cannot predict the effect and look the photographer is striving to achieve. It is for this reason that you shouldn't always rely on your camera's automated settings. Remember; you are the artist and, as such, you need to grasp control from your camera. Fail to do so, and your images will never truly convey your own individual interpretation of the subject you are shooting. Basically, what I am saying is that, without a good understanding of exposure, your images will never progress beyond pleasing snapshots.

Exposure can be manipulated for creative effect in so many different ways. For example it can be utilized to create the impression of movement, or to freeze fast action that otherwise would be too quick for the human eye to register. However, the skill isn't just to know how to create such effects; you also need to be able to judge when to employ certain settings. This handbook will help you make the right choices. It is designed to be an exhaustive manual on the subject, covering every aspect of exposure as well as offering helpful and practical advice on ways to improve your photography in general.

My hope is that this guide will inspire you; helping to open your eyes to the skills and techniques required to manage and control exposure in order to create images which succeed in relaying your artistic vision. However, reading this book alone will not improve your photography; you have to adopt and implement the things you learn to your own picture taking. After all, photography is a skill and, if you wish to improve, it has to be practised.

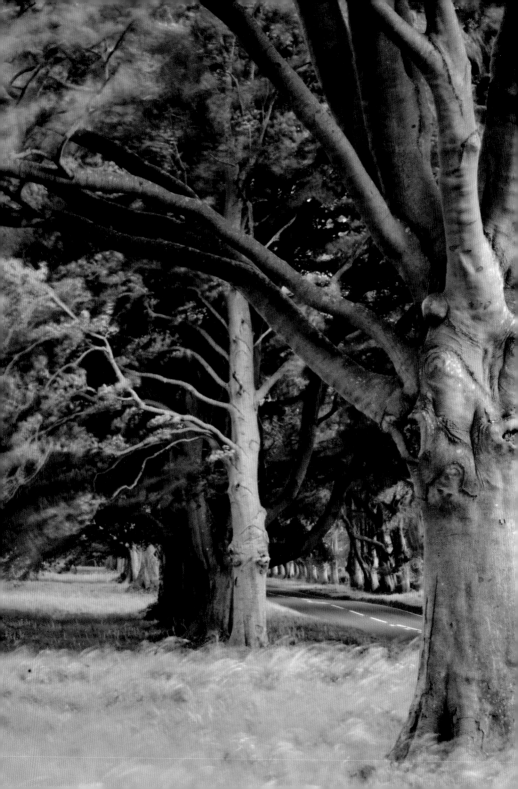

1 The basics of exposure

The basics of exposure

The word 'photography', which is derived from the French word 'photographie' means 'drawing' or 'painting with light'. Since the French lithographer Nicéphore Niépce created the first permanent photograph in 1826, by coating a pewter plate with asphaltum, controlling 'exposure' has been the key fundamental of photography. Even in this exciting digital age, exposure is still determined by the same three variable settings used since its advent: the sensitivity of the photo-sensitive material used to record the image, shutter speed and lens aperture.

ISO equivalency rating

ISO (International Standards Organization) equivalency refers to a sensor's sensitivity to light. It is a term adopted from film photography, when film was rated depending on the way it reacted to light. A low ISO rating – or number – is less sensitive to light, meaning it requires a longer exposure. In contrast, a high ISO equivalency is more sensitive to light, which in practical terms means it needs less exposure. Every doubling of the ISO speed halves the brightness of light – or the length of time required – to produce the correct exposure or vice versa. The sensitivity of an image sensor is measured in much the same way as film. For example, an ISO equivalency of 200 would react to light in an almost identical way to a roll of film with the same rating. Digital cameras allow photographers the luxury to alter ISO sensitivity quickly and easily.

Shutter speed

The shutter speed – or shutter time – is the length of time the camera shutter remains open. It determines the amount of light entering the camera to then expose the sensor. The duration of the shutter speed can be as brief as 1/8000 of a second or upwards of 30 seconds, depending on the light available and also the effect the photographer desires. As with the lens aperture, one full stop change in shutter speed will either halve or double the amount of light reaching the sensor. For example, reducing the shutter time

from 1/500sec to 1/250sec will double the length of time the shutter remains open and vice versa. The shutter speed greatly dictates how motion is depicted in the resulting photograph. A fast shutter time will freeze movement, whilst a slow shutter speed can create subject blur (if the subject is moving), creating the feeling of motion.

Lens aperture

The lens aperture is the size of the adjustable lens diaphragm, which dictates the amount of light allowed to reach the sensor. In isolation, its design

▼ *Sheeps tor*
To ensure that sufficient light exposes the sensor to record the scene or subject faithfully, an appropriate combination of ISO sensitivity, lens aperture and shutter speed needs to be selected.

Nikon D200, 10–20mm (at 12mm), 1sec at f/20, ISO100, polarizer and tripod.

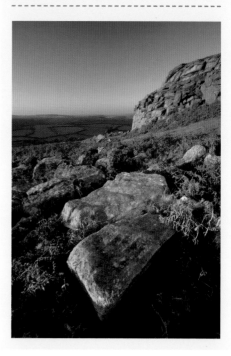

can be compared to that of a human eye. Our pupils contract in bright conditions, needing less light to distinguish detail, whilst in low light our pupils require more light so grow larger. By altering the lens aperture, photographers are affecting the amount of light reaching the sensor.

Apertures are measured using f-stops and, whilst all camera lenses are calibrated to the same measurement scale, the range of f-numbers will vary from one lens to the next – typically they start at f/1.4 and go up to f/32. Larger apertures (denoted by small f-number) allow light to reach the sensor more quickly, meaning less exposure time is needed. At small apertures (large f-number), it takes longer for sufficient light to expose the sensor, so that a longer exposure is required as a result. Each one-stop increase in aperture doubles the amount of light

reaching the image sensor, whilst each one-stop reduction halves the amount of light. The aperture affects depth of field (see page 50), with a large aperture creating a narrow depth of field and a small aperture producing a wide depth of field.

Summary

To achieve consistently accurate and faithful exposures, a good understanding of the three variables – and their relationship to each another – is crucial. Once you have selected an appropriate combination of lens aperture and shutter speed – for a given ISO sensitivity – a change in one will necessitate an equal and opposite change in the other. Quite simply, it is these three exposure variables that form the very basics of exposure.

▼ *Blurred tide*

For this image, I prioritized a slow shutter speed to intentionally blur the movement of the rising tide. I was able to do this by selecting a low ISO sensitivity and small aperture.

Nikon D300, 10–20mm (at 20mm), 20secs at f/22, ISO 100 and tripod.

Metering

Metering is the way light is measured to determine the best exposure value for that particular scene or subject. There are two types of metering tool – the camera's built-in TTL (through the lens) metering system or a handheld device. The systems employed by digital cameras are highly sophisticated and accurate, however, they are not infallible and prone to errors in awkward, contrasty light.

▼ *Emerging leaves*
Modern metering may be highly accurate and reliable, but it cannot predict the effect you are striving to achieve artistically. Photographers need to be aware of how light is measured, to enable them to manipulate it creatively.

Nikon D200, 150mm, 1/100sec at f/9, ISO 100 and tripod.

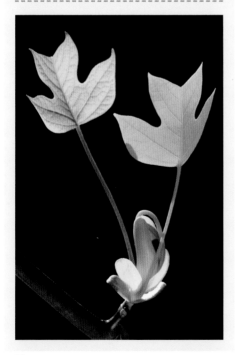

Reflected or incident – what is the difference?

Light is calculated in one of two ways – either by measuring the light reflecting off the subject (reflected light) or the amount falling on it (incident light). Cameras – and some handheld devices – incorporate reflected light metering systems. They work by measuring the amount of light actually reaching the camera and, in the instance of TTL metering, actually entering the lens. They perceive the subject's visual brightness based on the amount of light reflecting off it, translating it into an exposure value.

The main drawback of using this type of measurement is that the level of reflectance varies greatly depending on the subject, so it can only 'guess' at how much light is actually striking it. Also, they are affected by the tonality of the subject, being designed to give a middle grey (see page 20) reading, irrespective of its tone. This is fine when the subject's reflectance is sufficiently diverse throughout the image, which it is in the vast majority of instances.

Problems can arise when the scene or subject is excessively light or dark, as a reflected light reading will still endeavour to record tone as middle grey. As a result, light subjects will be underexposed, whilst dark subjects will be overexposed. However, as long as the photographer is aware of this, they can compensate accordingly by selecting an appropriate metering evaluation mode or by adjusting exposure.

The biggest advantage of using a reflected light meter is its practicality. You don't need to be in the direct vicinity of the subject – something which is impractical with many subjects.

An incident light meter works by measuring the light actually falling on the subject, and is commonly the type of metering employed in handheld devices. Therefore, they benefit from being uninfluenced by tonality and any light absorption properties of the subject. They are highly reliable, but meter readings need to be taken very near to the subject itself. Whilst this is fine for studio work, weddings and portraiture, it is not practical when photographing distant subjects.

Handheld light meters

At first glance, handheld light meters might appear old fashioned and redundant. The built-in metering systems of DSLRs (see page 18–23) are so dependable today that they can be relied upon in most situations. The versatility and accuracy of external meters mean they remain a popular accessory among enthusiast photographers, in particular those regularly working in a studio environment. There are two types of handheld meter; reflected and incident.

A **reflected light meter** – also known as spot – works in a similar way to TTL metering, measuring the light reflecting off the subject. The best hand-held reflected light meters offer a one degree spot metering facility, allowing users to assess the light from very specific parts of the composition. Whilst some DSLRs can spot meter from a 3–4 degree area, none offer this high level of metering precision and creative control. However, on the downside, hand-held devices do not calculate for external factors, like filters. Therefore, if a filter is attached – for example a polarizer with a 4x filter factor (see page 154) – the photographer must manually adjust the meter's recommended settings to compensate.

Incident light meters work by measuring the light actually falling on the subject, rather than reflecting off it, meaning they are unaffected by the tonality of the subject. They are designed with a white plastic dome – or invercone – which averages the light falling on it before the diffused level of light is measured by the meter's cell. While a handheld reflected light meter works by being pointed at the subject, an incident meter should be placed near to the subject itself, pointing back towards the camera – something which may not be practical for some subjects, like wildlife. However, due to the way they work, they are not influenced by contrasting areas of light or dark, making them popular among wedding and portrait photographers.

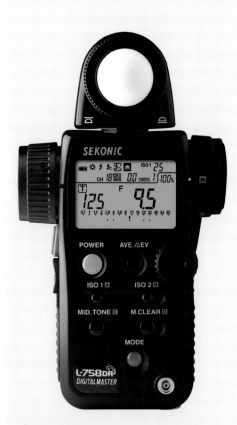

▲ *Handheld light meter*
Gossen, Kenko and Sekonic are some of the main manufacturers that produce handheld light meters. Many are highly sophisticated. For instance, the Sekonic L-758DR boasts independent programming of flash, ambient, incident and reflected measuring modes – customized to your digital camera. It also alerts you when a measured value exceeds your digital camera's dynamic range. It has a rectangular one degree spot viewfinder with vivid display.

TTL metering

Through the lens (TTL) metering is the 'brains' behind how your camera determines the shutter speed and aperture combination, based on the available light and ISO rating. TTL metering systems measure the reflected light entering the lens. Therefore, unlike handheld devices, they automatically adjust for external factors, like attached filters or shooting at high magnifications.

When TTL metering was first introduced, over 40 years ago, it was basic. Today, in-camera metering is sophisticated and reliable, producing accurate results in practically any lighting condition – meaning less need for handheld meters.

How your camera calculates exposure is determined by the metering pattern it employs to measure the light reaching the metering sensor. Digital SLRs boast a choice of metering patterns – typically, multi-segment, centre weighted and spot – each of which are designed to evaluate light in different ways. The metering patterns of today's cameras aim to keep exposure error to a minimum. However, each system has lighting conditions for which they excel and also for which they can fail. Therefore, it is important to understand how each one works so you can select the system most appropriate for your subject and also the shooting conditions you are facing.

▶ *Tree avenue*
Digital cameras offer users a choice of metering method. It is important to be familiar with each, so that you can confidently select the form of metering best suited to what you are photographing. When I took this image, I used multi-segment metering, knowing it would produce an accurate reading in the overcast conditions.

Nikon D200, 18–70mm
(at 70mm), 4secs at f/20,
ISO 100, polarizer and tripod.

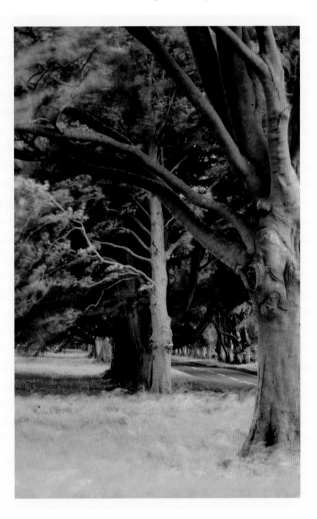

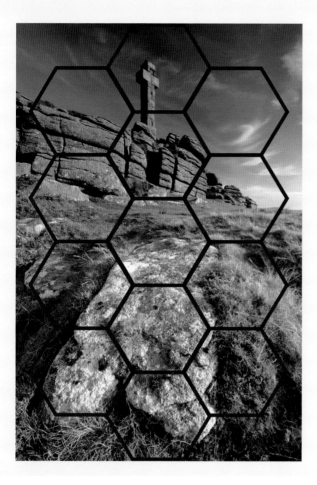

◀ *Granite cross*
**Multi-segment metering is
most effective when the scene
or subject is mid-tone, making
it well suited to subjects like
landscapes.**

- -

Nikon D200, 10–20mm
(at 11mm), 1/2sec at f/18,
ISO100, polarizer and tripod.

- -

Multi-segment metering

This form of metering offers photographers the highest ratio of success. Typically, this is a camera's default setting, being reliable in the vast majority of lighting conditions. As its name suggests, it works by taking multiple independent light readings from various areas of the frame. It then calculates a meter reading based on its findings.

This form of metering pattern is named differently, depending on the make of the camera – for example, it is also known as 'Evaluative', 'Matrix' and 'Honeycomb' metering. However, regardless of the title it is given, the principle of how it works is exactly the same. The viewfinder is divided into multiple segments from which the camera measures the level of light relative to that part of the image space. The camera's processor assesses this information, before assigning an exposure value via its viewfinder and LCD display. Multi-segment metering is most effective when the scene or subject is predominantly mid-tone, and the brightness range within the camera's dynamic range. As the majority of pictures taken fall within this broad description, it is easy to understand why this particular form of measuring light is so popular and effective. However, the system is less useful when you wish to meter for a specific area within the frame – for example a backlit or silhouetted subject.

Due to its nature, multi-segment metering will provide an overall average setting, thus limiting the creative control you have over the image. In situations like this, it is worthwhile switching to the precision of spot or partial metering.

Centre weighted metering

Centre – or average – weighted metering is the oldest form of TTL metering, but still found on the majority of modern DSLRs. While it has been greatly superseded by sophisticated multi-zone metering, it remains a highly useful form of measuring light. The system works by averaging the light reading over the entire scene, but with emphasis placed on the central portion of the frame. Typically, around 75% of the reading is based on a centre circle, visible through the viewfinder. This is often 8–12mm in diameter – although the size of the reference area from which the camera weights its light reading can be adjusted on some models.

Centre weighted metering works using the theory that the main subject is normally central in the frame. Therefore, it is well suited to portraiture photography or in situations where the subject fills a large portion of the image space. Also, this system is less influenced by areas of intense light or dark shadow at the edges, which would affect multi-zone readings. However, centre weighted metering is less useful when taking photographs where the subject brightness range, between foreground and background, exceeds the camera's dynamic range (see page 32). For example, landscape photography, where underexposure is likely in images boasting plenty of bright sky.

What is mid-tone?

Light meters – handheld and in-camera – are calibrated to always give a reading for a middle-tone subject that reflects 18% of the light falling on it. This is known as 18% grey or mid-tone and is the value of the mid-point of a photographic material's ability to read detail in both an image's highlights and shadows. To help understand this, imagine a scale from pure white to pure black, with each progressive step reflecting half or double the amount of light falling on its neighbour. Whilst you might presume 50% would be the mid-point, in reality this degree of reflectance would be substantially brighter than what would appear to be mid-tone. Therefore, this middle point is represented by 18% grey – although some would argue that the mid-tone is actually nearer to 12%. This is relevant, as light meters often work in greyscale.

Therefore, when photographing a medium tone subject – like the skin tone of a Caucasian, brickwork or grass – your light meter will be reliable, giving you a technically accurate exposure value. However, metering problems can arise when you photograph subjects that are darker or lighter than mid-tone, for example snow or a black dog. Your metering will still set a value for mid-tone, whereas in reality you will normally want subjects that are lighter or darker than mid-tone to appear so – otherwise they won't be captured faithfully. This is why, despite the accuracy of modern metering, it is still sometimes necessary to employ exposure compensation (see page 60).

▼ *Rose*

Centre, or average weighted, metering systems assign greater emphasis to the light falling in the middle of the frame. This makes it a reliable system for photographing subjects that fill the frame, like this close-up of a red rose.

Nikon D200, 150mm, 1/30sec at f/4, ISO 100 and tripod.

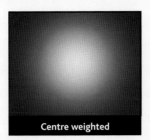

Centre weighted

Using this form of metering, approximately 75% of the sensitivity is directed towards the central part of the frame. As a result, it is less influenced by any areas of varying brightness at the edges of the frame that would otherwise trick the metering system.

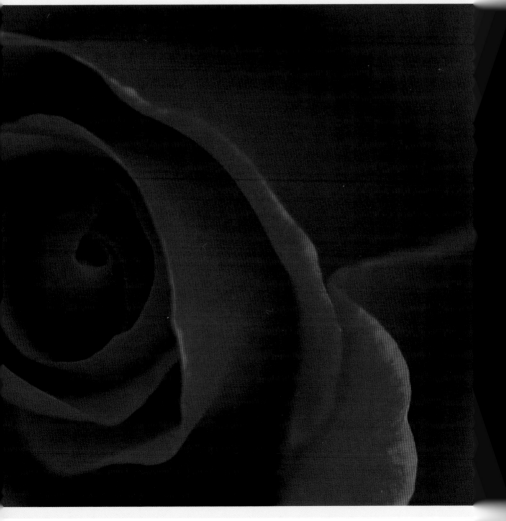

Spot and partial metering

These are the most precise forms of TTL metering available to photographers. Both systems calculate the overall exposure from just a small portion of the image space, without being influenced by the light in other areas. Typically, spot metering employs a reading from a central circle covering just 1–4% of the frame; partial metering works by measuring light from a larger area – typically 10–14%. Spot is a common metering system, found on the majority of DSLRs, whilst partial metering is found on only a few models – mostly Canon-made.

Spot and partial metering allow far more control over the accuracy of exposure than any other metering system. However, it also relies on greater input from the photographer, requiring them to point the metering spot directly towards the area of the scene they wish to meter from. By measuring the light from just a small percentage of the image space, it is possible to achieve a correct reading for relatively small, specific subjects within the frame. This is useful in a number of situations, but particularly when dealing with awkward, changeable light and high-contrast scenes – for example, when the background is much brighter than the subject due to backlighting (see page 105).

Although the metering circle is central in the viewfinder, some models allow the user to select an off-centre spot – for when the subject is not central. If your camera does not have this option, take a spot meter reading from the desired area and then employ autoexposure lock (AE-L) before recomposing the shot. Some cameras have a multi-spot option, which allows you to take several spot meter readings and then employ an average.

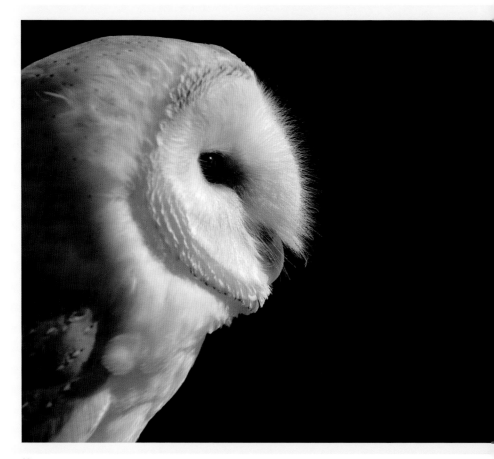

Spot and partial metering are highly useful tools, which – used correctly –
will help ensure you achieve the exposure you desire. However, remember to
switch your metering mode back to multi-segment metering when
you have finished, as this is better suited to day-to-day photography.

Exposure
tip

Exposure lock

The autoexposure lock (AE-L) button is a common feature on many DSLRs, permitting photographers to 'lock' the current exposure settings – regardless of changes to the incoming light levels through the viewfinder. In practice, this means you can take a meter reading from a small, specific area – typically using spot or partial TTL metering – and then lock the settings before recomposing the image and releasing the shutter.

As a result, your original reading will be unaffected by light or shadow in other parts of the frame and the region you metered from will be correctly exposed. Fail to do so and your camera will automatically readjust the settings when the composition is rearranged. If shooting in manual exposure mode, autoexposure lock isn't required as settings are altered by the photographer, not the camera.

◀ Barn owl

The owl's white plumage strongly contrasts with the inky black background, creating a difficult scene to meter correctly. I feared my camera's multi-segment metering would be fooled, so instead I selected spot, and metered from the top of its head. I then locked the settings, before readjusting composition and finally taking the picture.

Nikon D200, 200mm, 1/1000sec at f/5, ISO 100 and tripod.

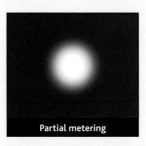

Partial metering

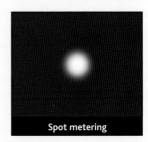

Spot metering

Spot and partial metering base their light readings on a small percentage of the frame, making them the most accurate form of TTL metering. However, as a result, they also require the most input and care from the photographer.

Sensor technology

At the hub of a digital camera is its image sensor. Sensors are silicon chips. The most common types found in digital SLRs are charge-coupled device (CCD) and complementary metal oxide semiconductor (CMOS). Whilst they have differing characteristics, both types work in a similar way, with each capable of excellent results.

Image sensors

Image sensors have millions of photosensitive diodes on their surface – called photosites – each of which capture a single pixel. They are normally arranged in rows on the chip and are only sensitive to monochromatic light. Therefore, to create colour, the majority of image sensors are overlaid with a Bayer mosaic, which filters light into red, green and blue. Each individual diode reads the quantity of light striking it during exposure, which is then counted and converted into a digital number. This number represents the brightness and colour of a single pixel. The information is then converted into an electrical signal and the charges are processed row by row to reconstruct the image.

It is due to the fact that information from rows of pixels is joined together – or coupled – that charge-coupled devices get their name. Finally, the picture information is passed to the storage media. It is remarkable to think that each time you take a picture your digital camera quite literally makes millions of calculations in order to capture, filter, interpolate, compress, store, transfer and display the shot. All of these calculations are performed in-camera by a processor – similar to the one employed in your desktop computer, but dedicated to this task.

Resolution

The number of pixels employed to capture a photograph is known as its pixel count or resolution. So, for example, if a digital camera produces an image size of 4,288 x 2,848, its maximum resolution is 12.21 million pixels (4,288 multiplied by 2,848). The term 'mega-pixel' is commonly used to express 1 million pixels. Digital cameras are often referred to by their maximum resolution, so, for example, a 12 mega-pixel camera is one which is capable of recording upwards of 12 million pixels.

The number of pixels used to capture an image is important, dictating how large the resulting photograph can be displayed or printed before image quality degrades. More pixels equate to added detail and sharpness. Therefore, it is always best to employ your camera's highest resolution – for the simple reason that you can make an image smaller using photo-editing software, but you cannot make it larger whilst still retaining the original quality. Regardless of the number of mega-pixels used to capture an image, pixels will always begin to show if enlarged enough – known as pixelization. However, with many digital cameras now boasting a resolution upwards of 10 million pixels, image quality remains outstandingly high even when images are printed or enlarged to A3 or bigger.

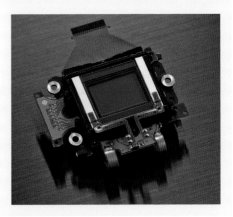

▶ *Sensor unit*
This is a product shot of the sensor unit found in the Nikon D300. It is typical of the units incorporated in today's DSLRs. This particular CMOS sensor boasts a total of 13.1 million photo detectors, but there are other models that boast upwards of 20 million pixels.

Image sensors

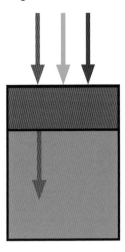
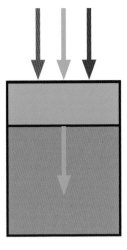

▶ *Bayer filter mosaic design*
The majority of digital cameras boast an image sensor that has a Bayer filter mosaic design. To capture colour, the pixel sensors in CCD and CMOS image sensors are organized in a grid – or mosaic – resembling a tri-colour chequerboard. Each pixel is covered with a filter which only allows one wavelength of light – red, green or blue – to pass through to any given pixel location. The filter pattern boasts twice as many green 'pixels' as red or blue to mimic the human eye's greater resolving power to green light.

An alternative sensor design is Fovoen. This sensor type employs three layers of pixels embedded in silicon. The layers are positioned to take advantage of the fact that silicon absorbs different wavelengths of light to different depths. The bottom layer records red, the middle records green and the layer at the top records blue. Each pixel stack directly captures all of the light at each point in the image to ensure it records colour other designs may miss.

Sensor size

Image sensors are produced in a variety of sizes – so called 'point and shoot' compacts employ the smallest, while large-format digital cameras boast the largest. Whilst some high-specification DSLRs employ a 'full frame' sensor – the same size of a traditional 35mm frame – most consumer models use a smaller APS-C size sensor. This is equivalent to the 'Advanced Photo System' size images, which are 25.1 x 16.7mm. This is commonly regarded as a cropped-type image sensor and effectively multiplies the focal length of the lens attached due to its smaller size – known as its multiplication factor. The degree of multiplication depends on the size of the sensor, but typically it is 1.5x. Therefore, a 200mm lens will effectively be 300mm when attached to a camera with this cropped-type design. This can be a disadvantage. For example, traditional wide-angle lenses lose their characteristic effect, meaning an even shorter focal length has to be employed to retain the same field of view. However, when photographing distant subjects, like wildlife and action, the multiplication factor can be hugely beneficial.

Generally speaking, the larger the sensor the better quality the resulting picture will be. Bigger sensors have larger photosites, capturing more light with less noise, so images are smoother, more detailed and sharper. For this reason, it is actually possible for a larger sensor, with fewer pixels, to capture better quality images than a sensor with a higher resolution, but that is smaller physically.

▼ *Multiplication factor*
The effect of using a cropped-type sensor (2), compared to a full frame model (1), is obvious from these two images.

1

Four-thirds system

The Four-thirds system gets its name from the CCD image-sensor it employs. The size of the sensor is 18 x 13½mm (22½mm diagonal). Therefore, its area is 30–40% less than the APS-C size image sensors found in the majority of other digital SLRs and its aspect ratio is 4:3 – squarer than a conventional frame, which has an aspect ratio of 3:2. It was devised by Olympus and Kodak with the intention to free manufacturers from the onus of providing compatibility with traditional camera and lens formats. The system has subsequently, been supported by Panasonic and Sigma. The diameter of its lens mount is approximately twice as big as the image circle, allowing more light to strike the sensor from straight ahead, thus ensuring sharp detail and accurate colour even at the periphery of the frame. The small sensor effectively multiplies the focal length by a factor of 2x, enabling manufacturers to produce more compact, lighter lenses. The Four-thirds system is providing a growing challenge to more conventional systems.

2

Histograms

The histogram is a highly useful tool, designed to help digital photographers assess exposure and quickly and easily identify where there may be under- or overexposure. A histogram is a two-dimensional graph – often resembling a range of mountain peaks – that represents an image's tonal extent.

The horizontal axis of a histogram represents the picture's range from pure black (0, far left) to pure white (255, far right); whilst the vertical axis illustrates how many pixels have that particular value. If a histogram shows a large number of pixels grouped at either edge, it is often an indication of a poorly exposed image – with either lost shadow or highlight detail. A graph showing a narrow peak in the middle – with no black or white pixels – indicates a photograph lacking contrast, and the result may look flat and lifeless.

Generally speaking, a histogram should show a good spread of tones across the horizontal axis, with the majority of pixels positioned left of the middle (100, mid-point). Normally, it is desirable to avoid peaks anywhere near the right-hand side of the graph, as this is usually an indication of 'burned out' (overexposed) highlights, resulting in lost detail. However, when assessing a histogram, it is important to consider the brightness of the subject itself. For example, a scene or subject boasting a large percentage of light or dark tones, like snow or a silhouette, will naturally affect the overall look of the resulting graph. Therefore, it is impossible to make generalizations about what is and isn't a good histogram. Whilst an even spread of pixels throughout the greyscale is often considered to be desirable you will need to employ your own judgement and discretion.

Digital cameras allow you to view, or overlay, a picture's histogram in the camera's LCD monitor via playback – making it easy to assess exposure immediately after taking the picture. It is then possible to adjust exposure and re-shoot if necessary. This is a far better method of assessing exposure than simply looking at the LCD picture display. This is due to the fact that it can be difficult – if not impossible – to make an accurate assessment of a replayed photo when there is light reflecting from the monitor. This is particularly true when outdoors, as the glare from the screen can prove very deceptive.

Exposure tip

Histograms are an essential aid to photographers striving for correct exposure. By scrutinizing an image's histogram, you can ensure highlight and shadow areas don't 'clip'. Therefore, remember to regularly use the histogram screen on your digital SLR.

▼ *Histograms*
A histogram with pixels predominantly skewed to the left or right is often an indication of poor exposure, whilst one showing the pixels evenly distributed throughout the graph is normally an indicator of good exposure. However, a histogram simply tells us how a picture is exposed, allowing photographers to decide whether – and how – to adjust exposure settings.

▼ dark histogram

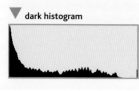

▼ correct histogram

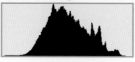

▼ light histogram

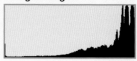

▼ *Water lily*

Studying an image's histogram will help you avoid making exposure errors. Very light and dark subjects often prove the most challenging to metering systems. For example, if a light subject like this water lily is overexposed, detail will be 'washed out' and lost altogether. In this instance, I studied the image's histogram to ensure the value for pure white didn't 'clip'.

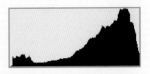

Nikon D70, 150mm, 1/20sec at f/18, ISO 100 and tripod.

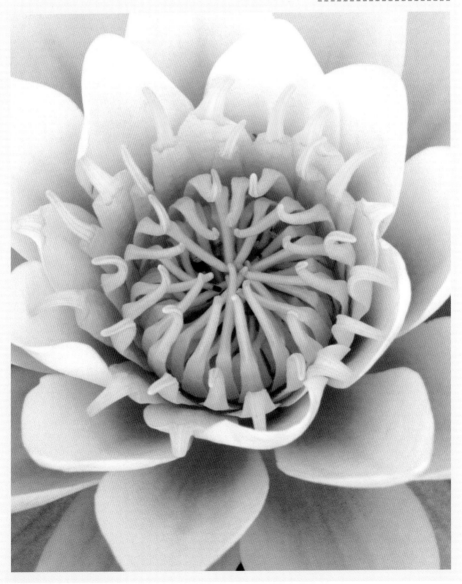

Histograms in practice

The basic rule when interpreting histograms is to always strive to get a reasonable colour spread – covering at least two thirds of the graph – and with its average slightly left of the mid-tone point. However, whilst this might be fine in theory, in practice it isn't quite that straightforward. Deliberately under- or overexposed images – like silhouettes (page 106) and high- and low-key images (page 42) – will produce histograms with peaks either towards the far left (black) or far right (white). Equally, photographs taken of a scene or subject possessing a large percentage of light or dark tones will have a corresponding histogram weighted to one edge of the graph. This doesn't mean the photograph is incorrectly exposed – the histogram is simply representative of the subject.

The following three images are all 'correctly' exposed, yet their histograms appear vastly different. Look at how the subject matter affects the resulting graph. The images help to illustrate that, whilst histograms are an essential aid to exposure, they come in all shapes and sizes and photographers must learn to interpret them depending on the subject matter.

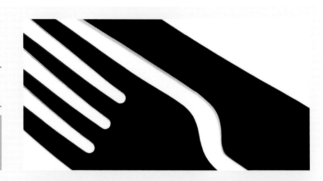

▶ *Knife and fork silhouette*

- -

Nikon D200, 150mm, 1/80sec at f/11, ISO 100 and tripod.

- -

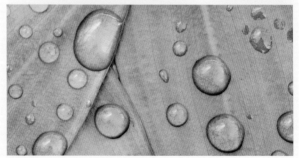

▶ *Leaf and water droplets*

- -

Nikon D200, 150mm, 1/30sec at f/14, ISO 100 and tripod.

- -

▶ *Sheep in blizzard*

- -

Nikon D70, 10–300mm
(at 300mm), 1/180sec at f/8, ISO
200 and tripod.

- -

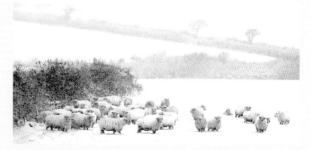

Exposure warnings – the highlights screen

The majority of digital cameras are designed with a playback function known as the 'highlights screen'. This useful function provides photographers with a graphic indication of when areas of the image are overexposed. This form of 'exposure warning' can prove a valuable in-camera tool and, arguably, is just as helpful as the histogram for ensuring you capture highlights within the sensor's dynamic range.

Whilst histograms provide a graphic illustration of an image's tonal extent, helping you assess exposure overall, the highlights screen – or highlights alert – is aimed specifically at helping photographers to avoid highlights burning out. White or very light subjects in direct sunlight are especially prone to

this. A histogram with a sharp peak to the far right will normally indicate that an image is suffering from areas of overexposure. However, the highlights alert actually identifies the pixels which exceed the value for pure white (255). Pixels that do so are not given a value, meaning they cannot be processed and are effectively discarded – having no detail or information recorded. When the image is replayed on the camera's LCD monitor the pixels falling outside the camera's dynamic range flash or blink – providing a quick and graphic illustration of where picture detail is 'burned out' and devoid of detail. To rectify this, set negative exposure compensation (page 60) so that the next frame is recorded darker.

A digital camera's highlights alert is not always switched on by default. Therefore, consult your user's manual and switch it on when you feel this type of exposure warning would prove useful. Normally this is done via the camera's Playback Menu.

▼ *Highlights screen*
The highlights alert causes groups of pixels that have exceeded the sensor's dynamic range – and are therefore recorded without detail – to flash as a warning. In this instance, areas of the blurred, white water cascading past a mossy boulder are 'burned out'.

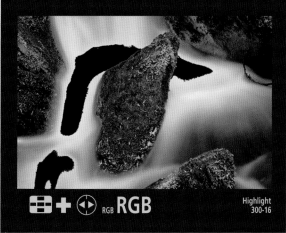

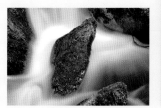

Dynamic range

Dynamic range is a term used to describe the ratio between the smallest and largest possible values of a changeable quantity. Within the realms of digital photography, it relates to the range of intensities that the camera's sensor can record in both shadow and highlight areas. Also referred to as contrast range or latitude, dynamic range is a term originally used in audio recording, but one that has grown more generalized.

Our eyes have a wide dynamic range and can distinguish between dark shadows and brightly lit areas with remarkable speed and accuracy. However, a digital chip has a much narrower perception and can struggle to simultaneously record detail in

Exposure tip

It is possible to merge several bracketed images, of an identical composition, to create a high dynamic range (HDR) image (page 182).

▶ **Fishing harbour**
Despite the contrast between the dark stormy sky and sunlit buildings, this image just remains within the sensor's dynamic range, with detail being retained in both the picture's highlights and shadow areas.

Nikon D200, 18–70mm
(at 18mm), 2secs at f/22,
ISO 100, Polarizer and tripod.

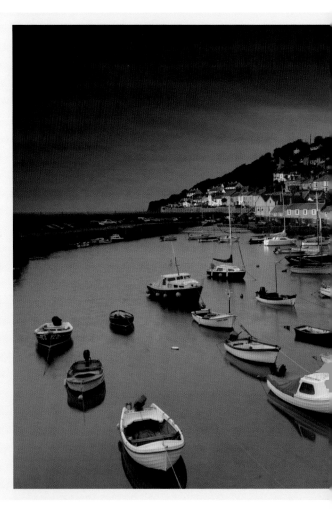

the darkest and lightest areas. Therefore, if there is a large degree of contrast within your photo, the camera will not be able to record all areas faithfully and the resulting image will be 'clipped', suffering from under- or overexposure. This is why photographing scenes boasting high contrast can prove so challenging.

In photography, dynamic range is often measured in stops of light. For example, colour negative film has relatively high latitude of around seven-stops. This means that the film will record detail in the picture's highlight up to seven-stops lighter than the shadow areas – or vice versa. The latitude of a digital sensor is defined by the largest possible signal divided by the smallest possible signal

Technology advances

As technology advances, dynamic range is being extended. Today's DSLR cameras already boast ample resolution. Therefore, the next area of product improvement for manufacturers is the quality of the pixels – as opposed to the number of them. For example, Fujifilm have developed, and incorporate, a CCD SR dual sensor in their DSLR cameras. This design features two photodiodes at each photosite – a single 'input pixel'. The 'S' pixel is normal sensitivity, capturing the same range of light as a conventional CCD photosite. The 'R' pixel is smaller and designed with a lower sensitivity to capture detail above the saturation point of the 'S' pixel. The camera then combines the information from the two photosites to create an extended dynamic range. This type of design will become increasingly common, as a new crop of technologies, using high dynamic range imaging, aim to extend the dynamic range of digital imaging technologies way beyond traditional media.

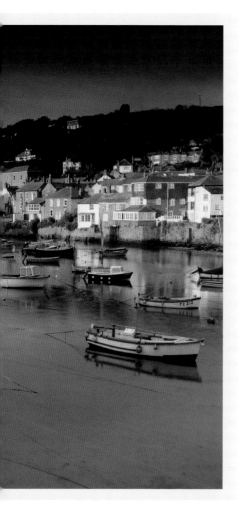

it can generate. The largest signal is proportional to the full capacity of the pixel, whilst the lowest signal is the noise level when the sensor is not exposed to any light. Therefore, a digital camera's dynamic range will differ depending on the design of the chip and the manufacturer. Buying a camera boasting a good dynamic range will benefit your images. However, there are other ways to extend a picture's dynamic range. For example, when shooting scenics, it is possible to attach a graduated neutral-density filter (see page 152) to balance the level of contrast between the bright sky and darker foreground. Another effective way to retain detail throughout contrasty images is to shoot two photographs – one exposed for the highlights and another for the shadow areas – and then combine the individual images post capture using photo editing software like Photoshop (see page 164).

To maximize your camera's dynamic range, shoot at low ISO sensitivities and in Raw format. Raw images preserve the dynamic range of the sensor, using Jpeg will 'clip' the shadows and highlights.

Exposure tip

Deliberate underexposure

When it comes to exposure, digital capture has many advantages over film. You can look at an image, and its histogram, immediately to check if your exposure is correct or not. Whilst you should strive to achieve an accurate exposure in-camera, digital images are relatively forgiving to a small degree of error that can be easily corrected. In fact, some exploit this 'latitude'; deliberately underexposing their results to avoid losing detail in the highlight areas.

Deliberate underexposure to avoid loss of highlights

Digital photographers are often advised to err on the side of underexposure when setting their aperture and shutter speed combination. There is a very logical reason for this. Although advances in technology are helping to extend a camera's dynamic range (see page 32), a sensor is not able to record detail in both the highlight and shadow areas of a photograph that exceeds its brightness range. Therefore, high contrast scenes – where the range of light is too great for the sensor – can pose

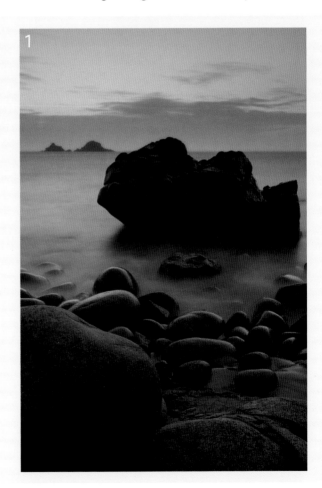

▶ *Coastal landscape*
In this image, I intentionally underexposed the image at the point of capture, to ensure all detail would be retained (1). I then later adjusted image brightness using curves in Photoshop (2) to reveal more detail in the foreground rocks. This ensured that the image looked correctly exposed overall.

Nikon D300, 10–20mm (at 14mm), 20secs at f/16, ISO 100 and tripod.

problems. There is no simple solution. For example, expose for the highlights, and the shadows will be underexposed; expose for the shadow areas, and the highlights will be overexposed.

Sometimes this imbalance can be remedied using neutral-density filtration (see page 150) or by merging differently exposed images together in Photoshop (see page 184) to effectively extend the sensor's dynamic range. However, in situations where neither of these options is possible or practical, given the choice between blown-out highlights or underexposed shadows, it is best to deliberately underexpose results or 'expose for the highlights'.

The reason for this is that when highlights are 'blown' or 'clipped', the detail within that area is lost and cannot be retrieved. If you set your camera to its histogram mode, this will be indicated by a large spike in the graph pushed up against its far right edge. Alternatively, switch your camera to its highlights mode (see page 31) and the overexposed areas will flash.

Whilst 'blown' highlights are void of detail, shadow detail obscured by a degree of underexposure can normally be recovered post capture using editing software. This is normally quite a quick and easy task thanks to the Curves or Levels tool. To apply a degree of intentional underexposure, select either a faster shutter speed or smaller aperture. The resulting histogram will show the majority of the pixels positioned left of mid-point.

When you are adopting this approach, try not to underexpose images more than is needed to preserve detail in the highlights. The reason for this is that if the shadows areas are too underexposed they can clip to pure black and be equally devoid of detail. To ensure this doesn't happen, again utilize your histogram, checking that the shadow areas aren't blown – indicated by sharp peaks in the graph to the far left of the graph. Also, if you push exposure too far to the left, increased signal noise will begin to obscure detail when you lighten the exposure post capture due to the way image sensors count light in a linear fashion (see page 36). This will degrade picture quality, which is why a technique known as 'expose to the right' is popular amongst many enthusiasts.

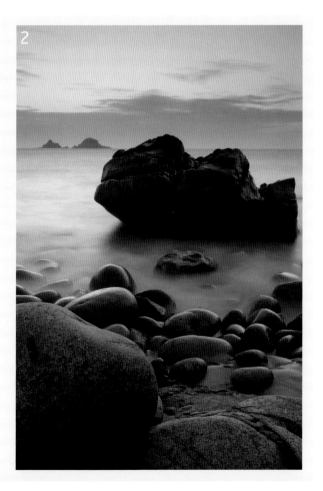

Deliberate overexposure

Deliberate overexposure is fast becoming a widely accepted approach to help maximize image quality – although it only applies if you shoot in Raw format. It is a technique where the photographer is effectively pushing their exposure settings as close to overexposure as possible without actually clipping the highlights. The result is a histogram with the majority of pixels grouped to the right of mid-point – hence it is sometimes called 'exposing to the right'.

Exposing to the right

The logic of this approach can only be understood once you appreciate that CCD and CMOS sensors count light photons in a linear fashion. Linear capture has important implications on exposure. For example, typically, a digital camera is able to capture six stops of dynamic range (see page 33). Most digital SLRs record a 12bit image capable of recording 4,096 tonal values. However, whilst you might automatically think that each f-stop of the

Whilst the look of your histogram will vary depending on what you are photographing, when adopting the 'expose to the right' approach, the majority of the pixels should be right of mid-point. Try to push exposure as close to the right of the graph as possible without 'clipping' the value for pure white. The resulting histogram may look similar to this one.

six-stop range would record an equal amount of the tonal value total, this is not so. The level corresponds exactly to the number of photons captured so, in reality, each stop records half the light of the previous one. For example, half of the levels are devoted to the brightest stop (2,048), half of the remainder (1,024 levels) are devoted to the next stop and so on. As a result, the last and darkest of the six stops only boasts 64 levels.

Linear distribution

At first, this might seem very confusing and the relevancy not obvious. However, in simple terms, what this signifies is that, if you do not properly utilize the right of the histogram – which represents the majority of the tonal values – you are wasting up to half of your camera's available encoding levels. Therefore, if you deliberately underexpose images to retain the highlights – as is common practice among many digital photographers – you are potentially losing a large percentage of the data the camera is capable of capturing. Also, signal noise significantly increases as a result – particularly to the mid-tones and shadows. This is because, when you open up the shadow areas during Raw conversion – in order to lighten an image – you have to spread the 64 levels in the darkest stop over a wider tonal range. This exaggerates noise and also an effect known as posterization – where the continuous gradation of tones is replaced with fewer tonal values, resulting in an abrupt change from one tone to another.

So, whilst it remains important not to actually overexpose images to the degree where the value for pure white is blown, 'exposing to the right' is a logical approach to exposure. Whilst the method needs applying with care, and relies heavily on using the histogram to avoid clipping, image quality will be maximized.

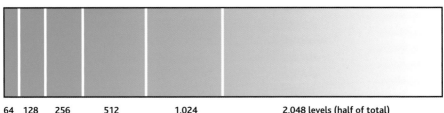

| 64 | 128 | 256 | 512 | 1,024 | 2,048 levels (half of total) |

▼ Expose to the right

When 'exposing to the right', the unprocessed Raw file may look washed out on the camera's monitor and when first downloaded onto your computer (1). However, as long as you have used your camera's histogram screen to ensure the highlights aren't actually clipped, colour and contrast can be quickly restored during conversion (2).

Nikon D300, 10–20mm (at 16mm), 2secs at f/22, ISO100, polarizer, 0.9ND and tripod.

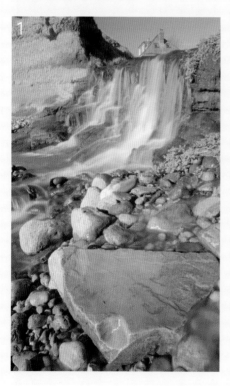
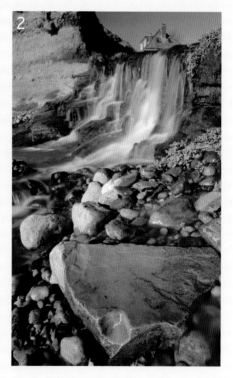

◀ Dynamic range

This illustration represents six stops of dynamic range – the typical latitude of a digital camera. The majority of DSLRs record a 12bit image capable of recording 4,096 tonal levels. Half of these (2,048 levels) are devoted to the brightest stop, half of the remainder (1,024 levels) are devoted to the next stop and so on. The darkest stop – on the far left of the graphic and representing the shadow areas – has only 64 levels, so is able to record less detail as a result.

File formats

Digital images can be captured – and stored – in different file types. The format of the digital file plays a key role, helping to determine image quality, size and the amount of memory that the picture will use on the storage card – and on your computer. The majority of digital cameras allow you to capture images in Jpeg or Raw – with many higher specification models offering the extra option of Tiff format. Once downloaded onto a computer, they can be saved as a number of other file types also – like a Gif or PSD.

Raw

Raw is a lossless file type – using a reversible algorithm – and is often considered the digital equivalent to a film negative. Unlike Jpegs or Tiffs, the shooting parameters are not applied to the image at the time of capture, but are kept in an external parameter set – accessed whenever the Raw file is viewed. Put simply, the image is unprocessed data. Once downloaded, a Raw file has to be processed – using compatible conversion software (see page 168). It is at this stage that you can fine tune the image and adjust the shooting parameters – like sharpness, contrast and white balance.

Raw is a relatively forgiving format with comparatively wide exposure latitude, so it is also possible to correct a degree of exposure error during conversion. Once processing is complete, Raw images have to be saved as a different file type – typically Jpeg or Tiff – but the original Raw file remains unaltered.

Raw is a flexible file type and image quality is highest. Therefore it is the preferred format for many photographers. While there are many advantages to shooting in Raw, their larger file size mean they consume card and disk space more readily. Also, being larger, the files take longer to open and – due to the necessity of having to process Raw files – more time is required sat in front of a computer.

Jpeg – Joint Photographic Experts Group

Jpegs are a lossy file type, so some data is discarded during compression. The pre-selected shooting parameters, like white balance and sharpness, are

applied to the image in-camera. Therefore, after the file is transferred from the camera's buffer to the memory card, the photograph is ready to print or use immediately after download. This makes Jpegs ideal for when a photographer needs to produce the end result quickly and with the minimum of fuss. However, as a result, the file is far less flexible and it is trickier to correct or alter the shooting parameters during processing. So, if you do make a technical error, you are less likely to be able to salvage the photo than if you made the same mistake shooting in Raw.

Digital cameras allow you to take Jpegs in different quality settings and sizes. Typically, the quality settings are Fine, Normal and Basic, while the image size – measured in pixels and varying depending on the resolution of the camera – can be captured in either L (large), M (medium) or S (small). The Basic and Normal settings – along with smaller file sizes – are ideal if you are taking snapshots; want lower resolution images to send via email; or only intend printing below 10 x 8 in size. However, for optimum image and print quality, it is best to always shoot in Jpeg Fine, set to its largest resolution.

Jpeg is a highly convenient and popular file format. At low levels of compression, image quality isn't affected significantly and, being smaller in size, more will fit on a memory card and archiving is easier. However, each time a Jpeg is re-saved, data is lost; so this should be taken into account should you plan on making future manipulations.

Tiff – Tagged image file format

In addition to Raw and Jpeg files, some digital SLR cameras are also capable of capturing images as Tiffs. Tiffs are lossless files, so photographers who shoot in Raw often tend to save and store their images in Tiff format once the original file has been processed. However, shooting in Tiff in the first instance has its disadvantages. A Tiff is a fully developed file with the pre-selected shooting parameters already applied – similar to shooting in Jpeg. Therefore, it cannot be adjusted with the same impunity as a Raw file. In addition to this, unlike compressed Jpegs, Tiffs are large, filling memory cards quickly and slowing the camera's burst rate. Therefore, they are a less practical file type for image capture. Instead, Tiffs are a format better suited to storing converted Raw files.

▼ Picture quality

To help illustrate how image quality is affected by compression, I saved this image of a large red damselfly (1) at different compression ratios. It is easiest to show image quality by enlarging just a small section. Image (2) shows the original Tiff. The image quality of the Jpeg set to its 'Finest' setting (3) is comparable to the Tiff, with no discernable difference between the two. Even at a 'Normal' form of compression, image quality remains good (4). However, at the 'Basic' setting (5), compression is high, leading to a significant loss of image data and picture quality.

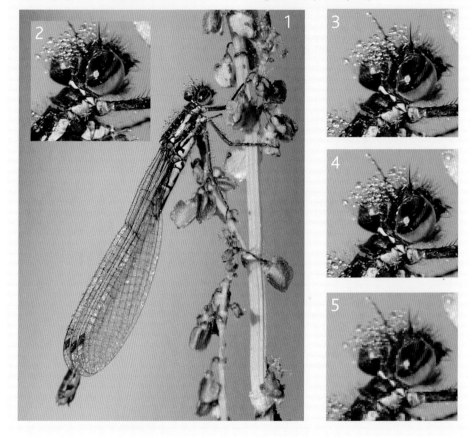

Compression

Due to their large size, when digital images are captured they are normally compressed in some way. The reduction in file size allows more images to be stored in a given amount of disk or memory space. There are two forms of compression – lossless and lossy. As the name suggests, lossless (LZW) compression stores images without losing any information and as a result, image quality is optimized. In contrast, some information is discarded when lossy files are compressed – the greater the compression, the more detail that is lost. This will not often result in a visible drop in picture quality and, being smaller in size, ie. bytes; not its physical dimensions – they are not quite so memory intensive. There are pros and cons to both types of compression, but to maximize image quality it is best to opt for a lossless file type, like Raw.

Overall exposure brightness

Contrast is a regularly used term, describing the subjective difference in brightness between the light (highlights) and dark (shadows) areas of an image. Photographs with a wide tonal range – with dark shadows and light highlights – are said to be high contrast, whilst photographs possessing lots of similar shades of grey are regarded as being low contrast.

High

Low

▲ *High- and low-contrast*
These two illustrative histograms demonstrate how the tonal extent of both a high- and low-contrast image differs.

Contrast is the difference in visual properties that make a subject distinguishable from other objects and its background. In visual perception, contrast is determined by the difference in the colour and brightness of the subject and other objects within the same field of view. It can have a significant visual impact on our images. High-contrast images – also regarded as contrasty or harsh – have deeper shadows and more pronounced highlights, helping to accentuate texture, shape and a subject's three-dimensional form. A low-contrast image can appear quite flat, with little difference in the density of its colours or tones. Both high- and low-contrast images can work well – depending on the effect you desire.

Contrast is greatly influenced by the direction and intensity of light. It is greater under direct lighting conditions – for example point light sources like the sun or when light is positioned to the side or directly above the subject. If lighting is diffused, or the light source is in front of the subject, the degree of contrast is reduced. A low-contrast image may also result due to the subject matter or conditions, for example photographs taken in fog, mist or smoke will have little contrast.

An image's histogram (see page 28) can be used to evaluate its contrast. A broad histogram, demonstrating a wide tonal range from dark to light, reflects a scene with good contrast. However, a narrow histogram signifies low contrast and the resulting picture may look flat. Contrast can be remapped post capture using tools like levels (page 172) or curves (page 174). This is useful

▶ *Misty morning*
This photo of autumnal trees, taken early one misty morning, is a good example of an image with low contrast. In this instance, the narrow contrast is caused by the weather conditions and whilst – due to the lack of contrast – the image may look quite flat and one dimensional, the result is atmospheric and faithful to the original scene.

- -

Nikon D200, 100–300mm (at 270mm) 1/20sec at f/11, ISO100 and tripod.

- -

in situations where, due to a sensor's limited latitude, a picture is recorded with less contrast than is faithful to the original scene. Alternatively, you may simply wish to alter an image's contrast to enhance its impact.

Exposure tip

Low-contrast images, particular those caused through atmospheric conditions like mist or fog, can look very striking. Therefore, don't enhance contrast using levels or curves just for the sake of it. The image will only look artificial as a result, so use your discretion.

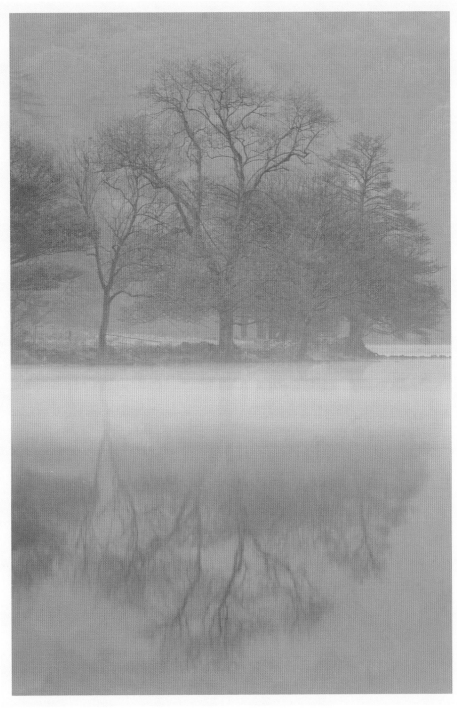

High- and low-key images

High and low key are terms used to describe exposures that are predominantly light or dark. High key refers to an image which is light in tone overall. An image which is dark, with the majority of the tones occurring in the shadows, is deemed low key. Whilst you might imagine that due to their nature, high- and low-key images would lack impact, in reality this approach can create striking results.

High key is a photographic style, where the image is predominantly white or brightly lit – in other words, there is little mid-range tonality. Low key is an approach where the subject is surrounded by dark tones and in which there are few highlights. Both styles intensively use contrast and can be used to convey differing moods. High-key images are light, bright and often considered positive, while low-key images are often dramatic and atmospheric.

High-key images have little or no shadow and lack contrast, with the subject rendered in a light tone similar to that of the background. There are few middle tones and, in addition to the tone being bright, it will often be quite even across the image. One of the best high-key subjects is people, with the sitter being photographed against a white background – often dressed in white or light clothing. Exposure levels often need to be high, but images shouldn't be overexposed. With low-key photographs the tone is dark, and the controlling colour is usually black. Special attention will normally be given to the subject's shape, form and curves – often emphasizing them with highlights – to provide the picture's interest and impact. Low-key images often have a high level of contrast.

Before you take a picture, it is a useful to identify whether or not your subject qualifies as high or low key. Cameras measure reflected light, opposed to incident light (see Metering, page 16), so they are unable to evaluate the absolute brightness of the subject. Cameras employ sophisticated algorithms to try to circumvent this limitation, which estimates the image's brightness. This estimate will often place brightness in the mid-tones and, whilst this is acceptable for most subjects, it will often result in high- and low-key images being incorrectly exposed. Therefore, high- and low-key images often require a degree of manual exposure adjustment relative to what the camera would do automatically. For example, high-key images often require longer exposure than recommended, with low-key images needing less exposure time.

Exposure tip

Histograms for high-key images will often show peaks to the far right, whilst low-key images will show peaks grouped left of the mid-tone point.

▶ *Dalmatian*
High-key images are mostly light in tone, often with both the subject and background brightly lit. Photographing a Dalmatian against a white background, emphasized the dog's markings.

Samsung GX10, 100mm, 1/180sec at f/4, ISO100 and handheld.

▼ Boulders

Low-key images are dark in tone and rely on either highlights or colour to highlight the subject's shape and contours.

Nikon D200, 100–300mm (at 300mm), f/8, ISO 200 and tripod.

Exposure value (EV)

The 'law of reciprocity' (see page 58) states that the relationship between aperture and shutter speed is proportional. As a result, a 'technically' correct exposure can be made by using a variety of lens aperture and shutter speed combinations. For example, if an exposure of 1/125sec at f/5.6 is correct, then it is also possible to employ settings of 1/250sec at f/4 or 1/60sec at f/8 and maintain the amount of light reaching the sensor. The exposure value (EV) number represents all combinations of aperture and relative shutter speed that can be selected to produce the same level of exposure.

The EV concept was developed in Germany during the 1950s in an attempt to simplify choosing among combinations of equivalent camera settings. Every combination of lens aperture, shutter speed and sensitivity refers to an exposure value for a given ISO. The EV is a number that – when used in conjunction with an exposure value chart – gives

the appropriate combinations of exposure settings that maintain the same amount of light reaching the sensor. For example, 0 EV is equivalent to an exposure setting of f/1 at one second at an ISO sensitivity of 100. Each time you halve the amount

▼ *Swaying crop*

Whilst all camera settings with the same EV number will create the same level of exposure, the resulting pictures can differ greatly. These images were both taken using the same EV. However, due to the different aperture and shutter speed combinations employed, motion is recorded very differently. Remember that the shutter speed dictates the amount of motion blur and the relative aperture determines the level of depth of field.

Nikon D300 12–24mm (at 12mm), EV 10, ISO 100, polarizing filter and tripod. (1) 1/15sec at f/8 and (2) 1sec at f/32.

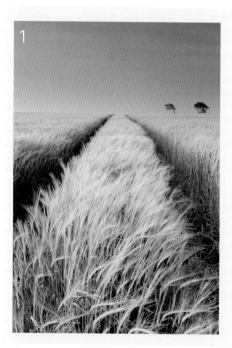

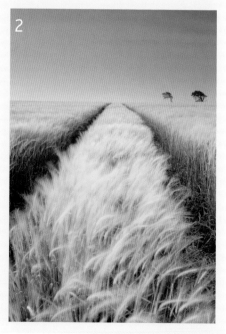

The numbers stated in an EV chart relate to a specific ISO rating, typically 100. If the ISO sensitivity if different, then you will need to adjust exposure accordingly. For example, if you are using 200 ISO, then you need to adjust the above settings by -1 stop.

	f/1.0	1.4	2.0	2.8	4.0	5.6	8.0	11	16	22	32
1 sec	0	1	2	3	4	5	6	7	8	9	10
1/2	1	2	3	4	5	6	7	8	9	10	11
1/4	2	3	4	5	6	7	8	9	10	11	12
1/8	3	4	5	6	7	8	9	10	11	12	13
1/15	4	5	6	7	8	9	10	11	12	13	14
1/30	5	6	7	8	9	10	11	12	13	14	15
1/60	6	7	8	9	10	11	12	13	14	15	16
1/125	7	8	9	10	11	12	13	14	15	16	17
1/250	8	9	10	11	12	13	14	15	16	17	18
1/500	9	10	11	12	13	14	15	16	17	18	19
1/1000	10	11	12	13	14	15	16	17	18	19	20
1/2000	11	12	13	14	15	16	17	18	19	20	21
1/4000	12	13	14	15	16	17	18	19	20	21	22

of light collected by the image sensor – for example, by doubling the shutter speed or by halving the aperture – the EV will increase by one. Therefore, one EV represents f/2 at 2seconds – half the amount of light of 0 EV – and so forth. Basically, each one unit change in EV is equal to a one-stop adjustment in exposure. High EV numbers will be used in bright conditions requiring a low amount of light to be collected by the camera's sensor to avoid overexposure, while low EVs will be employed when there is less available light and a greater degree of exposure is needed to avoid underexposure.

EV charts

The relationship between shutter speed and lens aperture is proportional – make an increase in one value, and you must make a proportional reduction in the other to maintain the same level of exposure and vice versa. Therefore, simple tables of exposure values can be calculated relatively easily for any given aperture.

Exposure value charts like this may look quite daunting at first, but they are actually quite straightforward to interpret. The value on the left relates to the shutter speed in seconds and the value along the top refers to lens aperture. Typically, an EV chart will include an aperture range from f/1 to f/32 – it is unusual for a camera lens to have a range exceeding this. Whilst the concept of EV may not prove quite so useful or relevant to photographers today, they do allow you to take photographs fairly reliably under certain lighting conditions without a light meter.

ISO sensitivity

ISO (International Standards Organization) is a numeric indication of a photographic material's sensitivity to light. This standard measurement was originally used to show the speed of film. However, since digital cameras use an image sensor instead, the term is now used to refer to the ISO equivalent. Therefore, ISO signifies how sensitive a digital camera's sensor is to the amount of light present. Film users need to change to a new roll of film to alter ISO speed but digital photographers can quickly alter the ISO rating for individual frames.

A digital camera's ISO range varies from camera to camera, but a typical DSLR can be set between ISO 100–3200, although some models boast a finest setting as low as ISO 50. The ISO setting you employ has a huge bearing on exposure, being directly related to the shutter speed/aperture combination needed to obtain a correct result. For example, at low sensitivities, more light is required to enter the camera in order to expose the image. Therefore,

either a longer shutter speed or larger aperture is needed. At high ISO sensitivities – for example 800 or 1600 – the sensor is more sensitive and therefore requires less light to obtain the correct exposure. As a result, a faster shutter speed or a smaller aperture is needed. Photographers normally utilize a higher ISO rating as a quick, convenient way to generate a faster shutter speed – desirable when shooting movement or in low light. However, a high ISO speed will also exaggerate digital noise, which appears like grain and degrades image quality. It is for this reason that, as a rule, it is best to employ your camera's lowest ISO setting whenever possible. This shouldn't normally present a problem, presuming that the light is good, you are using a camera support, or the subject is static.

Changes to ISO ratings are measured in stops – just as they are for adjustments to aperture and shutter speed. This helps to simplify exposure calculations. Each time the ISO rating is doubled it is the equivalent to one stop. For example, adjusting sensitivity from ISO 100 to 200 will generate one stop of light, ISO 400 two stops and so on.

▶ *Blue tit*

To generate a shutter speed fast enough to freeze the movement of this flighty garden bird, I selected a setting of ISO 400. This gave me an extra two stops of light, compared to the camera's base rate. Whilst this caused a slight increase in noise, it enabled me to take pictures which didn't suffer from subject blur.

Nikon D200, 100–300mm (300mm), 1/300sec at f/8, ISO 400 and tripod.

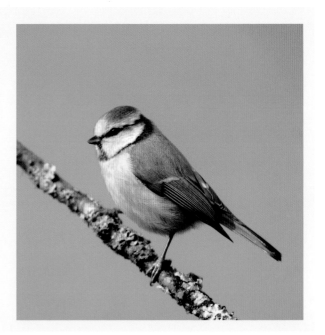

▲ *Stormy evening*

Using the latest digital cameras, the effects of signal noise are barely noticeable – even at ISO sensitivities of 400 or 800.

However, it is still advisable to select your camera's base rating whenever practical, to maximize image quality.

Nikon D200, 10–20mm (at 18mm), 1/20sec at f/16, ISO 100, polarizer and tripod.

When using a high ISO rating – or lengthy exposure time – shoot in Raw to minimize digital noise. This is due to the fact that Jpegs are a compressed file format and typically demonstrate more noise than their Raw counterparts.

Exposure tip

Noise

In conventional photography, high ISO films are more responsive to light due to the fact that the silver halide crystals are larger. As a result, the film and the image produced is grainier, which degrades image quality. In digital photography, employing a high ISO rating creates a similar affect, known as 'noise'. Noise is unrelated, brightly coloured pixels which appear randomly throughout the image. This is a result of electrical interference between the photodiodes that form a digital camera's sensor. Whilst noise is hardly noticeable at a camera's lowest ISO rating, when light sensitivity is increased, the interference – or signal noise – is also amplified. In principle, the effect can be compared to turning up the volume of a radio with poor reception.

Doing so not only amplifies the (desired) music, but also the (undesired) interference. Noise can also grow more obvious in pictures taken using a shutter speed longer than one second – as it can amplify while the sensor is active. For this reason, many DSLR cameras have a noise-reduction (NR) facility. This works by taking a dark frame and then subtracting the background noise from the final image.

Advances in sensor technology are steadily reducing the affects of noise, to the point that even at relatively high ratings, like ISO 800, image quality remains excellent. However, it is still advisable to always select the lowest ISO practical in any given situation.

Lens apertures

Aperture is the common term relating to the iris diaphragm of a lens. It consists of a number of thin, metal blades that can be adjusted inward or outward to alter the size of the near circular hole – the lens aperture – through which light passes. Like the pupil of an eye, controlling the size of the lens iris determines the amount of light that enters the lens and exposes the sensor. Varying the aperture means the level of depth of field (see page 50) is affected.

Lens apertures are stated in numbers – or f-stops. Typically, this scale ranges from f/2–f/32. However it will depend on the lens itself, with some having more or fewer settings. The f-numbers stated below relate to whole-stop adjustments in aperture:

What is a stop?

In photography magazines and books – including this handbook – the term 'stop' is often used. One of the keys to controlling exposure is understanding the significance of the 'stop'. In the context of photography, a stop is a unit of measurement relating to light. A stop is equivalent to doubling or halving the quantity of light entering the camera – either via the lens aperture or the duration of the shutter speed (see page 52). For example, if you increase the size of the aperture from f/11 to f/8 you are effectively doubling the amount of light reaching the sensor by one stop. If you increase the shutter speed from 1/250sec to 1/500sec you are halving the length of time the shutter remains open by one stop.

| f/2.8 | f/4 | f/5.6 | f/8 | f/11 | f/16 | f/22 | f/32 |

However, modern DSLRs also allow photographers to alter aperture size in 1/2 and 1/3stop increments, for greater exposure precision.

The f-number corresponds to a fraction of the focal length. For example, f/2 indicates that the diameter of the aperture is half the focal length; f/4 is a quarter; f/8 is an eighth and so on. With a 50mm lens, the diameter at f/2 would be 25mm; at f/4 it is 12.5mm and so forth.

A lens's aperture range is often referred to by its maximum and minimum settings. The maximum – or fastest – aperture relates to the widest setting of the lens iris; while closing it down to its smallest setting – allowing the least amount of light through – is the minimum aperture. Many zooms have two maximum

apertures listed, for example 70–300mm f/4–5.6. This indicates that the lens's maximum aperture changes as you alter focal length.

F-numbers often cause confusion, particularly among new photographers. This is due to the way a large (wide) aperture is represented by a low number, for example f/2.8 or f/4; and a small f-stop – when the aperture is closed down – is indicated by a large figure, like f/22 or f/32. This may appear to be the opposite way round to what you would imagine. Therefore – to help you remember which value is bigger or smaller – it can be helpful think of f-numbers in terms of fractions – for example, $1/8$ (f/8) is smaller than ¼ (f/4).

Exposure tip

'Stopping down' is a frequently used term in photography. This refers to reducing the light entering the lens by decreasing the aperture size. For example, by altering the f-stop from f/5.6 to f/8, you are effectively 'stopping down' the lens by one stop. 'Opening up' the aperture is when you select a larger aperture.

Lens aperture is determined by the size of the hole – iris diaphragm – through which light passes. Small apertures create the greatest depth of field and are denoted by larger f-numbers; large apertures produce a more limited depth of field and are indicated by smaller f-stops. Apertures are one of the key variables controlling exposure.

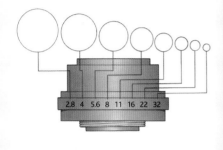

2.8 4 5.6 8 11 16 22 32

▲ *Grasshopper*
The aperture affects the depth of field recorded. A large aperture (lower number) will create a shallow depth of field, ideal for isolating a subject from its surroundings.

Nikon D200, 150mm, 1/300sec at f/4, ISO 100 and tripod.

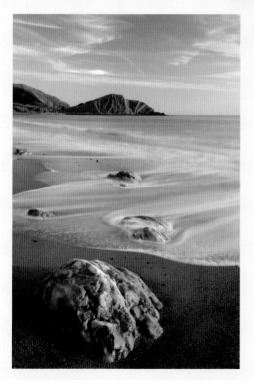

◀ *Dorset coastline*
By selecting a small aperture (higher number), depth of field will be extensive – ideal for scenic images. In this instance, I prioritized a small f-stop to ensure both the boulders in the foreground and distant coastline were recorded acceptably sharp.

Nikon D300, 10–20mm (at 20mm), 4secs at f/20, ISO 100, 0.9ND grad, polarizer and tripod.

Depth of field

Adjusting the size of the aperture alters the speed at which sufficient light can pass through the lens to expose the image sensor. Select a large aperture (small number) and light can pass quickly, so the corresponding shutter speed is faster; select a small aperture (large number) and the exposure will take longer, resulting in a slower shutter speed. This has a visual effect, with the aperture determining the area in your image that is recorded in sharp focus. This zone is known as depth of field.

Depth of field is a crucial creative tool. At large apertures, like f/2.8 or f/4, depth of field is narrow. This will throw background and foreground detail quickly out of focus, reducing the impact of any distracting elements within the frame and helping to place emphasis on your subject or point of focus – ideal for action, portrait and close-up photography. Select a small aperture, like f/16 or f/22, and depth of field will be extensive. This will help capture good detail throughout the shot and is particularly well suited to landscape photography, when you will often want everything – from the foreground to infinity – to appear in focus.

Depth of field preview button

To ensure the viewfinder is always at its brightest – to assist viewing and focusing – cameras are designed to automatically set the lens's fastest (maximum) aperture. As a result, what you see through the viewfinder isn't a fair representation of the level of depth of field that will be achieved in the final image. A depth of field preview button allows photographers to properly assess how the final image will appear at the aperture selected.

It works by stopping the lens down to the chosen f-stop. When you do this, the scene will darken in the viewfinder – the smaller the aperture, the darker the preview – but you will be able to assess whether the aperture selected provides sufficient depth of field. If not, adjust the aperture accordingly. Whilst this function can take a while to get used to, it can prove highly useful. However, it may be helpful to reduce the aperture gradually, stop by stop, so that changes in depth of field are more obvious. Not all cameras have this facility. If yours doesn't, assess depth of field by shooting a test shot and then review it via image playback.

Hyperfocal distance

To maximize depth of field, a technique known as hyperfocal focusing is well worth employing. To do this, it is important to remember that depth of field falls one third in front and two thirds behind the point of focus. Therefore, if you simply focus on – or near to – infinity, the part of the zone falling beyond the point of focus is wasted. Hyperfocal focusing prevents this from happening. The hyperfocal distance is where depth of field is at its maximum. First, it is best to set your camera on a tripod. Next, select the lens aperture you will be using. Focus the lens to infinity and release the shutter. View the resulting image on your camera's LCD monitor and ascertain the closest point of the scene that remains acceptably sharp – this is the hyperfocal point. Refocus the lens to this distance before taking the final shot. This method will ensure you make the most of the available depth of field.

Whilst the lens aperture is the overriding control dictating the level of depth of field achieved, it is also affected by the focal length of the lens; the subject-to-camera distance and the point of focus. This is useful to know in situations where you want to maximize the zone of sharpness without altering the f-number. For example, longer focal length lenses produce a more restricted depth of field than those with a shorter range. Wide-angle lenses can produce extensive depth of field, even at relatively large apertures. The distance between the camera and the object being photographed also has a bearing on depth of field – the closer you are to the subject, the less depth of field you will obtain in the final image. This is one of the reasons why it can prove so challenging to achieve sufficient focus when shooting close-ups.

Finally, the exact point at which you focus the lens will affect where depth of field falls in the final image. Depth of field extends from approximately one third in front of the point of focus to roughly two thirds behind it, so it can be maximized by focusing on the hyperfocal distance – see box.

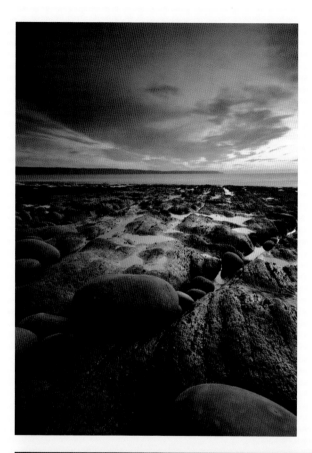

◀ Sunset

To ensure you achieve sufficient depth of field in your images, focus on the hyperfocal point. This is particularly useful when shooting scenic images when a wide depth of field is often essential.

Nikon D200, 10–20mm (at 11mm), 4secs at f/20, 0.6ND grad, polarizer and tripod.

▼ Droplets

It is important to achieve just the right amount of depth of field. Too little, and your subject may not be recorded sharp throughout; too much, and distracting back- and foreground objects may become too prominent and conflict with your main subject. To help achieve the right balance, use your camera's depth of field preview button if it has one.

Nikon D70, 150mm, 1/13sec at f/14, ISO 200 and tripod.

Shutter speed

The shutter speed is the very precisely calibrated length of time that the shutter remains open to expose the image sensor. It is one of the principal controls of exposure – along with the lens aperture (see page 48) and ISO sensitivity (see page 46). Generally speaking, the way shutter speeds work – and their role – is easier to understand than apertures. The majority of images taken require shutter speeds of just a fraction of a second, although exposure can take seconds, minutes or – for a few specialized forms of photography – even hours.

The shutter speed dictates how motion will appear in the resulting picture. Basically, a fast shutter speed will freeze subject movement – suspending action and recording fine detail – whilst a slow shutter time will blur its appearance – creating a visual feeling of motion and energy. Digital SLR cameras have a wide range of shutter speeds, typically from 30 seconds to speeds of, or exceeding, 1/4000sec. Most SLRs also have a 'Bulb' setting, which allows the shutter to be opened for an infinitive length of time. Shutter speeds are generally quoted in stops (see page 48) and the scale of measurement employed is roughly half/double the length if time of its immediate neighbour. The agreed standards for shutter speeds are as follows:

| 30 | 15 | 8 | 4 | 2 | 1 | 1/2 | 1/4 | 1/8 | 1/16 | 1/30 | 1/60 | 1/125 | 1/250 | 1/500 | 1/1000 sec |

Bulb setting

A DSLR normally boasts a maximum automatic exposure of 30 seconds. For exposures longer than this, the camera needs to be set to 'Bulb' or 'B'. Using this setting, the shutter will remain open for as long as the shutter-release button is depressed – either manually or via a wireless remote. The term 'bulb' refers to old-style pneumatically actuated shutters – squeezing an air bulb would open the shutter, while releasing it would close it again. When using the bulb setting, exposure has to be timed manually, meaning a degree of trial and error is required. When using shutter speeds of this length, a sturdy tripod is essential to ensure sharp results.

To provide a greater level of precision over shutter times, digital SLRs allow photographers to adjust shutter speeds in increments smaller than stops – for example 1/2 and 1/3 stop adjustments. This allows photographers to make very fine alterations to exposure, helping ensure they achieve exactly the exposure and result they desire. In order to have full creative control over the shutter speed employed, it is best to either select shutter-priority (page 63) or manual (page 65) exposure mode.

▶ *Church ruin*
The shutter speed greatly influences the subject's appearance in the final image. A fast shutter speed will suspend fast movement, capturing the finest detail, while a slow exposure, will blur subject movement. In this instance, I selected a slow shutter to deliberately blur the grasses and flowers swaying in the foreground of this picture of a church ruin.

Nikon D200, 10–20mm (at 13mm), 4secs at f/20, ISO100, polarizer and tripod.

Camera shake

Camera shake is a common problem, which occurs when the selected shutter speed isn't fast enough to eliminate the photographer's natural movement. The result is a blurred image, effectively ruining the shot. The problem can be further exaggerated if using a long focal length lens or high degree of magnification. There are two ways to rectify camera shake; select a faster shutter speed or use a camera support – like a monopod, beanbag or tripod. A tripod is the best solution – providing good stability,

whilst allowing you to retain your original exposure settings. However, it is not always practical to use a support. In situations like this, where you have no other choice but to shoot handheld, it will be necessary to select a faster shutter time.

It is easy to overestimate how steady you can hold a camera, but a good basic rule is to always employ a shutter speed equivalent to the focal length of the lens you are using. For example, if you are using the long end of a 70–200mm zoom, select

◀ *Camera shake*
Camera shake is a common problem, often caused by photographers overestimating how still they can hold the camera. When I took the first image, the shutter speed of 1/30sec proved too slow to freeze my movement. I used a tripod to take the subsequent shot, and the result is sharp.

a minimum shutter time of 1/200sec. If your lens is designed with image stabilizing technology, use it; sharp images can be produced at speeds two or three stops slower than normal. You can also employ a larger aperture, or increase the camera's ISO sensitivity, to help generate a faster shutter speed. However, this will reduce depth of field, or increase noise levels, respectively.

It is also possible to limit the effects of shake through the way you support your camera. For example, kneeling is more stable than standing. Hold your elbows in towards your chest and hold the camera firmly to your face. Hold it with both hands and squeeze the shutter-release button smoothly.

Freezing

When shooting popular subjects like sports, action, birds and mammals, you will often want to suspend movement – capturing it in sharp detail. Selecting a fast shutter speed will do this, freezing the motion of moving subjects. However, the speed required to do this will be relative to that of the subject's; the direction in which it is moving; and also the focal length of the lens being used. For example, a man running parallel with the viewfinder will be moving more slowly across the frame than, say, a travelling car. Therefore, the minimum shutter speed needed to 'freeze' the runner will be slower than that for the car, but faster than if the man were simply walking. If the runner is jogging directly towards the camera he will be crossing less of the sensor plane and therefore will require a slower minimum shutter speed to be rendered sharp than if he were running parallel across the frame. Using a longer focal length will mean the subject is larger within the image space, therefore moving proportionally faster within the frame than if you were using a shorter focal length.

The exact shutter speed needed to suspend the movement of the subject you are photographing will be dictated by the factors mentioned above. Therefore, a degree of 'trial and error' may be

▲ *Robin*

Prioritize a fast shutter speed if you wish to freeze movement. In this instance, a shutter speed of 1/640sec suspended the movement of the singing robin.

Nikon D70, 400mm, 1/640sec at f/4, ISO200 and handheld.

required to achieve the speed desired. Whilst many DSLRs are capable of shutter speeds exceeding 1/4000sec, in practice, shutter times of 1/500–1/2000sec will often prove more than sufficient.

Using a fast shutter speed will often result in a wide aperture. Therefore, bear in mind depth of field will be shallow. Whilst this will help your subject stand out from its background, focusing will need to be precise.

Exposure tip

Blurring

Employing a slow shutter speed will blur the appearance of motion. Whilst this might not always be desirable, combined with the right subject, the results can be ethereal and striking – creating the feeling of motion. This type of intentional blur is commonly used in scenic photography to record flowing water as a milky wash to emphasize its movement. However, blur can suit all types of

subjects, for example a bustling crowd, crops or flowers swaying in the breeze or a flock of birds in flight. When you adopt this approach, a tripod is an essential tool. Blur is achieved using slow shutter speeds, so without a support, you will add your own movement to that of the subject's (see camera shake page 54). As a result, the whole scene will be blurred – not just that of the subject.

The shutter speed required to create blur is, again, relative to the subject's movement, but a good starting point is ¼sec or less. For more dramatic, pronounced effects, a shutter speed of a second or longer may be required. Subject blur is a subjective effect, but one that I like very much.

Exposure tip

To generate long exposures, opt for a small f-stop and select your camera's lowest ISO rating. If the resulting shutter speed is still too fast, attach a neutral-density filter.

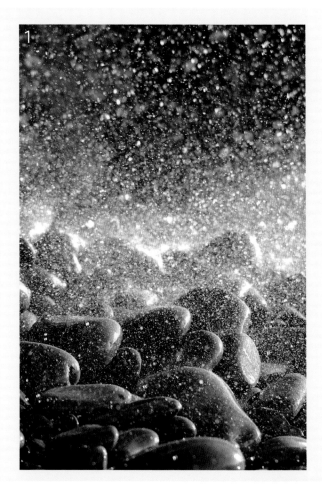

▶ *Record in motion*
The shutter speed can have a dramatic effect on a subject's appearance. When I took this photograph – of water cascading onto pebbles – I took two images; the first using a fast shutter speed of 1/500sec (1) and then a second using a slow shutter ½sec (2). The contrasting way in which the water's movement is recorded, creates two very different shots.

Panning

'Panning' is when the photographer shoots a moving subject whilst moving the camera in tandem with the subject's movement during exposure. The result is a sharp subject with a blurred background – suggesting a feeling of motion and action. It is a well used technique among sports and wildlife photographers, creating dynamic action shots. To do this, requires selecting a relatively slow shutter speed – typically in the region of 1/30sec. Then, track the subject's movement through the viewfinder and continue to smoothly 'pan' the camera after you depress the shutter-release button. For best results, try to position yourself so that you are parallel to the path of your subject – this will also simplify focusing – and keep your movement constant from start to finish to ensure the motion blur in the image's background remains smooth. A steady hand and practice is required, but the results will make your patience worthwhile.

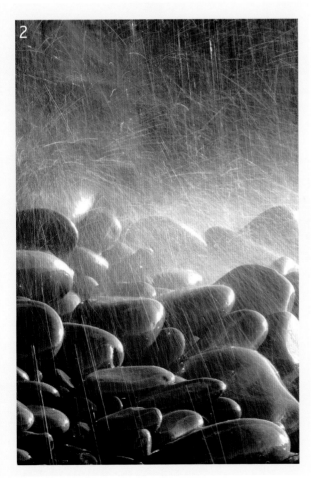

Therefore, I regularly employ a lengthy shutter speed of around 30 seconds in order to blur water, foliage or clouds. This can create atmospheric, ethereal looking results, but often an exposure of this length is only possible in low light or through the use of neutral-density filtration. When taking this type of image, experimentation is key to achieve just the right result. Too little blur, and the effect won't look intentional; too much, and the subject may become unrecognizable. I strongly recommend that you try doing your own tests and shutter speed comparisons – it will prove helpful long term.

Reciprocity

In photography a reciprocal value is used to explain the aperture/shutter speed relationship. The 'law of reciprocity' refers to the inverse relationship between the intensity and duration of light that determines the exposure of a light-sensitive material – an image sensor, for example.

The law of reciprocity states that exposure = intensity x time. Therefore, the correct exposure can be retained by increasing duration and reducing light intensity, or vice versa. Put simply, if you adjust aperture or shutter time, it must be accompanied by an equal and opposite change in the other to maintain parity. Therefore, if you double the amount of light reaching the sensor, by selecting a larger aperture, you also need to halve the length of time the sensor is exposed in order to maintain a correct exposure, or vice versa.

To give you an example, the following list of aperture/shutter speed combinations all let in the same light – despite appearing vastly different – and are, therefore, reciprocal: f/1.4 at 1/2000sec, f/2 at 1/1000sec, f/2.8 at 1/500sec, f/4 at 1/250sec, f/5.6 at 1/125sec, f/8 at 1/60sec, f/11 at 1/30sec, f/16 at 1/15sec, f/22 at 1/8sec and f/32 at 1/4sec.

However, it is worth noting that, whilst the above settings would all retain the same overall level of exposure, the resulting images would actually look dramatically different. This is due to the shift in depth of field (see page 50) created by adjusting aperture, and also the way different shutter speeds record motion (see page 52–57).

Reciprocity law failure

Although it is often referred to as the 'law of reciprocity', it is actually more of a general rule. This is because reciprocity can begin to break down at extreme exposures, particularly at lengthy shutter speeds of several seconds. This is known as 'reciprocity law failure'. Although image sensors are far less prone to this problem than film, digital photographers should still be aware of the affect.

Light-sensitive materials grow less sensitive to light the longer they are exposed, so when shooting at shutter times upwards of a second, it may be necessary to increase exposure time – beyond the law of reciprocity – to compensate. The effect can be monitored by reviewing images on the cameras monitor. However, as digital sensors are far less affected by the duration of exposure, little, if any, compensation should be required.

Reciprocity can also break down at extremely high levels of illumination at very short exposures, but whilst this can prove a concern for scientific and technical work, it rarely applies to general photography.

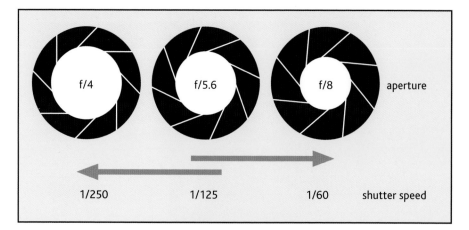

▲ Common frog

When I photographed this frog, I took two frames. For the first image (1), I employed an exposure of f/2.8 at 1/500sec, whilst for the subsequent frame (2) I adjusted the settings to f/16 at 1/15sec. While the exposure value for both images is, in fact, identical, the two images actually appear radically different due to the shift in depth of field created by the contrasting apertures.

Nikon D300, 150mm macro, ISO 200 and handheld.

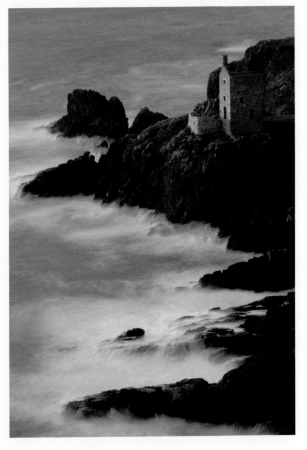

▶ Engine house

I took this photograph, of a ruined Cornish tin mine, using a lengthy ten-second exposure to intentionally blur the rough sea. For film users, an exposure of this length would cause the failure of the law of reciprocity and require extra exposure. However, digital sensors are greatly unaffected by this problem and, in this instance, I didn't have to alter the recommended settings.

Nikon D200, 18–70mm (at 60mm), 10secs at f/22, ISO 100, 0.9 ND filter and tripod.

Exposure compensation

Despite their sophistication, metering systems are not infallible. If we always simply relied on our camera's recommended exposure settings, there would be times when the results are either under- or overexposed. Photographers need to be aware of this and be able to compensate when it is required.

Light meters work on the assumption that the subject being photographed is mid-tone. Whilst this is normally fine, as a result, it can incorrectly expose subjects that are considerably lighter or darker. For example, very dark subjects will often be recorded overexposed, as the meter will take a reading designed to render them mid-tone. Conversely, very light subjects may fool the camera into underexposing them, making them appear darker than reality.

Thankfully, once you know this – and with a little experience – the errors your metering system is likely to make are easy to predict and compensate for. For instance, a subject that is significantly lighter than mid-tone, like a wintry scene or pale flower, is likely to be underexposed by your camera, so select positive compensation (longer exposure). In contrast, if the subject is much darker than mid-tone, it is

likely to be rendered overexposed by your camera's metering. Therefore, apply negative compensation (shorter exposure). The exact amount of positive or negative compensation required will depend on the subject and lighting. This is not always easy to judge, which is why bracketing can prove so worthwhile.

When required, applying exposure compensation is quite straightforward. If you are using manual exposure mode (see page 65), it is simple to manually dial in the level of compensation required. If shooting in one of the camera's automatic or semi-automatic modes, utilize your DSLR's exposure compensation feature to set the level of positive or negative compensation required. However, if you do this, remember to reset exposure compensation to +/-0 when you have finished. Fail to do so, and the same level of compensation will be applied to future images, which will likely result in incorrectly exposed results.

Exposure bracketing

Bracketing is when you take multiple photographs, of an identical scene or subject, using different exposure settings. The idea being that one of the resulting frames will be perfectly exposed. Typically, the photographer will take one frame using the camera's recommended light reading, before

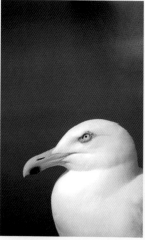

▶ *Exposure compensation*
This is a typical example of how a subject can deceive your metering system. When I photographed this gull, the camera attempted to record its bright, white plumage as mid-tone, so the result is underexposed. I quickly dialled in a positive compensation of one stop and the subsequent image is correctly exposed.

- -

Pentax K10D, 55–200mm
(at 200mm), 1/800sec at f/5.6,
ISO 200, handheld.

- -

Whilst bracketing is a technique most regularly applied to exposure settings, the same principle can be applied to white balance, flash output and even focusing.

Exposure tip

▲ -1

▲ 0

▲ +1

▲ *Bracketing*
This sequence helps illustrate how bracketing works. Silhouetted subjects can fool the camera's metering, so I bracketed one stop either side of the recommended settings. However, in this instance, I preferred the image taken with the original settings.

Nikon D200, 80–400mm (at 120mm), 1/2sec at f/8, ISO 200 and tripod.

shooting an under- and overexposed frame using an increment of up to one stop. However, for added precision, it is often better to shoot a larger bracketed sequence of seven or even nine frames, each taken at 1/3 or 2/3 stop increments either side of the original setting. Although this can be done manually – either by using exposure compensation or by shooting in manual exposure mode (see page 65) – the majority of DSLRs are designed with an automatic bracketing programme. This feature allows the user to select the number of images in the series, and the level of exposure increment. The photographer can then later compare the images from the series, before deciding which one is the most accurate.

Bracketing is a highly useful and effective method of obtaining the correct exposure. Whilst there is no need to bracket every shot, it is a technique well suited to situations where it is difficult to determine the exact exposure. For example, when the light is contrasty or very changeable, or when shooting very bright, reflective or backlit subjects which can fool your camera's metering system. Bracketing is also a useful precaution for beginners who are more liable to make exposure errors.

Bracketing played an essential role in film photography. However, there is less need to bracket settings today with the advent of digital capture, as exposure can be scrutinized via playback. However, it is not always possible to accurately assess the brightness of an image using the camera's monitor, due to light reflecting on the LCD screen. Also, there simply may not be time to review images between frames. For this reason, like many photographers, I regularly bracket to guarantee a perfectly exposed result.

Exposure mode programs

Digital SLRs have a choice of exposure mode – each one offering the user a varying level of control. Many cameras boast a number of pre-programmed modes designed to optimize settings for specific conditions or subjects. However, many photographers prefer to rely on the 'core four', which are program, aperture-priority, shutter-priority and manual. They are often referred to as the 'creative modes' – affording a greater degree of control over exposure.

Your choice of exposure mode is important, as it has the potential to greatly alter the look of the final image. Therefore, it is wise to be familiar with the purpose of each, so you can match the most appropriate mode to the conditions or subject.

Programmed auto

Programmed auto (P) is a fully automatic mode. The camera itself selects the aperture and shutter speed combination, allowing the photographer to concentrate on composition alone. DSLRs are so sophisticated today that this mode can be relied upon to achieve correctly exposed results in the majority of situations. However, as the camera is in complete control of the exposure equation, this mode can stifle creativity and artistic interpretation. After all, a camera is simply a machine – it cannot predict the effect you are trying to achieve. Therefore, programmed auto mode is best employed for snapshot photography only – if you want to fulfil your photographic potential, don't use it as your default setting. Instead, grasp control back from the camera by using either S, A or M modes.

▼ *Cornish harbour*

To take this view, of a Cornish harbour, I employed my camera's programmed auto mode, as it is ideally suited for taking simple snapshots like this.

However, if you want to improve your photography, you need greater control over exposure and should switch to a semi-automatic mode or manual.

Nikon D70, 18–70mm (at 20mm), 1/125sec at f/11, ISO 200.

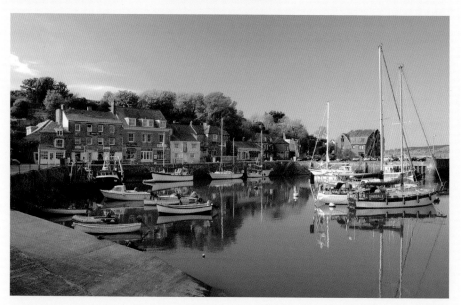

▶ *Bird movement*

When photographing moving subjects, the shutter speed you employ will affect the feel and look of the resulting image. Select a shutter speed too fast, or too slow, and the shot may be ruined. For example, the first two images in this sequence (1,2) suffer from subject blur. However, by using shutter-priority mode to select a faster exposure of 1/500sec, I was able to freeze the bird's movement on my third attempt (3).

Nikon D200, 100–300mm (at 300mm), f/8, ISO 200 and tripod.

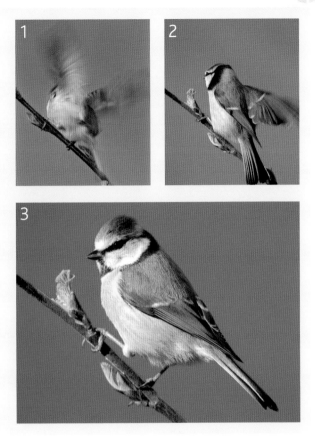

Shutter-priority auto

In shutter-priority (S or 'Tv') auto mode, the photographer manually sets the shutter speed, whilst the camera selects a corresponding aperture to maintain an overall correct exposure. Typically, shutter speeds can be set to values ranging from 30 seconds to 1/4000 – or even faster on high-spec DSLR models.

This mode is most useful for determining the appearance of motion (see page 56). For example, if you wish to blur subject movement, then you should select a slow shutter speed. Exactly how slow depends on the speed of the subject's motion, but an exposure in the region of ½sec is normally a good starting point. In contrast, if you wish to freeze the subject's motion, then you should prioritize a fast shutter speed. Again, the setting should be dictated by the speed of the subject's movement.

For example, a fast-moving subject will naturally require a quicker shutter speed in order to freeze it. However, an exposure upwards of 1/500sec should prove sufficient to capture all but the fastest action.

Shutter-priority mode is a useful method to quickly select a sufficiently fast shutter speed to eliminate the risk of camera shake in situations where it is impractical to use a tripod.

If there isn't sufficient light to use a fast enough shutter speed to capture the subject's movement, select a larger aperture or use a higher ISO sensitivity.

Exposure tip

Aperture-priority auto

This is arguably the most popular mode among enthusiasts. Aperture-priority (A or 'Av') is similar in principle to shutter-priority, but works in reverse. Therefore, the photographer manually selects the lens aperture, while the camera automatically sets a corresponding shutter speed depending on the meter reading.

The f-stop selected dictates the depth of field available; the smaller the aperture, the more depth of field and vice versa. Therefore, this mode is intended to give photographers full control over depth of field (see page 50).

Depth of field can be used creatively in a variety of ways. For example, scenic photographers often require foreground-to-background sharpness. Therefore, aperture-priority mode is a quick method to select the small aperture required to ensure the foreground, middle distance and background are all rendered crisply. The resulting shutter speed is often immaterial, as the subject is static and a tripod is normally used.

Alternatively, you might want to select a large aperture to purposefully create a shallow depth of field. This can be helpful if you wish to place emphasis on your point of focus or to isolate your subject from its surroundings – useful when taking

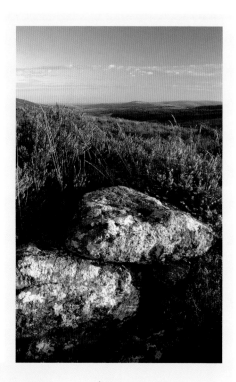

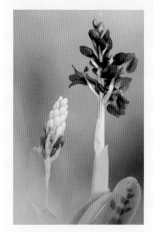

◀ *Early purple orchid*
When I photographed this early purple orchid, I switched the camera to aperture-priority to enable me to intentionally select a large aperture to create a shallow depth of field. This helped isolate the flower from its surroundings.

- -

Nikon D200, 100–300mm (at 280mm), 1/80sec at f/4, ISO 100, reflector and tripod.

- -

▲ *Moorland view*
To achieve sharpness from the granite wall in the foreground through to the hills in the far distance, I required a wide depth of field. Using aperture-priority mode, I selected an aperture of f/22, which provided the large depth of field needed.

- -

Nikon D70, 18–70mm (at 18mm), 1/8sec at f/22, ISO 200, polarizer and tripod.

- -

Exposure tip

Despite its name, aperture-priority is also a quick way to set the fastest or slowest shutter speeds. To select the quickest shutter speed, set the aperture to its widest setting; to select the slowest shutter speed simply set the narrowest aperture available.

portraits or shooting floral close-ups. It is important to note that the range of apertures available is not determined by the camera itself, but by the lens attached. This will vary depending on its speed, determined by its maximum aperture (smallest f-number).

Manual

As the name suggests, manual (M) mode overrides the camera's automatic settings. The photographer sets the value for both aperture and shutter speed, providing them with full control over the exposure equation. Without doubt, this is the most flexible exposure mode, which is why it is favoured by many professionals. It is also the mode that relies most heavily on the photographer's knowledge and input.

The user can set a shutter speed within the camera's range and select an aperture within the minimum and maximum value of the lens attached. Similar to the other exposure modes, the camera takes a light reading from the scene or subject

when the shutter-release button is semi-depressed. However, the camera doesn't apply the values to the exposure settings. Instead, the information is displayed in the viewfinder and/or LCD control panel, and left to the discretion of the photographer.

Thanks to the control manual mode provides, it is quick and simple for photographers to 'tweak' the camera's recommended settings. For example, in very bright, dark or contrasty conditions the camera's metering system may be fooled, but – using manual mode – it is easy to compensate accordingly. Or, you may want to ignore the recommended settings as you wish to expose creatively.

▼ *Misty morning*

I was concerned that the light reflecting from the morning mist would trick the camera into underexposing this scene. Using the manual mode, I was able to adjust exposure settings to compensate.

Nikon D200, 150mm, 1/40 at f/11, ISO 100 and tripod.

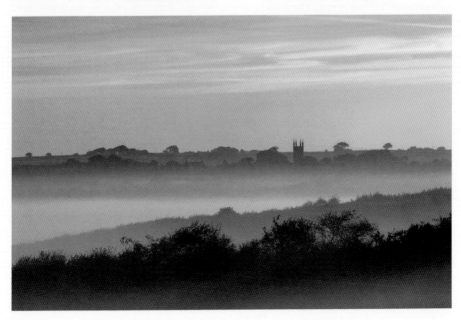

Auto picture modes

In additional to the traditional 'core four' exposure modes, the majority of DSLRs boast a variety of subject-biased programs. Often termed as 'picture' or 'subject' modes, the programs are developed to bias settings according to a specific type of photography. Basically, they are variations of programmed-auto mode (see page 62), with the camera setting both lens aperture and the corresponding shutter speed.

By selecting one of the pre-programmed modes, for example, 'sports', 'portraits' or 'close-up', the camera then knows whether to give priority to shutter speed – as it would for sport – or aperture – as it would for scenic subjects. Admittedly, picture modes don't offer photographers the same level of control as shutter-priority, aperture-priority or manual. However, they are well suited to beginners who are still unsure about which exposure settings to select in specific shooting conditions.

Picture modes are found on the majority of digital cameras – particularly entry-level models. They are normally represented with appropriate symbols on the camera's mode dial. The number and type included will vary depending on the make. However, listed below is a handful of the most popular 'picture modes' included on many digital SLRs.

 Portrait

In this instance, the camera selects the best aperture and shutter speed combination for portrait and people photography. A wide aperture is prioritized to intentionally soften and blur background detail. For the best results, try using a short telephoto lens (70–100mm).

 Sports

The subject is presumed to be moving, so the camera automatically employs a fast shutter speed to freeze movement. As a result, a wide aperture is selected and depth of field will be shallow. The camera will be set to continuous AF and also continuous shooting, so it can record action sequences. In addition to sports, this mode is well suited to any moving subject, for example, running animals, flight and moving vehicles.

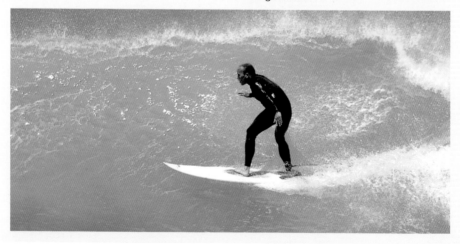

 Landscape

In this mode, the camera will give priority to a large depth of field, to maximize background-to-foreground sharpness. It will also attempt to set a

shutter speed sufficiently fast to prevent camera shake. The flash system will be disabled, as the subject is presumed to be too far away.

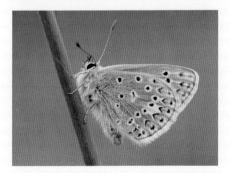

Close-up

The camera attempts to select the best f-stop and shutter speed combination to provide enough depth of field to render close-up subjects in focus. The camera automatically activates the central AF sensor, assuming that the subject will be positioned centrally in the frame. This mode is suited to all types of close-up subjects, like plants and insects.

Auto picture modes can prove a quick, hassle-free method of selecting appropriate settings for the scene or subject you are photographing. However, they offer the user limited creative control, so use them sparingly.

Exposure tip

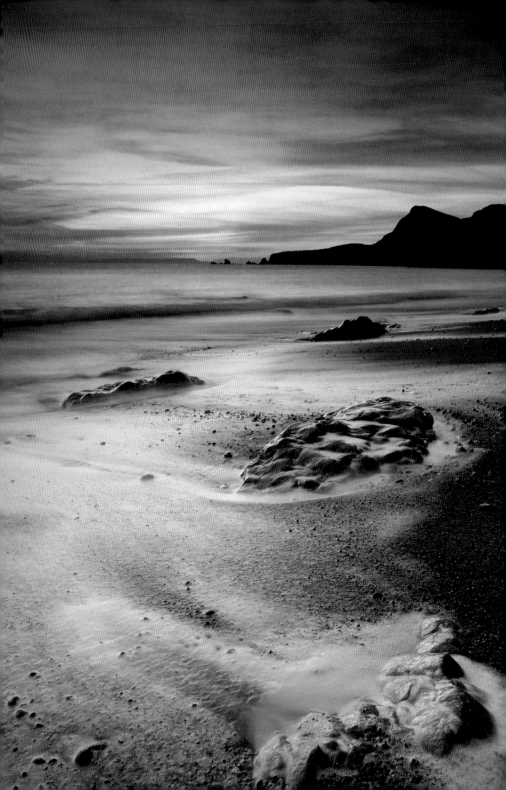

Exposure in practice

Exposure in practice

A good understanding of exposure is vital to creative photography. Only when armed with this knowledge can you grasp full creative control of your digital camera. It will help you to adjust the shooting parameters confidently and make the right decisions when taking pictures on a day-to-day basis.

You may understand the mechanics of exposure, but this knowledge means little unless you put the theory into practice. There are no 'hard and fast' rules when taking pictures, but often the way you apply exposure will be dictated by the subject, light and the result you wish to achieve. Every picture-taking opportunity is unique and should be treated as such.

Different subjects will require a different approach. For example, when shooting landscapes, achieving a wide depth of field is often priority, requiring the selection of a small f-stop. In contrast, when shooting sports or wildlife, a fast shutter speed is often preferred, in order to freeze rapid action.

The 'exposure equation' can be manipulated in different ways, depending on the subject, but knowing when to apply which settings takes time and experience. This chapter is dedicated to exposure in practice – looking at its affect and role in combination with a handful of traditionally popular photographic subjects. However, whilst this will hopefully help and guide you, it is only through taking pictures of your own that things really begin to make sense. There is no better way to learn than by putting your knowledge of exposure into practice.

▼ *Flowing river*
Through experience, I knew a slow shutter speed would suit this scene, blurring the water's movement for creative effect.

Nikon D200, 10–20mm (14mm), 4secs at f/20, ISO 100, 0.9ND and tripod.

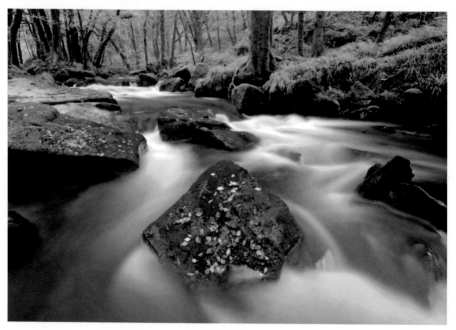

Compositional rule of thirds

Rules are there to be broken, but when it comes to composition, the so called 'rule of thirds' is a reliable and effective guideline. It was first developed by painters centuries ago, but remains just as relevant to visual artists today.

The idea is to imagine the image-space split into nine equal parts by two horizontal and two vertical lines. In fact, some digital SLRs can be programmed to overlay such a grid in the viewfinder to assist composition. Then, by simply placing your subject – or a key element within the scene – at or near a point where the lines intersect you will create a more balanced composition overall and effectively lead the viewer's eye through the image.

This rule is relevant to all subjects, but particularly those featured in this chapter. By using this approach, you will create more depth, balance, energy and interest in your photographs than had the main subject been placed centrally in the frame. Whilst you shouldn't always conform to the rules, follow this age-old rule and your images will be consistently stronger as a result.

▼ *Granite Cross*

In this image the horizon is positioned so that the sky forms one third and the foreground two thirds of the image-space. The granite cross was intentionally placed roughly one third into the frame. The composition appears far stronger, with a better balance, than had the cross and horizon been central in the frame.

Nikon D200, 10–20mm (at 13mm), 1/2sec at f/16, ISO100, 0.9ND grad and tripod.

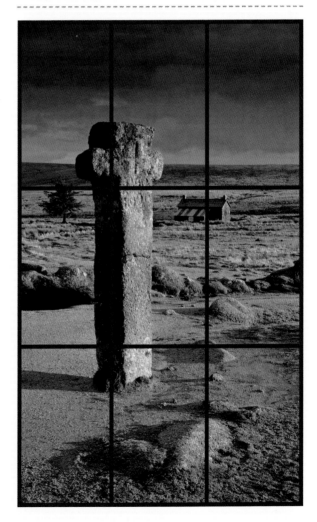

Landscape photography

A good working knowledge of exposure is essential whatever subject you photograph. However, it could be argued that this is never more important then when shooting scenics. Landscape photography is one of the most popular and accessible subjects, but whilst anyone can take a pleasant snap of the view before them, intelligent use of light, composition and depth of field is essential if you wish to capture 'light and land' creatively.

Landscape photography is one of the most challenging forms of photography. This is mostly due to the changeability of light. Scenic images rely heavily on the quantity, quality and direction of light for their impact and drama. However, natural light is constantly changing (see chapter three, 'Ambient light'). The position of the sun, and its intensity, alters throughout the day and also according to the season. A camera's TTL metering will automatically adjust exposure depending on the level of light, but it is still important to be aware of its effect on exposure and the landscape's appearance.

The light during the so called 'golden hours', an hour after sunrise and an hour before sunset, is best suited to scenic photography. Whilst the light at other times of day can still be used – particularly if the conditions are stormy or dramatic – it is dawn and dusk that is best for scenic photographers. At these times of day, the sun is low in the sky. Not only is the light soft and warm as a result, but the long shadows cast help to accentuate the landscape's texture and create the perception of depth.

Whilst the pupils of our eyes work like a constantly changing aperture, enabling us to see detail in a wide range of brightness, a camera lens with a fixed aperture is more limited. Typically, there is an imbalance in light between the sky and darker ground. Whilst this can be negligible, it can amount to several stops of light and often the contrast in brightness will be too great for the sensor's dynamic range. Recognizing this is a key skill for landscape photographers. This light imbalance needs to be corrected, otherwise the image will either have an overexposed sky – if you expose for the ground – or an underexposed foreground – if you meter for the sky.

Graduated neutral-density filters (page 152) are the best way to correct exposure in-camera. Quite simply, they are an essential tool for scenic photographers – I rarely take a landscape image without one attached. Alternatively, you can shoot two or more bracketed exposures and merge them during post processing to effectively extend the camera's dynamic range (page 32).

▼ *Rain clouds*

Traditionally, early morning and late evening, when the sun is low in the sky, are the best times of day to shoot scenics. However, if the conditions are stormy and menacing, it is possible to capture dramatic images at any time of the day.

--

Nikon D200, 10–20mm (17mm), 1/30sec at f/16, ISO 100 and tripod.

--

▼ *Coastal sunset*

In this image, I combined two graduated neutral-density filers, equivalent to five stops of light. This enabled me to record detail in the foreground, whilst also preventing the bright, colourful sky from overexposing.

Nikon D300, 10–20mm (18mm), 20secs at f/14, ISO 100, 0.9 and 0.6 ND grads and tripod.

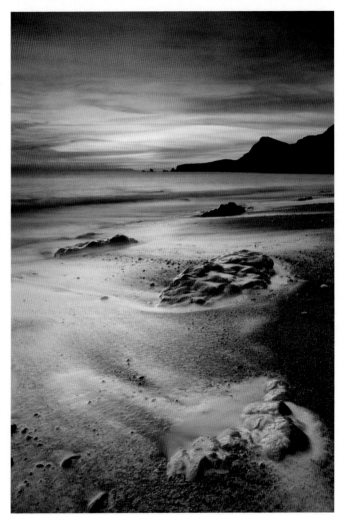

Overcast light may often be less dramatic for landscape images, but it shouldn't be overlooked. In fact, when shooting woodland scenes, dull conditions can prove best. Bright light filtering through trees can create contrast which cannot be corrected using filtration. By intentionally shooting in overcast weather, it is possible to record colour and detail with greater accuracy.

Exposure tip

Composition and foreground interest

Whilst light is a key ingredient to a landscape image's success, if the composition is poor, or the depth of field insufficient, the opportunity will be wasted. Eye-catching scenics are normally the result of creating an interesting and balanced composition. This is normally achieved by including some type of foreground interest, designed to lead the viewer's eye into the frame. However, to ensure everything within the composition is recorded acceptably sharp – from your foreground to infinity – it is important you set a suitable aperture.

When you peer through the viewfinder, the key to good composition is to arrange the key elements within the landscape so that they form a visually interesting scene. The composition needs to hold the viewer's attention; so you need to take their eye on a journey around the frame from the immediate foreground to the distant background. The 'rule of thirds' (see page 71) is an important tool for scenic photography.

Scenic images can often be dramatically improved by simply including something in the immediate foreground. You can use almost anything – although it does need to complement the scene overall. For example, a wall, rocks and boulders, a tree, fencing, footpath or road can provide your photo with an 'entry point' and also help add depth and scale. Often, this approach works best in combination with a wide-angle lens. By using a short focal length and moving quite close to your foreground, you can exaggerate perspective to create dynamic compositions.

Another benefit of using a wide-angle lens is that they possess extensive depth of field, so by selecting a small aperture, it is possible to record almost everything, from the foreground to infinity, in focus. Some landscape photographers instinctively select their camera's minimum aperture to maximize back-to-front sharpness. However, this is not always wise due to the affects of diffraction (see box). Instead – where practical – it is best to employ a medium aperture, in the region of f/11 to f/16. This will help maximize image quality – although remember to focus on the hyperfocal point to make the most of the available depth of field.

Typically, shutter speeds are quite slow when shooting landscapes. This is due to the relatively small apertures required, and also the use of filters – like polarizers – that absorb light. Therefore, if you shoot handheld, camera shake is a genuine

Lens diffraction

The affect of diffraction seems to be rarely mentioned, but it can have a great bearing on image quality. As you stop down the aperture – making it smaller by selecting a larger f-number – the light passing through the hole tends to diffract or, in other words, scatter. The reason for this is that the edges of the lens's diaphragm blades tend to disperse light passing through. The smaller the hole, the greater the effect. As a result, even if depth of field is increased, image sharpness can deteriorate. This can create a conflict of interests for photographers, particularly when shooting landscapes. For example, traditionally a small aperture is a priority when shooting scenics to ensure everything from the foreground to infinity is in acceptable focus. However, whilst an f-stop in the region of f/22 or f/32 will maximize back-to-front sharpness, it also exaggerates the effect of diffraction. At a lens's smallest aperture, often the gain in depth of field isn't sufficient to offset the increased level of diffraction. Therefore – as is so often the case when setting exposure – a compromise has to be made. Although it will depend on the scene and the level of depth of field required, f/11 is generally considered to be the smallest aperture that remains greatly unaffected – or is 'diffraction limited' – on cropped-type cameras. If you are using a full frame DSLR, this 'guideline' tends to be f/16. Using the appropriate f-number for your camera's sensor type will enable you to maximize image sharpness, but be sure to use the full width of the depth of field available to you by focusing on the hyperfocal point (see page 50).

possibility. In truth, a tripod is essential if you wish to take good scenics. Not only will it solve the problem of shake, but a tripod is also a great compositional aid – allowing you time to scrutinize, and fine tune, your composition.

▶ *Dartmoor*

Practically anything can be used as foreground interest or a 'lead-in line'. Here, the image was composed so that a dry stone wall formed the foreground, and led the viewer's eye into the shot.

- -

Nikon D200, 10–20mm (at 12mm), 2secs at f/14, ISO100, polarizer, 0.9ND grad and tripod.

- -

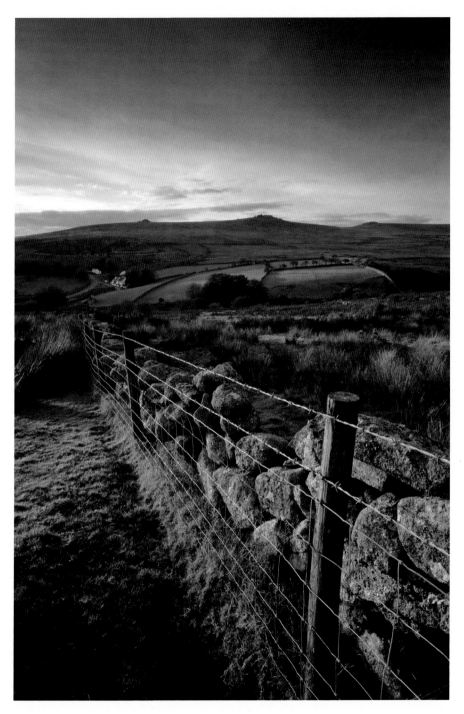

Urban architecture

Architecture is all around us. Big or small, old or new, industrial or residential – buildings come in many shapes and sizes and can prove highly photogenic. Whilst houses, office blocks, skyscrapers and places of worship may be designed and constructed to serve a functional, practical role, their huge photographic potential shouldn't be overlooked.

Urban landscapes can look striking – day or night. Towns, cities and urban areas are full of interest and it is possible to capture great images with just a very basic set-up – a standard zoom will normally suffice. Often, it is best to opt for strong, bold compositions, in order to create images boasting impact – maybe using the shape of one building to frame another. High and low viewpoints often prove the most dramatic and, whilst angles may converge as a result, this can actually enhance the final result.

The appearance of architecture alters greatly throughout the day as the position of the sun changes. Light and shade help emphasize a building's form and design. Buildings that are east-facing receive most light in the morning, whilst west-facing structures will be lit in the afternoon. However, a building might be in shade for many hours a day depending on the position and height or neighbouring buildings.

Therefore, it can prove beneficial to visit a location beforehand, at different times of the day, to observe how the light affects a building or a specific view. The golden hour of sunlight – an hour after

▼ *Modern architecture*
New developments and modern architecture can be very photogenic, with eye-catching and unusual designs. They often suit a very low or high viewpoint to create arty, abstract-looking results.

Nikon D300, 12–24mm (at 14mm), 1/180sec at f/10, ISO 200, polarizer and handheld.

sunrise and an hour before sunset – will often provide the most attractive light, giving buildings a warm, orange glow.

Old buildings – often found at the heart of a city – remain among the best architecture to photograph, often boasting beautifully constructed pillars, arches and stonework. This type of architectural detail, whether exterior or interior, shouldn't be overlooked and is often best photographed in isolation – using either a medium telephoto lens or tele-zoom to crop in tight. Old buildings can also look good photographed in context with a modern construction – the striking contrast between old and new creating visual interest. Modern buildings constructed predominantly from glass can look really striking – particularly if photographed along with some very strong reflections of say, a blue sky or neighbouring buildings.

When photographing buildings, aperture selection should be your priority – opting for the f-number that will provide you with sufficient depth of field to keep the building sharp throughout. After all, buildings are static, so the shutter speed is of no great concern unless you are shooting them handheld. Motion can work well as part of an urban view – for example, a long exposure will 'ghost' the movement of pedestrians and vehicles. Therefore, a neutral-density filter (see page 150) can prove a useful accessory to keep in your camera bag.

Converging verticals

When photographing architecture, converging angles is a common problem. This is a term used to describe the way parallel lines in an image appear to lean inward to one another. This perspective distortion is created when we angle our camera upward or downward, which is often necessary when photographing a tall building from nearby in order to photograph all of the structure. The effect is further exaggerated when using a wide-angle lens.

Converging angles can look very odd; giving the impression a building is leaning or falling over. However, the effect can be used to create some very striking, dramatic or even abstract-looking results. Therefore, there will be times when you should actually try to emphasize the effect, rather than attempt to correct it. You can do this by moving closer to the building, angling your camera more or by attaching a shorter focal length.

When converging angles are undesirable, you can minimize the problem by moving further away and using a longer focal length. However, this is not always practical and you may be better trying to correct it post capture using software. To do this open the picture in Photoshop and select the whole image by pressing Ctrl-A. Next, click Edit > Transform > Perspective. Drag the top markers outwards until the verticals are correctly aligned. When doing this, it may be necessary to increase the canvas width. This is achieved by clicking Image > Canvas size.

▼ *Converging verticals*
Converging angles can create the impression a building is leaning or about to topple over. Although the effect can be undesirable, used appropriately, it can also create some very striking results.

Nikon D300, 12–24mm (at 18mm), 1/100sec at f/10, ISO 200, polarizer and handheld.

Do not photograph sensitive buildings – like government-owned buildings, airports and schools – unless you have prior permission. The authorities may well question whether your intentions are purely creative and, in some countries, you can be arrested for photographing certain buildings.

Night photography and exposure

Urban scenes and city skylines adopt a special quality when photographed at night or in low light. Street and flood lighting helps emphasize the design and shape of buildings and, when combined with the little natural light remaining, can create images bursting with impact. The best time of the day to photograph low-light cityscapes is the hour between sunset and nightfall, when the warm sky will help to enhance the outlines of subjects. However, whilst this type of 'twilight' image can prove highly effective, equally, they can be hugely disappointing if you get the exposure equation wrong.

When taking images at night time, the resulting long exposure can present photographers with one or two challenges. Shutter speeds may be anything up to 30 seconds – or even longer in some situations. Therefore, a heavy tripod is essential to keep your camera still during exposure. Also, when possible, release the shutter using the camera's self-timer, or a remote release, as manually pressing the button can vibrate the camera slightly and soften the image.

In a bustling city, there will normally be a certain amount of movement within your scene – moving traffic or people, for example. Due to the

▼ Low light
In low light conditions, a camera's metering can fail to work well. By switching to spot metering, it is possible to take two or more readings from different areas of brightness within the image. You can then calculate an 'average' exposure. It is also worthwhile bracketing to guarantee a correct result.

Nikon D300, 80–400mm (280mm), 8secs at f/11, ISO 200 and tripod.

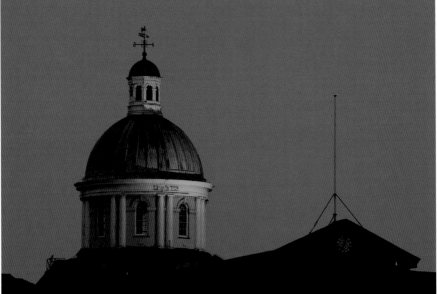

lengthy shutter speeds you will be employing, this motion will be blurred – creating some interesting effects. For instance, the trails of light created by car headlamps and rear lights will add visual interest and an extra dimension to your night images.

When photographing in low light conditions, meter for the scene in the same way you would at any other time of the day. Often metering will remain accurate, despite the lack of light. However, all meters operate within a finite range in which they can accurately measure light – so problems can occur if the light levels are so low that they are beyond its sensitivity range. One of best ways to overcome this is to use your spot meter (see page 22). First, take a general TTL reading, then switch to spot metering and take a second reading from a bright area of the scene. Now, calculate the difference in brightness value and adjust your settings accordingly. Doing so should help you

obtain the correct exposure, although – when working in such extremes of light – it is worthwhile bracketing results. Finally, remember, long exposures will enhance the effects of signal noise (see page 47), so turn on your camera's long exposure noise reduction facility before you begin shooting.

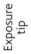

If you are setting up a tripod on a pavement, be considerate where you position the legs of your support and be mindful not to obstruct other people.

Exposure tip

▼ Light trails
It is best to shoot night-time urban landscapes within an hour of sunset. The light trails of car head and rear lights, created due to the long exposure time, can look striking. Therefore, select a viewpoint where you can include them within the shot. In this instance, a bus created the unusual streaks of light.

Nikon D300, 12–24mm (at 13mm), 25secs at f/22, ISO200 and tripod.

Wildlife photography

Natural history photography has a reputation for being highly specialized, requiring long, pricey telephoto lenses and exotic locations. In truth, regardless of the equipment you own or your budget, it is possible to take frame-filling shots – and you may not need to travel further than your own back garden or a local park to find suitable subjects. Wildlife can be a challenging and technically demanding subject. However, by practising your knowledge of exposure, you greatly enhance your chances of producing successful results.

Birds

Few subjects are more challenging to photograph than birds. They can prove difficult to approach and will fly away if disturbed. Whilst a long focal length, in the region of 400mm or 500mm, will help – particularly if combined with a DSLR with a cropped-type sensor (page 26) – it is surprising just how near to the subject you still need to be to shoot frame-filling images, particularly of smaller species. Therefore, it is best to begin by photographing birds that are relatively accustomed to human activity – for example, ducks and waders which reside at a local reservoir or wetland. Often, they will tolerate a close approach on foot, so prove good subjects to begin honing your skills. Larger birds, like geese and

▼ *Female mallard*
One of the best places to begin honing your wildlife photography skills is a local reservoir, wetland or park – where the resident wildlife is more tolerant of human activity. This photograph was taken along a local canal, the duck posing happily while I photographed her from just a few metres away.

Nikon D200, 80–400mm (at 300mm), 1/400sec at f/5.6, ISO 100 and tripod.

When looking at photographs of wildlife, we are naturally first drawn to the subject's eyes – if they are in soft focus, the image will be ruined. Therefore, one of the golden rules of wildlife photography is to always focus on the animal's eyes.

Exposure tip

swans, which are already used to being fed, can be enticed using some grain. If they allow you to get very near, try using a short focal length or even a wide-angle lens and, shooting from a low angle, take a shot which shows the bird within its environment – the shot will have far more impact than a standard portrait.

Truly wild birds will rarely allow you to get within shooting distance through stalking on foot. Instead, a hide of some sort will be required. Compact and collapsible hides are available quite cheaply, and are perfect for concealing your whereabouts – alternatively, try making your own. Place your hide close to a feeding station, or a spot where you know – or have been told – that birds visit regularly. Try to enter your hide before daybreak, to minimize subject disturbance.

When possible, try capturing an element of behaviour – for example, a display of courtship, singing or flight. This will give your bird images more impact and help them to stand out from others. Flight photography, in particular, is quite tricky, but the results can look amazing. Keeping the subject in sharp focus, while you follow their flight path through the viewfinder, is made easier by using a continuous AF shooting mode, designed to track moving subjects. To photograph birds in flight – or other subject movement – you need to prioritize a fast shutter speed. Naturally, the speed you require to freeze your subject's motion is relative to that of the subject's, but, generally speaking, it is best to opt for an exposure upwards of 1/500sec. In order to do this, you will probably need to select a large aperture. Whilst this will help to throw back- and foreground detail pleasantly out of focus, your focusing will need to be pin-sharp as depth of field will be shallow as a result.

▼ Puffin

When photographing wildlife, try to capture some form of subject behaviour to help your images stand out. This could be flight, courtship, hunting or singing. In this instance, I released the shutter just as this puffin was calling out to another bird.

Nikon D70, 100–300mm (at 300mm), 1/400sec at f/4, ISO 200 and tripod.

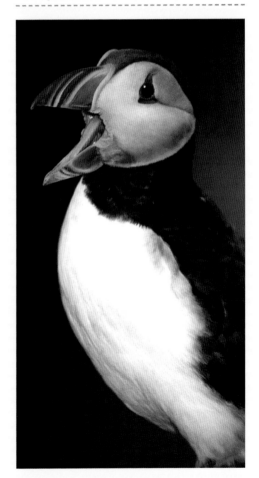

Garden wildlife

Whether your garden is big, small, urban or rural, it can be used to get near to wildlife. Most backyards are home to a variety of garden birds, small mammals, amphibians, spiders, snails and insects – larger animals, like foxes, might also visit regularly. One of the benefits of shooting garden wildlife is that, generally speaking, it is more accustomed to human activity and therefore more approachable. A focal length in the region of 300mm or 400mm will often prove sufficient for birds or mammals, whilst a macro lens or close-up attachment is ideal for miniature bugs and beasties.

To entice wildlife nearer to your lens, try placing suitable food at a predetermined point – a technique known as 'baiting'. Consider the light's direction (see page 104) before setting up your 'feeding station', ensuring that the spot you select receives ample sunlight at the time of day you intend taking pictures. Try placing the bait near to a window – or shed – which you can use as a makeshift hide. Disguising your whereabouts, by hanging camouflage netting over the open window, will enable you to shoot from the comfort of indoors.

What is the ideal ISO sensitivity for wildlife photography?

There is no right or wrong answer to this. A good general rule is to employ the lowest practical ISO rating that provides you with a sufficiently fast exposure. This will depend on a number of factors – including available light and artistic interpretation. However, a fast shutter speed is often a priority when photographing wildlife, to freeze subject movement and eliminate the risk of camera shake – a common problem when using long, weighty telephotos. Whilst lenses boasting image stabilizing technology will help minimize the risk of shake, in low light, you may need to select a higher ISO sensitivity to generate an exposure fast enough to freeze the subject's movement – particularly if it is running or in flight. Whilst increasing a camera's ISO from its base setting will generate more signal noise (see page 47), thanks to advances in sensor technology, noise remains comparatively low even at ratings of up to 800. Therefore, nature photographers shouldn't be afraid of up-rating ISO when the situation or light dictates. After all; even if image quality is slightly compromised, it is still preferable to a shaky image or one with unintentional subject blur.

◀ *Barn swallow*
This image was a 'chance' shot. I had to shoot handheld and was using a long focal length, so I knew camera shake was likely unless I selected a fast shutter speed. To generate this, I altered my ISO from 100 to 400. The image may be very slightly 'noisier', but this is still preferable to a shot which suffers from shake.

Nikon D200, 100–300mm (at 300mm)
1.4x tele-converter, 1/400sec at f/5.6, ISO 400.

If you are new to wildlife photography, it is worthwhile visiting a zoo or safari park, where you can practise techniques and experiment with exposure. If wire fencing is proving distracting, select your lens's largest aperture – this will help throw distracting backdrop detail unrecognizably out of focus. Exposure tip

You could also add photogenic 'props' near your feeding station which the birds will perch on – a branch with colourful blossom or some bright berries, for instance.

Don't overlook the smaller, less obvious creatures residing in your backyard. If you have a garden pond, or there is one nearby, you may find frogs in damp vegetation. A low, eye-level viewpoint is usually best for amphibians, combined with a large aperture of f/2.8 or f/4 to render its foreground and background attractively out of focus. Also, look for reptiles, snails and small invertebrates – they might not be the most glamorous of subjects, but can create striking images. Natural light is often restricted when shooting in close-up – if it needs supplementing, consider using macro flash.

▼ *Slow worm*
This slow worm was photographed in my garden. Reptiles can be enticed by providing suitable shelters in your garden – like corrugated iron sheets, rubble or wood piles.

Nikon D70, 105mm, 1/125sec at f/13, ISO400, handheld.

People

Practically anyone who has ever picked up a camera will have taken pictures of people at one time or another, from simple family and holiday snapshots, to professional wedding, portrait and nude photography. As with any type of subject, good technique is needed to capture fresh, eye-catching photographs. However, the key ingredient to successful people pictures is having the ability to recognise, capture and portray a person's mood, emotion and personality.

▼ *Ice cream fun*
Generally, friends and family will be more relaxed and happy to pose, compared to a stranger. In this instance, I gave my young nephew an ice cream and told him to have fun and do whatever he liked. A large sheet of white card was positioned behind to create a simple, clean backdrop.

Samsung GX10, 18–70mm (at 70mm), 1/300sec at f/5.6, ISO 100, fill-flash and handheld.

Communication

Entire books are dedicated to the skill and art form of people photography. Even though – theoretically – a photographer can control light, composition and the subject, capturing consistently good portraits is far from easy. Too often, people pictures fail simply due to the fact that they look unnatural, contrived or the sitter looks awkward or 'stiff'. Therefore, in many situations, your ability to communicate – putting your sitter at ease – is every bit as important as your technique and use of exposure.

Unless you are using a professional model, few people enjoy having their picture taken – let's face it, it can be an intimidating prospect. Therefore, you first have to ensure your sitter is feeling relaxed – otherwise they will be uncomfortable and anxious and your images will reflect this. Good communication is vital. Keep talking, explaining what you are doing and why and ensuring they know the type of image you are striving to achieve. If possible, show them examples of different poses and styles beforehand, so that they have a better idea of what

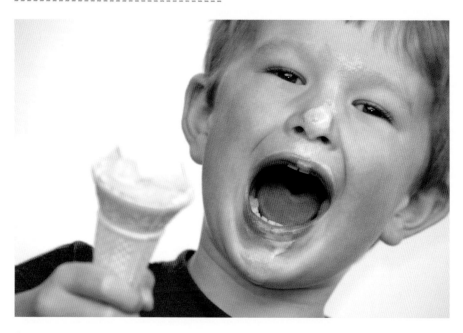

Traditionally, a popular accessory among portrait photographers is a soft focus filter. Not only can they add mood and atmosphere to your images, but they will also help disguise spots or imperfections in your subject's complexion. Alternatively, a soft focus filter effect can be applied post capture (see page 158).

Exposure tip

you require from them – this will be of particular help to anyone not accustomed to having their picture taken.

When you begin shooting, work confidently and be in control. Offer encouragement to your sitter and, calmly and politely, give clear instructions on how you want them to pose and look. As your sitter grows more confident and relaxed, you will notice that their expressions appear more natural and the resulting images will look better. The relationship between photographer and sitter is a key factor to an image's success. Once you have mastered this, the job of taking good portraits will become far more straightforward.

Focal length

The look and feel of the portraits you take is influenced by many things. Naturally, your subject's pose and expression will greatly dictate the image's mood, but focal length is also a key consideration. A wide-angle lens can be attached to create distorted, wacky portraits, whilst a tele-zoom is normally the best choice for candid shots. For the majority of portraits, a short telephoto, in the region of 75mm to 180mm, will often prove best. This is

Environmental portraits

One method to help reveal your subject's character and personality is to photograph them within a fitting environment. This type of portrait might be shot in that person's place of work or possibly their home – for example, a baker in a bakery, a postman doing his rounds or maybe even a busker in a street environment. This type of approach can produce unusual, eye-catching images, which reveal far more about the subject than a standard portrait is able to. The surroundings are of equal importance to the person you are photographing, so creating a balanced composition is important. Often, a short focal length is best – a standard 18–70mm zoom being a versatile and effective focal range. In this instance, you will require a wider depth of field to keep both your subject, and their surroundings, in acceptable focus. An aperture in the region of f/11 or f/16 should be adequate.

a flattering focal length, which also allows a large enough working distance to ensure your subject doesn't feel too self-conscious or intimidated.

▶ **In trouble with the law**
Environmental portraits can reveal or imply so much about the subject. Using a wide-angle lens, it is possible to create eye-catching portraits by shooting your subject close-up, with the background portraying something about your subject.

Nikon D2x, 16mm, 1/60sec at f/22, ISO 100 and tripod.

Light and exposure for portraits

Lighting is a crucial ingredient to any portrait image. How the subject is lit will not only help determine their appearance, but it should also complement the look and mood of the subject. Although for some types of people photography you will simply have to work with the ambient light available – candid shots, for example – often you will have at least some control over lighting. Both natural and artificial light is suitable for portraiture and, even if you don't have the budget or luxury of using a professional studio environment, it is still possible to create stunning results in the comfort of home. In fact, many photographers prefer using natural light to illuminate their subject, believing flash or studio lighting is unable to match the natural qualities of sunlight. In truth, both types of light have their merits – it depends on the result you want.

Whilst strong sunlight might suit some subjects, bright, but overcast conditions are best for people. A cloudy sky will act like a giant diffuser, softening the light and proving flattering to skin tone. In contrast, bright direct light – particularly during midday when the sun's overhead – is too harsh, creating ugly shadows underneath facial features and also causing your sitter to squint. This is one of the reasons why wedding photographers will often pose people in the shade of a tree or building.

Daylight can also be used when shooting indoors, for example natural light entering a room via a window or patio doors. If the light is too strong, it can be diffused by simply hanging muslin or a net curtain across the window. Be mindful of your subject's background. Often, it is best to keep the backdrop clean, simple and uncluttered. To help draw attention to your point of focus – typically, your subject's eyes – employ a large aperture in the region of f/4. This will create a shallow depth of field that will help throw the background pleasantly out of focus. It will also help generate a relatively fast shutter speed that will enable you to shoot handheld – preferable when taking portraits, allowing you to alter your shooting position freely and quickly. The drawback of using natural light, is that you can't control it and it has a nasty habit of changing

when you least want it to. For this reason, many professional portrait photographers spend much of their working life in a studio environment. The main advantage is that they have precise control over the direction of light and the way the subject is lit. Studio lighting can prove costly, but it is possible to create similar results using two flash heads. Whilst light will look less natural, it is possible to emphasize a specific area of the image through the way it is lit. Even strong, contrasty light can prove effective when used precisely and appropriately in a studio – it will depend on the effect you wish to achieve.

▼ *Georgie*

In a studio, it is easier to create some sort of artificial set-up, or utilize props, which can either complement or conflict with your model – the choice is yours. As ever, lighting is a crucial ingredient. In this instance, the way the model is lit makes her stand out boldly against her contrasting environment, creating an eye-catching and unusual result.

--

Nikon D2x, 18–70mm (at 24mm), 1/60sec at f/10, 1SO 100, Bowens lighting kit.

--

Exposure tip

To lift any unflattering shadows beneath your subject's eyes or nose, ask your sitter to hold a reflector, or sheet of white card, on their lap, angled to reflect light upward.

Candid photography

Candid photography relies on spontaneity. It can be best described as an unplanned, un-posed and unobtrusive form of people photography, where the photographer captures a moment of everyday life. Often, pictures are taken from further away, so that the photographer remains largely unnoticed – a focal length in the region of 200mm is ideally suited. As a result, candid images look completely natural.

Good candid photography relies on timing – for example, a split second too early or late and the person being photographed may turn and look in the wrong direction or their expression change. Therefore, you need to work quickly.

Wedding receptions, bustling markets, high streets and festivals are among the places where great candids are possible. However, some people do object to having their picture taken. So, if possible, introduce yourself first and ask permission. Presuming they agree, simply wander off and place yourself strategically within shooting range. They will soon forget you are there. You can then begin shooting natural-looking candids.

For this type of photography, a relatively large aperture of f/4 or f/5.6 is often best, helping to throw background detail quickly out of focus and placing greater emphasis on your subject.

▶ *Child paddling*
Good candid images rely on spontaneity and timing. Your subject should be unaware of you and your camera, so that images are natural and genuine. Having been given permission by this child's parents, I took this shot whilst the little boy paddled in the evening light.

Nikon D70, 70–300mm
(at 200mm), 1/400sec at
f/4, ISO 200 and handheld.

Still life

For centuries, artists have depicted still lifes. The term refers to a depiction of inanimate objects – man made or natural – arranged creatively by the artist. Still life photography is popular and accessible to all – you don't even need to step foot outside, with a typical household being full of objects with potential. It is a great subject to hone your compositional, lighting and exposure skills, as the subject is stationary and the photographer has complete control over every aspect of capture. However, that isn't to say it is easy, after all, this is one of the very few subjects where you have to 'make' the picture before you can take it.

One of the key skills to still life photography is having the ability to identify suitable subjects. A bowl of fruit, or vase on a softly lit side table are typical of the still life subjects that normally first spring to mind. However, with a little imagination you will soon think of far more original subjects. Even mundane, everyday objects can create striking images. Have a wander around your home, looking with a creative eye. Cutlery, stationery, work tools, bottles and jars, flowers, fruit, vegetables and toys are all subjects with potential – either photographed in isolation or combined with another object.

As you would expect, how best to light your subject is a key consideration. Some form of artificial light – flash or studio lighting, for example – will often be necessary as, typically, you will be working indoors. Using artificial light, a photographer can control its direction and quantity to create just the effect desired. However, if you are new to still life photography, you might find it easier simply to use ambient light to begin with. By doing so, you can see the light's effect on the subject. If you are using household light, be aware that tungsten light (page 116) has a lower colour temperature than daylight. As a result, a warm, orange cast will affect exposures taken under tungsten, unless you correct this via your white balance setting. Alternatively, you could simply use window light, diffusing it if necessary using muslin or a similar material.

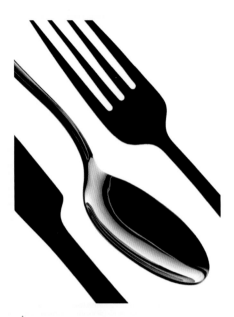

▲ *Cutlery*

Everyday objects, that you wouldn't normally consider photographing can be transformed thanks to the three key ingredients to a successful still life – lighting, composition and arrangement. In this instance, I carefully positioned a knife, fork and spoon, using a lightbox to create a simple, white backdrop.

Nikon D200, 150mm, 1/20sec at f/14, ISO 100 and tripod.

▶ *Pencils*

Look around your home and you will soon find plenty of potential still life subjects. Often a simple arrangement is best – don't over complicate things. Whilst mono can create mood and a feeling of nostalgia, colour will create impact. In this instance, I arranged a number of coloured pencils, positioning them diagonally to strengthen the composition.

Nikon D70, 105mm, 1sec at f/14, ISO 200 and tripod.

Contrast, shape and form are all important aspects of successful still life photography. Whilst colour often works best, don't overlook the possibilities of converting to mono (page 180). Black and white can convey a sense of nostalgia, well suited to many still life subjects.

Exposure tip

Equipment and set-up

Still life images are normally taken close up. Whilst, for larger arrangements, a standard zoom lens should be adequate, for smaller subjects, opt for a macro lens, close-up filter or extension tube. A tripod is essential, allowing you to alter your arrangement knowing the camera's position is fixed and your composition won't change. It will allow you to make as many 'tweaks' to your set-up as you want, until you achieve just the right look and balance through the viewfinder.

You can buy specific still life tables or coving – a curved white background that makes it easy to shoot objects against a neutral backdrop. They are ideal for product photography and are available in a variety of designs and sizes – ranging from small table-top set-ups to large professional studio tables. The 'Magicstudio' range by Novoflex is ideally suited to still life work, being compact, portable and easy to

store. However, if you don't want the extra expense, a table top can easily be used as a makeshift mini studio. You can even move it adjacent to a window should you wish to use natural light. Here, you can begin to arrange your still life.

The background you select will play a significant role – the right backdrop will help the subject stand out, whilst the wrong one will only hide it. It is normally best to keep it simple, ensuring it is complementary to your main subject. A piece of black or white card, available cheaply from a craft shop, will create a simple, neutral backdrop.

When you begin arranging your still life, start modestly. Often 'less is more' when shooting this style of image and simplicity is best. Look at the way the light affects the shadows and the shape of the item. Keep 'building' your arrangement, making fine adjustments until you are finally satisfied.

Exposure tip *You can learn a great deal from simply studying still life images published in books, magazines and on the internet. Notice how photographers often use lines, repeating shapes, contrast and colour. Study the lighting and collect images that you like – this will help inspire you when you're taking pictures of your own.*

Exposure for still lifes

It is impossible to make any general statements about the exposure settings best employed for still life photography – it will depend on the subject, focal length and the effect you desire. If you require back-to-front sharpness, select a small aperture. The resulting shutter speed may be slow, but this won't matter as the subject is stationary and the camera mounted on a tripod.

To create very arty-looking still life images, select a large aperture to create a narrow depth of field. By doing so, only your point of focus will be pin-sharp – with everything in front and behind drifting pleasantly out of focus. This can prove to be a very effective approach, but still life photography is highly subjective – experiment in order to discover what you like and dislike.

◀ *Water droplets*

Simple ideas often create the most striking images. This image was created by positioning an A4 computer print of the symbol for water behind droplets on a windowpane – the reflection of which can be seen in each and every tiny drop.

Nikon D200, 150mm, 1/10sec at f/18, ISO 100 and tripod.

▶ *Keyhole*

Not all still life images have to be set up. 'Found still lifes' refer to photographs taken of subjects that the photographer has chanced upon, rather than pre-arranged. In this instance, I noticed the peeling paintwork on this old blue door, and recognized the still life potential. I used the keyhole as a point of interest. The cloudy, overcast conditions provided nice, diffused lighting.

Nikon D200, 150mm, 1/20sec at f/14, ISO100 and tripod.

Abstract and patterns

Abstract is like no other form of picture taking. The normal 'rules' of exposure can often be disregarded altogether. For example, the compositional rule of thirds can be ignored, focusing doesn't always need to be pin-sharp and images can be 'technically' over- or underexposed. Photographers who shoot abstracts and patterns simply use imagination, creativity and originality to capture stunning, eye-catching images.

▼ *Drinking straws*
Abstract photography places greater emphasis on texture, detail, form and colour, rather than capturing the subject in full. With a little imagination, even mundane objects, like these colourful drinking straws, can be arranged and photographed in an abstract way.

Canon 400D, 60mm macro, 1/30sec at f/11, lightbox and tripod.

Choosing a subject

Abstract photography is the process of using colour, tone, symmetry, patterns, form, texture and repeating lines or shapes to create an image. The subject matter doesn't need to be recognizable or the pictures have any great meaning – it is purely art. As a result, this is a highly subjective form of photography; there are no definitive 'right or wrongs'.

Practically anything can be shot in an abstract way – big or small, indoors or out. Unusual angles of architecture or modern buildings, the human form, floral close-ups and textures – natural or synthetic – are typical of the type of subjects popular among abstract photographers. If you are still lacking inspiration, type 'abstract photography' into a search engine on the internet and look through some of the results – this should give you a few extra ideas. However, it isn't necessarily the subject matter itself that is important – instead, it is the photographer's own interpretation of that particular subject which is most significant.

Traditionally, the two lens types best suited to abstract photography are a macro lens, to help isolate detail, and a super wide-angle or fisheye lens, which can be used to creatively distort a subject's appearance.

Exposure tip

Exposure for abstracts and patterns

Although creativity is the key ingredient to abstract photography, you still need to be technically competent – shooting abstracts is not an excuse to be lazy. Without a good, working knowledge of exposure, you will be unable to reproduce your thoughts and visions. The f-number you select will be greatly dictated by the level of depth of field required. Often, to create arty, abstract-looking images, a shallow depth of field is best – throwing practically everything other than the point of focus into a soft haze of colour. Visually, this can prove a highly effective approach. Also, through selecting a large aperture, the resulting shutter speed will often be fast enough to allow you to shoot handheld should you wish. Whilst I am normally an advocate of using a camera support whenever possible, when shooting abstracts, the freedom of shooting handheld can help promote creativity and original shooting angles.

Another popular technique is to blur subject movement through the use of a slow shutter speed (see page 56).

Digital capture has encouraged creativity and experimentation. By reviewing the results achieved via image playback, you can see what works visually and what doesn't. You can then alter your set-up or exposure settings accordingly until you achieve just the effect you desire.

▼ Water droplets

We are constantly surrounded by potential abstract subjects. With this type of photography, the possibilities are simply endless – your only restriction is your own imagination. A close-up of water droplets, which had formed on a discarded metal pedal bin, created this striking-looking pattern.

Nikon D70, 150mm, 1/8sec, at f/10, ISO 200 and tripod.

There are no definitive guidelines for creating abstracts – natural or otherwise. What one person likes, another won't. For this reason, you must capture images which satisfy your creativity first and foremost – don't worry if they don't always meet with the approval of others.

Abstracts and patterns in nature

Whilst many man-made objects are well suited to being photographed in an abstract way, there is no better provider of suitable subjects than nature. New patterns are formed naturally every day, so where better to begin looking for potential abstract subjects than the great outdoors.

Usually, a camera records a subject with a high degree of realism, but, by definition, an abstract image is not a recognizable, accurate representation of the subject. The photographer simply identifies a point or area of interest, isolating it through the focal length of the lens they use or by moving near to the subject.

Form is primary; content is irrelevant. Therefore, you need to re-think how you would normally photograph any given subject. You need to look with fresh eyes at natural subjects that you might normally ignore – like moss, bark, geology and sand.

By photographing such subjects in an abstract way, employing an unusual angle or using a creative technique, you will achieve striking results.

It is not just miniature natural objects that form interesting abstracts. Rather than photograph subjects using a traditional approach, try shooting them more imaginatively. Once again, motion can be a useful visual tool. Normally, any camera movement during exposure would result in a ruined image. However, this is abstract photography, so no approach can be ruled out completely. In fact, intentionally moving the camera during a relatively slow exposure of around 1/2sec can create very impressionist results – particularly when combined with strong lines, like an avenue of trees. Whilst this technique can prove very hit and miss and may take many attempts to get right, moving the camera during exposure can create a surreal effect.

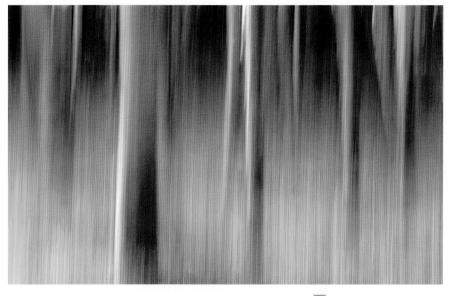

◀ ◀ Bark
You will need a sharp creative-eye to shoot abstract-looking textures and patterns. The simple form of the bark of a Tibetan cherry tree created this striking and colourful shot.

Nikon D70, 150mm, 1/4sec at f/22, ISO 200 and tripod.

◀ Sand pattern
Natural abstracts are often easily missed, so you need to look carefully. In this instance, the low, evening light emphasized the ripples in the sand, creating a simple, but attractive pattern.

Nikon D70, 105mm, 1/30sec at f/16, ISO 200 and tripod.

▲ Blurred trees
When shooting abstracts, the traditional 'rules' can be largely ignored. In this instance, I moved my camera up and then down during the exposure. By doing so, I created this blurry, streaky effect of an avenue of beech trees.

Nikon D70, 18–70mm (at 40mm), 1/2sec at f/18, ISO 200, polarizer and tripod.

▼ Weir
Motion can prove a highly effective tool when attempting to capture arty, abstract images. In this instance, an exposure time of 1/6sec proved sufficient to blur the water cascading over a small weir, creating this striking-looking result.

Nikon D70, 70–300mm (at 270mm), 1/6sec at f/32, ISO 200 and tripod.

Close-up photography

Practically any object is suited to being shot in close-up. By moving nearer to your subject, you will reveal detail, colour and texture that would otherwise go unnoticed. Close-up photography allows us to view subjects from a totally new viewpoint and capture visually striking, often abstract-looking, photographs indoors or out.

Equipment for close-ups

It is a common misconception that, to capture great close-up images, you need pricey, specialist equipment, like a macro lens – optimized for close focusing. In truth, many standard zooms offer a useful reproduction ratio of around 1:4 at their longest end, which is sufficient magnification to photograph many small subjects. There is also a wide range of close-up attachments available, many of which are inexpensive. For example, supplementary close-up lenses are a good introduction. They are similar to a filter, screwing into the lens's filter thread, and act like a magnifier.

Also available are extension tubes – hollow rings that fit between the camera and lens. They work by extending the distance between the sensor and lens. This allows it to focus nearer than normal, increasing its magnification. However, some close-up attachments reduce the amount of light entering the lens – affecting exposure. Shutter time is lengthened as a result. While modern TTL metering automatically adjusts for any reduction in light caused by using a close-up attachment, it is useful to be able to calculate its level of light absorption. Simply set your lens to infinity and then take a meter reading from an even-toned object, like a wall. Next, take a subsequent meter reading of the same object, but with your close-up attachment in place. Compare the two meter readings – the difference is the absorption factor for that piece of equipment. For example, if the first reading is 1/500sec at f/8 and the second – with the attachment – is 1/250sec at f/8, then the loss of light incurred by using it is one stop. Knowing the level of compensation required is essential if you are using a handheld light-meter or a non-automatic accessory – like a manual extension tube.

Lighting for close-ups

When shooting close-ups, natural light can be restricted. Often, this is due to the close proximity of the camera in relation to the subject – with the photographer, camera or both casting a shadow across small subjects. This can be tricky to avoid when using certain close-up attachments, as the lens may be positioned only centimetres away from what you are photographing. Sometimes the problem can

▼ **Door handle**
Practically anything can create a striking image in close-up – even mundane objects that you would normally overlook. Using a close-up attachment, it is possible to isolate interesting colour or detail, drawing attention to a specific area. In this instance, the door handle and keyhole from a colourful beach hut door created an eye-catching shot.

Nikon D200, 70mm, 1/40sec at f/20, ISO 100 and tripod.

be solved by simply altering the shooting position or by using a longer focal length to increase the subject-to-camera distance. However, if this isn't possible you may need to supplement the available light. For the most natural-looking results outdoors, reflect light back onto the subject using a reflector. The light can be intensified or reduced simply by moving the reflector closer or further away from the subject.

Compact, collapsible versions are relatively cheap and a good accessory to keep in your camera bag. Alternatively, a piece of white card or tin foil can be used. If a reflector doesn't work, try using flash. However, flash from a hotshoe-mounted flashgun may well miss (or only partly illuminate) the subject – either passing overhead or being obstructed by the lens. Therefore, position your flashgun off-camera, using an off-camera flash cord or consider investing in a dedicated macro flash (see page 130).

What is reproduction ratio?

Reproduction ratio is a way of describing the actual size of the subject in relation to the size it appears on the sensor – not the size to which the image is subsequently enlarged on screen or when printed. For example, if an object 40mm wide appears 10mm on the sensor, it has a reproduction ratio of 1:4 – or quarter life-size. If the same object appears 20mm in size, it has a ratio of 1:2 – or half life-size. While if it appears the same size on the sensor as it is in reality, it has a reproduction ratio of 1:1 – or life-size. This can also be expressed as a magnification factor, with 1x as 1:1 life-size.

▼ Common frog
Nature is a popular subject; however, light is often restricted due to the close distances involved. Light bounced onto the subject via a reflector will be less intrusive than a burst of artificial flash. Here, I used a small reflector to evenly illuminate this frog.

Nikon D300, 150mm, 1/320sec at f/4, ISO 200, reflector and handheld.

Depth of field for close-ups

On pages 50–51 we looked at depth of field and the way its affects our images. One of the greatest challenges of close-up photography is working with a more limited depth of field than normal. The zone of sharpness, in front and behind the point of focus – for any given f-stop – grows progressively shallower as the level of magnification is increased. For example, when photographing a flower, its stamens may be recorded pin-sharp, but the petals in front and behind might be rendered out of focus. Moving further away from the subject will create a larger depth of field, but this would defeat the object. Instead, the logical solution is to select a smaller aperture (higher f-number), as this widens depth of field. As a result, the light reaching the sensor is reduced so, to compensate, the shutter speed has to be lengthened to maintain the correct exposure.

However, when taking pictures at high magnifications, even the smallest movement is exaggerated so the risk of camera shake (see page 54) is greatly enhanced – particularly when also using a relatively slow shutter speed. Presuming the subject is static, the best solution is to use a tripod to support the camera. However, if the subject is moving or being wind blown, the shutter speed may not be fast enough to freeze its movement. In instances like this, select a faster ISO rating to generate a quicker shutter, or consider using macro flash (see page 130).

A good understanding of depth of field is important for creative close-up photography. The degree of back-to-front sharpness can greatly alter the subject's appearance in the final image. Contrary to popular belief, a large depth of field is not always desirable when shooting close-ups, as it can render too many distracting foreground and background elements in focus. For this reason, many photographers purposely opt for a narrow depth of field to help isolate their subject and direct the viewer's eye to their chosen point of focus. Employ a large aperture of between f/2.8 and f/8 to do this. Depending on the level of magnification you are employing, depth of field may only be a matter of millimetres, so accurate focusing is essential.

Exposure tip

If you are unsure of the level of depth of field to use, take a sequence of images, altering the aperture value each time. You can then compare the results later.

▼ *Thick-legged beetle*

This colourful beetle was only 20mm in length. I had to employ a reproduction ratio of approx 1:2 to ensure it was large enough in the frame. However, at such a high magnification, depth of field is severely restricted. To compensate, I selected a relatively small aperture of f/14 to provide sufficient depth of field.

Nikon D200, 150mm, 1/40sec at f/14, ISO 200 and tripod.

Position your camera parallel to the subject, rather than at an angle. This will help you to make the most of the depth of field available to you at any given f-stop.

Exposure tip

▼ Poppies

Sometimes you will require back-to-front sharpness to ensure everything within the frame remains in focus. However, using a shallow depth of field will help draw attention to your chosen point of focus – isolating the subject amongst its environment. In this instance, a single poppy is sharp, whilst the surrounding out-of-focus flowers create a haze of colour.

- -

Nikon D200, 70–200mm (at 200mm), 1/800sec at f/2.8, ISO 100 and tripod.

- -

Close-up or macro – what is the difference?

The terms 'close-up' and 'macro' are often used to describe the same photograph. However, there is actually a distinct difference between the two. Technically speaking, a 'close-up' is an image captured using a reproduction ratio ranging from 1:10 to just below life-size: whilst 'macro' is life-size to 10:1 life-size. Anything taken with a greater magnification than 10x life-size belongs to the specialist field of 'micro' photography.

Photographers, books and magazines often use the word 'macro' loosely – using it to describe practically any close-up image. Whilst this might be technically incorrect, in truth the distinction is academic; it is the quality of the image that really matters.

3 Ambient light

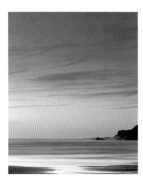
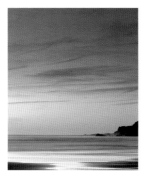
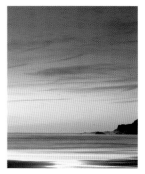

Ambient light

Ambient light – also known as 'available' or 'existing' light – is a commonly used term by photographers and other visual artists. It refers to the illumination surrounding a scene or subject by which to take photographs. Typically, ambient light isn't supplemented or added to in any way by the photographer. For example, sunlight, tungsten lighting or even candlelight can be the source of the ambient light used in your photographs.

Natural ambient light is one of the best forms of illumination and, personally, I'm a great advocate of using natural light whenever practical. Admittedly, unlike flash (see chapter four) a photographer has no control over ambient light. However, once you learn how to use it to good effect, your images will look more natural, boasting colours faithful to the original scene or subject.

Light is an image's most vital ingredient. The quantity, quality and direction of light will have a huge bearing on the look of the final image.

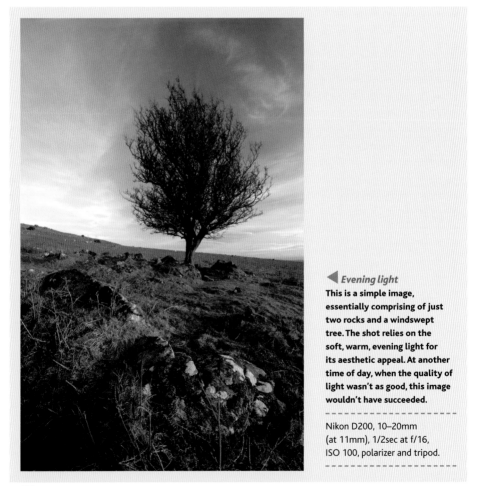

◄ *Evening light*
This is a simple image, essentially comprising of just two rocks and a windswept tree. The shot relies on the soft, warm, evening light for its aesthetic appeal. At another time of day, when the quality of light wasn't as good, this image wouldn't have succeeded.

Nikon D200, 10–20mm (at 11mm), 1/2sec at f/16, ISO 100, polarizer and tripod.

▲ *Backlit leaf*
**The level and direction of illumination can alter
a subject's tonality, affecting its brightness and
colour. These leaves would normally be mid-tone,
but by backlighting, them they appear lighter.**

Nikon D200, 150mm, 1/10sec at f/14,
ISO 100 and tripod.

By simply altering your shooting position, a
subject can look radically different. For example,
a subject which is backlit or cast into silhouette
can look far more dramatic than if simply lit from
the front or side.

The colour of light will also influence your
results. Digital cameras are designed with a
white balance setting to enable photographers to
neutralize colour casts created by ambient lighting.
However, it is worth remembering that sometimes a
cast should be enhanced, rather than removed, as it
can improve an image aesthetically.

Light's affect on tonality

A subject's tonality can be greatly affected by the intensity
and direction of light, altering its apparent colour and general
appearance. For example, a very dark object can appear to
be white or even silver depending on just how the light falls
on it. Also, translucent subjects, like a leaf or the wings of a
butterfly, can be rendered much lighter when backlit
(see page 105).

Tonality is rarely fixed, so nuances like this will greatly
influence the way the subject is recorded, and later perceived
by the viewer. Recognizing just how light can alter the
tonality of your subject will help you to reproduce it just as
you wish in a photograph.

Direction of light

The direction of light is an important tool – helping determine a subject's appearance when captured in the two-dimensional form of a photograph. There are four broad categories: front lighting, backlighting, side lighting and overhead lighting. Matched to the right scene or subject, each type is capable of producing striking – and very different – results.

Front lighting

Front lighting is the easiest to handle. It illuminates the front of the subject evenly, removing visible shadows. Therefore, whilst it is fine for showing subjects with no particular emphasis, this form of light often produces flat, formless results – lacking contrast, impact and atmosphere. This is why it is best to ignore the old saying 'always take pictures with the sun behind you' – advice suited to a different age of photography.

Overhead lighting

Overhead light is typical of the type of harsh lighting you will encounter during the middle of the day, when the sun is high, which photographers are advised to avoid. It can make subjects appear flat and, unless the subject is horizontal, isn't good at emphasizing texture or form. Depending on the situation, overhead light can also create areas of high contrast with unpleasant, unflattering shadows – although they can easily be relieved by using fill-in flash (see page 132) or a reflector (see page 118).

▼ *Beach huts*
Side lighting is best for highlighting texture and form. It is particularly well suited for defining the shape of multi-dimensional objects, like buildings.

Pentax K10D, 18–55mm (at 18mm), 1/80sec at f/11, ISO 100 and handheld.

Side lighting

Side lighting is one of the best, and most regularly used, forms of light – helping add depth to a subject and create a three-dimensional feel. It is for this reason that many outdoor photographers prefer shooting at the beginning and end of the day. Side lighting highlights form, defining shape and edges – although to what degree depends on the subject itself and the angle and intensity of the light source. Side lighting will normally produce images with a good degree of contrast (see page 42). However, this can present a problem if the contrast in light is greater than the sensor's dynamic range – with either the shadows or the highlights – or sometimes both – being rendered without detail.

Backlighting

It is a common misconception that you should not shoot in the direction of the sun. Whilst it is true that you should never point your lens in the direction of a bright light source, in practice, backlighting is one of the most dramatic forms of lighting. However, it can also prove the trickiest to meter for. So, to ensure you achieve the correct exposure, it is advisable to bracket your exposure settings (see page 60). The two most common forms are rim lighting and silhouetting. Rim lighting is

Lens flare

Flare is the product of non-image-forming light reaching the sensor; normally caused by shooting in the direction of intense light, like the sun. Flare can appear in many different forms, but typically brightly fringed polygonal shapes – of varying size – in addition to bright streaks and a reduction in contrast. It is created when light doesn't pass directly along its intended path and instead bounces back and forth between the internal lens elements before finally striking the camera's sensor. Although flare can be used creatively, it is normally undesirable, degrading picture quality. For this reason, modern lenses are designed with surface coatings to combat its effects and a detachable lens hood is normally supplied as standard.

where there is still detail rendered in the face side of the subject and a golden halo of light surrounds it. Silhouetting is the most extreme form of backlight, with the subject recorded without colour or detail (see page 106). Translucent subjects, like leaves, can look particularly striking backlit, highlighting detail and colour. However, when shooting towards the light, the risk of lens flare is enhanced – if necessary, attach a lens hood or you could alter your shooting position slightly.

◄ *Backlit fungi*
Translucent objects can look striking when backlit, with miniature detail highlighted. On this occasion, I selected a viewpoint where the fungi would be backlit by the low, morning sunshine.

Nikon D200, 150mm, 1/10sec at f/11, ISO100 and tripod.

Silhouettes

It could be argued that a silhouette is the result of poor exposure. It is the most extreme form of backlighting, where the subject is recorded as a black outline – without colour or detail – against a lighter background. In other words, the subject is grossly underexposed. However, silhouetted subjects create powerful and striking imagery – especially when contrasted against a colourful sky or sunset. They prove, once again, that there really is no such thing as a 'correct exposure'.

Choosing a subject

Silhouettes are easily achieved – especially at either end of the day, when the sun is lower in the sky. What the photographer is striving to achieve is a photograph where the main subject is devoid of detail or colour. For this reason, it is important to select a subject with a strong, instantly recognizable outline. People, buildings, a cityscape or an isolated tree are good examples of suitable subjects. In my opinion, the key to shooting successful silhouettes is to keep the composition simple; too many competing elements within the frame will detract from the picture's impact.

Exposing silhouettes

To create a silhouette, the subject needs to be backlit. But backlighting can easily confuse your camera's TTL metering. To guarantee a successful result, you could simply bracket (see page 60) your camera's recommended settings – progressively underexposing results by half- or third-stop increments. However, it is more reliable to spot meter (see page 22) from an area of bright lighting behind your subject. The difference in stops between this area, and the subject you intend silhouetting needs to be greater than the dynamic range

(see page 32) of your camera's sensor to produce a true silhouette. Presuming that it is, when you take the photograph using the readings from the highlight area, your subject will be rendered pure black, creating a perfect silhouette. Check the image's histogram (page see 28) to be certain – the majority of the pixels should be skewed towards the left-hand edge.

▼ *Leaf*

A silhouetted subject doesn't have to be set against the sky; it is possible to create one by photographing a subject through a backlit, translucent layer – like a leaf. In this instance, I noticed the outline of a second leaf silhouetted against the one in front.

Nikon D200, 150mm, 1/100sec at f/14, ISO 100 and tripod.

Exposure tip

When spot meter reading from a brightly lit portion of the frame, be careful never to look directly at the sun through the camera, or you risk damaging your sight.

▶ *Jigsaw puzzle*

Silhouettes can also be created indoors, by photographing an object against a bright light source. A lightbox is a great form of illumination. To take this image, I arranged a section of jigsaw on my lightbox and metered for the highlights. As a result, the puzzle itself was grossly underexposed, creating the effect I desired. I removed a piece to create visual interest.

Nikon D70, 105mm, 1/80sec at f/14,
ISO 200 and tripod.

▼ *Breakwater*

Silhouettes can look striking as part of a landscape. The sun had nearly disappeared behind the horizon when I took this shot. The breakwater was cast into inky silhouette, contrasting perfectly with the rising tide, which I deliberately blurred by employing a lengthy shutter time.

Nikon D200, 18–70mm (at 46mm), 13secs at f/29,
ISO 100, 0.9ND filter and tripod.

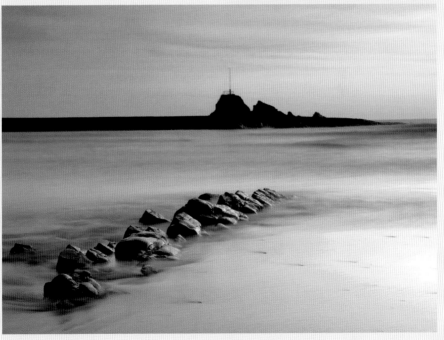

Quality of light

Photographers often refer to the 'quality' of light, which relates to its harshness. This is determined by its source. For example, light from the sun, a spotlight or other type of point light will typically produce quite a hard quality of light. In contrast, light which is diffused in some way is deemed quite soft and attractive in quality. Therefore, the 'quality' of light can greatly affect the look of your final image.

Talk to an experienced outdoor photographer and they will tell you that it is not hills, lakes, trees, rocks, plants and so forth, that they are photographing, but the light reflecting off them. Light helps to define a subject and its quality and direction (see page 104) can greatly alter a photograph. It can prove the difference between a good and great image. For example, shoot an identical composition, but at different times, in varying types of light, and the results will be very different.

When photographers talk about the quality of light, they are actually referring to its intensity. High-intensity lighting, such as direct sunlight or spotlighting, is deemed hard, creating well-defined shadows and a high degree of contrast. However, if the sunlight is diffused by cloud, or a soft box in a studio environment, its intensity is lessened. As a result, shadows are softer and contrast is reduced.

Different types of light suit different subjects; for example, when shooting portraits, soft lighting will normally give the most flattering results. Of course, when using artificial light, a photographer can manipulate and control the light's intensity to create the effect they want. However, natural light cannot be controlled, so photographers working outdoors have to either make do, or wait until the quality of light changes naturally.

Both cloud and the time of day can greatly influence the sunlight's intensity. Blanket cloud eclipsing the sun will produce diffused, even light without shadows – well suited to shooting flora, as colour appears more saturated. In contrast, on a clear, cloudless day, the sun acts like a giant

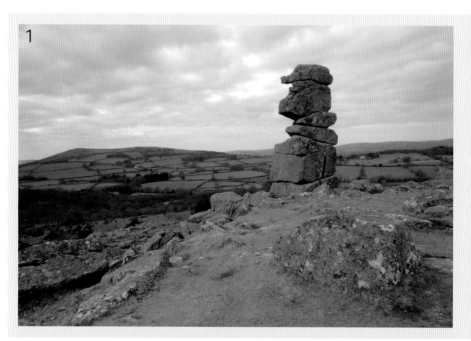

1

The quality of natural light is generally best when the sun is lower in the sky. Not only is the light softer and warmer, but the longer shadows help create the feeling of depth. Therefore, a good rule to remember is; 'if your shadow is longer than you are, the light is suited to photography'.

spotlight, casting harsh shadows. The best light is normally produced when the sky is punctuated with broken cloud. This both diffuses and reflects the light, so contrast becomes more manageable. Also, the sky itself becomes far more interesting if you are shooting scenics.

The position of the light source also has a huge impact on the quality of light. For example, when the sun is high overhead at midday, the resulting absence of shadow leaves the landscape looking flat and 'over-lit'. A similar effect can be observed in a studio. For this reason, the middle hours of the day are best avoided – for landscape photographers in particular. The so called 'golden hour', after sunrise and before sunset, yields the best quality of light. The sun's rays are not only softened and diffused by its oblique path through the layers of the atmosphere, but are also wonderfully warm.

The quality of light can also affect exposure. Hard lighting conditions heighten the level of contrast within a scene, potentially beyond the

limits of the sensor's dynamic range (see page 32), making it more difficult to retain detail throughout the image.

▼ *Granite tor*

In this instance, the scene is transformed by the quality of light. Although only taken moments apart, the quality of light is radically different in the two images. In the first shot (1), the sun was hidden by cloud, so the photo looks dull and shadowless. However, when the sun reappeared seconds later, the direct, late evening sunlight transforms the scene, with the light and resulting dark shadows giving the image life and depth (2).

Nikon D200, 10–20mm (at 12mm), 1/10sec at f/20, ISO100, polarizer and tripod (2) only.

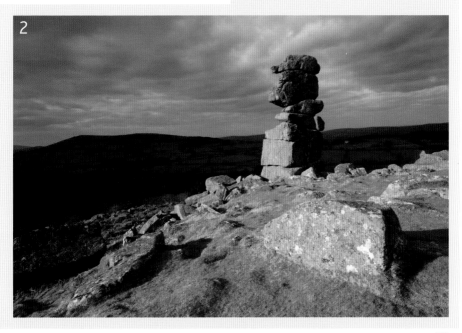

Colour of light – white balance

White balance (WB) is a term unique to digital capture. It is a feature found on digital cameras, designed to correct undesired colour casts produced by different temperatures of light. Although most cameras have a useful automatic white balance facility – where the camera looks at the overall colour of the image and sets WB accordingly – this setting will not always produce the best results. For example, if a scene or subject is dominated by one colour, the camera can be easily fooled. The most aesthetically pleasing result will not necessarily be the one which is 'technically' correct – deliberately mismatching the WB setting can create a better result visually.

a variety of common lighting conditions, for example 'incandescent', 'fluorescent', 'daylight', 'cloudy' and 'shade'. By setting WB to a specific colour temperature, we are actually informing the camera that the light is that colour, so that it can then bias the setting in the opposite direction. Although the camera's WB presets are unable to guarantee exact colour reproduction, when matched correctly with the prevailing light, they help photographers get acceptably close to it. Many digital SLRs also allow photographers to set WB manually, so that it is possible to dial in a specific Kelvin temperature for even greater accuracy.

Colour temperature

Each and every light source contains a varying level of the three primary colours red, green and blue (RGB). Lower temperatures have a greater percentage of red wavelengths, so appear warmer; higher temperatures have a greater proportion of blue wavelengths and appear cooler. The temperature of light is measured in degrees of Kelvin (k). For example, the concentrated warm light of a candle flame has a low value of around 1,800k, whilst shade under a cool blue sky is equivalent to around 7,500k. Light is considered neutral at around 5,500k – this rating being roughly equivalent to equal amounts of the RGB wavelengths of white light.

The colour temperature of light has a significant affect on photography, influencing the appearance and feel of the resulting picture. While the human eye naturally compensates for the light's temperature – natural or artificial – so that we always perceive it as white or neutral, a camera's sensor isn't so discerning and needs a helping hand. To capture colour authentically, digital photographers need to match the colour temperature of the light falling on the subject with the appropriate WB setting on their camera. The majority of photographers rely heavily on WB presets to do this. The presets are designed to closely match

This chart is a good guide to help you understand the way colour temperature alters depending on the type of light source.

1,800–2,000k	Candle flame;
2,500k	Torch bulb
2,800k	Domestic tungsten bulb
3,000k	Sunrise/sunset
3,400k	Tungsten light
3,500k	Early morning/late afternoon
5,200–5,500k	Midday/direct sunlight
5,500k	Electronic flash
6,000–6,500k	Cloudy sky
7,000–8,000k	Shade

If you shoot in Raw format (see page 38) it is possible to adjust the WB parameter in photo editing software post capture, allowing photographers the luxury to either correct colour casts or add them creatively at a later date.

▶ *White balance comparison*

This sequence of images – of an identical scene – help illustrate the dramatic effect of different white balance settings. Presets designed to correct a low colour temperature, like 'incandescent' and 'fluorescent', will cool down an image, while settings designed to balance a high colour temperature, like 'cloudy' and 'shade', will create a warm colour cast. In this instance, the 'daylight' setting records the colour temperature of light authentically, but the corrective and creative possibilities of WB are clear to see.

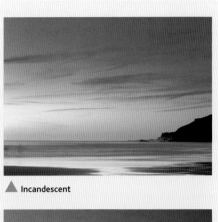

▲ Incandescent

▲ Fluorescent

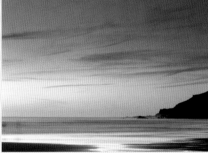

▲ Daylight

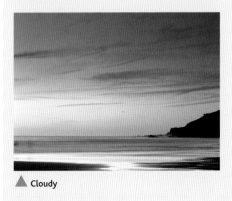

▲ Cloudy

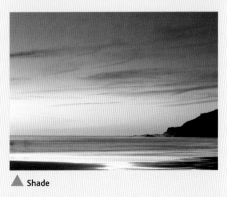

▲ Shade

Correction

If the light's colour temperature isn't correctly balanced, the light will adopt an unnatural colour cast. An artificial hue will often prove destructive, ruining a photograph's natural flavour. To prevent colour casts forming, match the WB setting with the lighting conditions. This is preferable to relying on your camera's automatic white balance (AWB) setting. Whilst AWB is capable of excellent results, it selects between a wide set of values – typically 3,000–7,000k. Therefore, it can prove inconsistent, struggling to differentiate between the colour of light and the intrinsic colours of the subject itself. Also, it can attempt to compensate for atmospheric lighting conditions that are actually part of what you're attempting to record. AWB can only 'guess' at the colour temperature required so, whilst often reliable, it is not infallible and can be fooled by tricky or mixed lighting. For example, if the colour of the

subject matter is predominantly warm or cool, AWB can mistake this for a colour cast created by the light source itself. As a result, your camera may try to adjust, trying to record colour closer to neutral. By doing so, the camera is mistakenly altering the subject's natural tone. Admittedly, some cameras are less prone to error than others, but it is still safer to manually match the WB preset with the light source.

One method to guarantee accurate white balance is to bracket your WB settings. Bracketing is a term used when taking multiple photographs of the same scene or subject using different settings. Most commonly, you bracket exposure settings (see page 60), but the same principle can also be applied to white balance. Many cameras have a function to do this automatically. If not, simply alter the WB setting manually for each subsequent frame.

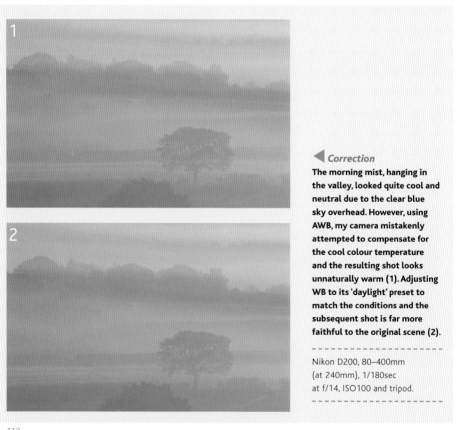

◀ *Correction*
The morning mist, hanging in the valley, looked quite cool and neutral due to the clear blue sky overhead. However, using AWB, my camera mistakenly attempted to compensate for the cool colour temperature and the resulting shot looks unnaturally warm (1). Adjusting WB to its 'daylight' preset to match the conditions and the subsequent shot is far more faithful to the original scene (2).

Nikon D200, 80–400mm
(at 240mm), 1/180sec
at f/14, ISO100 and tripod.

Creativity

Colour which is rendered 'technically' correct will not always create the best results. Depending on the scene or subject, photographs can benefit from being 'warmed up' or 'cooled down'. This is easily and quickly achieved by intentionally mismatching the WB setting with the light's colour temperature.

Warming up images is a particularly popular technique, flattering skin tone in portrait images and enhancing sunrises and sunsets. To do this, select a higher Kelvin value than the ambient light requires. For example, midday daylight is roughly equivalent to 5,500k. Therefore, by selecting a temperature of 6,000k (or your 'cloudy' WB preset), the resulting image will appear warmer. In contrast, a blue hue conveys a feeling of coolness and mystery and is well suited to misty, wet or wintry conditions. To create the effect, manually dial in a lower colour temperature setting. For example, in average daylight, a WB setting of 3,200–4,200k would create a cool blue colour cast. If you prefer, you could try using your camera's 'fluorescent' or 'incandescent' presets to create a similar effect.

Whether you intend warming up or cooling down your images, presuming you wish to retain a natural feel to your shots, adjustments to WB should be subtle. Having said that, don't overlook larger shifts in colour temperature; in some instances, they can prove effective. Experience will help you to intuitively know when to manipulate WB creatively, but experimentation is the key.

▼ *Warming up*

These two images were taken within moments of each other. Whilst the first shot records colour more faithfully (1), the subsequent frame – taken using a higher Kelvin value – looks warmer and is more attractive (2). A warm colour cast is suited to landscapes in general, and many scenic photographers shoot with their WB set at +200–400k.

Nikon D200, 10–20mm (at 14mm), 1/2sec at f/20, ISO100, polarizer and tripod. Shot (1) taken with a WB setting of 'daylight', Shot (2) 'cloudy'.

Natural ambient light

Nature provides us with an ever-changing, variable light source – the sun. With the exception of photographers who shoot exclusively in a studio environment, sunlight provides the ambient light in the vast majority of images. The quantity, effect and look of sunlight varies greatly, depending on the weather, time of day and also the time of year. Although photographers have no control over sunlight, a good appreciation of its many qualities will help you use natural ambient light to its best effect.

Whilst, in terms of distance, sunlight is fixed, its size can effectively vary. For example, on a clear day, direct sunlight can be considered to be a small point light source – relative to its distance from objects on the earth's surface – producing quite harsh lighting. In contrast, when the conditions are cloudy, the sun's rays are spread and scattered by the cloud – effectively creating a much larger light source and more diffused light. Therefore, the sun's intensity can vary greatly; not just day-to-day, but potentially, from one minute to the next. Due to the changeability of natural ambient light, two identical compositions – taken just moments apart – can look radically different. This is particularly so on days

▶ *Lake*
Natural ambient light is in a constant state of transience. The light can appear radically different depending on the time of day, season and also the weather conditions. For example, these two images were taken of the same view at around 7am in the morning, but months apart. The results look radically different, due to the season and the way the sun's position has changed – altering the sunlight's effect on the landscape.

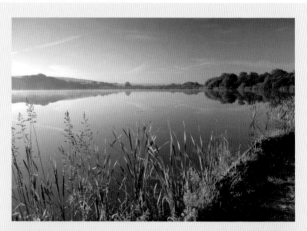

when there is broken cloud. The sun may appear for just a few moments before being shrouded in cloud again. In conditions like this, the exact moment you release the shutter can make a vast difference to the final image. Timing can be key when working with natural light.

I have previously mentioned how the quality of natural ambient light changes, relative to the time of day. Typically, outdoor photographers favour the hour immediately after sunrise and the hour before sunset in which to take their images. The light is naturally softer and warmer. The longer shadows cast help create the perception of depth and accentuate form. If you are working indoors, but using the natural light filtering through a window or door, the time of day remains important, with the 'so called' quality of light being far more photogenic at either end of the day.

Sunlight is in a permanent state of transience and the time of year also has a dramatic affect. Week by week, the light is subtly changing. The days are either growing shorter or longer and the arc of the sun varies. For example, during wintertime, the arc of the sun is at its shortest – so it doesn't appear to be as high in the sky as it does in, say, the summer months. As a result, the quality of light remains relatively good throughout the day, even at midday – traditionally the worst time to take pictures.

Thanks to the transience of natural light, a scene or subject rarely looks the same twice. Whilst, on one hand, this can make a photographer's life more difficult, on the other, the changing qualities of natural ambient light make photography far more exciting and unpredictable.

▶ *Windswept tree*

Natural ambient light can be used in many different ways. I took this photograph by shooting in the sunlight's direction – intentionally casting this windswept tree into silhouette to create a simple, graphic photo.

Nikon D300, 18–70mm
(at 40mm), 1/2sec at f/11,
ISO 100 and tripod.

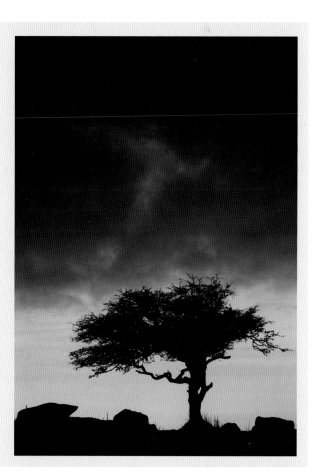

Artificial ambient light

The term 'ambient light photography' refers to any light type not added to in any way by the photographer. Therefore, not just natural sunlight, but artificial light sources too. For example, light from a table, floor or ceiling light, neon signs, street lights, car headlights, a fire or candle can all potentially provide the illumination for your pictures.

Basically, any form of existing light not provided by the sun or moon is considered to be artificial ambient light. It can have a very different quality and colour to natural lighting, so photographers need to be aware of this if they wish to record their subject authentically.

Typically, the majority of images taken using an artificial ambient light source are taken indoors using either incandescent or fluorescent light. A light bulb that employs a metal filament, heated to a high temperature by the passage of electricity is considered incandescent light. Most household light bulbs employ tungsten as a filament – a metallic element with a high melting point – and it is for this reason that photographers often use the generic term 'tungsten light' to describe artificial room lighting. Tungsten light is quite inefficient, with much of its energy leaving the bulb in the form of heat, not light. However, it is often perfectly adequate for taking pictures indoors – for example, to shoot portraits or still life images. When using this type of artificial ambient light, it is important to be aware that tungsten filaments emit a much lower colour temperature than daylight. Whilst our eyes neutralize this effect, a camera will record a warm, orange colour cast. Whilst this can prove attractive, often it will look ugly and unnatural and should be corrected via your white balance setting (see page 112). The colour temperature for incandescent light is around 3,000k, so manually adjust WB accordingly or select your camera's incandescent WB preset – designed to neutralize the excessive warmth of shooting under tungsten light.

Fluorescent, or strip lighting, contains mercury vapours which produce ultraviolet light when an electric current is passed through, causing the tube to glow or fluoresce. Like tungsten, strip lighting

produces a colour cast, unseen by the human eye. In most instances, fluorescent light will create a slightly greenish tinge to images. To ensure your shots look natural, select your DSLR's fluorescent WB preset, or a colour temperature value of around 4,200k. Fluorescent light is typically brighter and more even than tungsten. The higher level of illumination makes it easier to achieve sufficient exposure, helping to record detail in areas which other types of existing light may not.

The advantage of using artificial ambient light, as opposed to flash, is that its effect on your subject is immediately obvious. Unlike flash, subject distance

1

Using the artificial light available is useful in a number of different circumstances. For example, when flash isn't appropriate or allowed – during a wedding ceremony or indoor sporting event, for instance.

does not have a bearing on exposure – just meter for the subject as you would normally and shoot. Also, you may be able to control the amount of ambient light, by switching lights on or off or diffusing them. However, indoor lighting can be quite contrasty – for example, when your subject is close to the light source and well illuminated, but its surroundings are not. In situations like this,

a reflector may be an option in order to balance the artificial ambient light. However, you may need to add a supplementary burst of flash to solve the problem. Whilst this means you are no longer relying on the existing light, by bouncing the flash (see page 140) off a wall or ceiling, you can effectively reduce contrast without spoiling the image's natural feel.

2

◀ **Cassette tape**
Our eyes naturally neutralize the lower colour temperature of tungsten lighting. However, unless you adjust your camera's white balance setting accordingly, a warm, orange cast will prevail in images taken under incandescent light. In this high-key image of a cassette tape, the effect of tungsten light (1) is obvious compared to the subsequent shot where I adjusted WB to the camera's incandescent preset (2).

Nikon D200, 150mm, 1/20sec at f/11, ISO 100 and tripod.

Reflectors

A reflector is a highly useful lighting accessory – particularly suited to portrait, studio and close-up photography. Basically, it is a large reflective 'disc' that works by bouncing light back onto the subject. The reflector should be angled manually to direct light onto the area you require – adding extra light to your subject and relieving harsh shadows. It can prove so effective, that it will negate the need for flash light in certain situations.

Exposure tip

It is easy to make a small reflector, by simply securing a sheet of tin foil to a piece of stiff cardboard. You can then use it to angle light onto your subject.

When light levels are low or limited, a burst of flash can seem like the obvious answer. However, if not applied correctly, artificial light can destroy the natural feel of an image – particularly close-ups of plants or insects. Often, a better alternative is to manipulate the light available by using a reflector.

▶ *Reflected light*
A reflector can dramatically enhance the look of an image. By carefully bouncing the light onto the subject, it is possible to illuminate the area desired. The results look more natural than using flash. In this instance, a reflector has greatly relieved the ugly shadows on this bluebell.

Reflectors are relatively inexpensive and available in different sizes and colours. The colour of the reflector is important – white provides a soft, diffused light; silver is more efficient, but can look harsh, whilst gold or sunfire will add warmth. Many reflectors have a different colour on either side, providing choice depending on the subject matter. For photographers on the move, it is practical to opt for a collapsible version. They fold away, so can be stored away neatly. Reflectors are available from 30cm up to sizes of 120cm or more. The larger the size, the greater the area of reflected light; therefore a small reflector is only suited to shooting small objects.

By using a reflector, it is possible to alter the intensity, and therefore, quality of light. You can easily adjust the intensity of the reflected light by

moving it closer or further away from the subject. However, avoid placing it too near, or you risk giving the image an artificial feel. It is normal to handhold a reflector in position to achieve just the type of illumination that the subject requires – although reflector brackets or clamps are available to buy. For portrait photographers, reflectors are an essential tool. For example, sunlight can cast ugly shadows, particularly under the chin and neck. A reflector, held at waist height, angled upward, will even up the lighting, producing a more flattering result.

Using a reflector naturally adds light to the subject you are photographing, which in turn affects exposure. Therefore, remember to meter with the reflected light in place. Fail to do so and you risk overexposure.

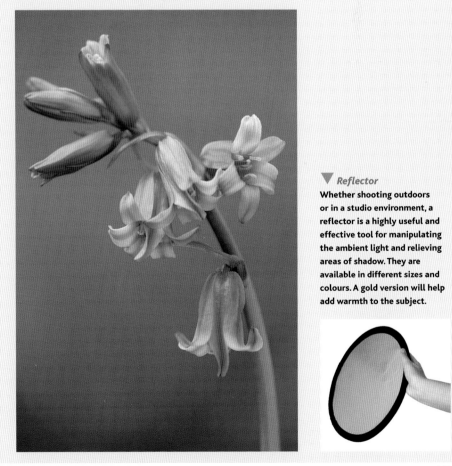

▼ *Reflector*
Whether shooting outdoors or in a studio environment, a reflector is a highly useful and effective tool for manipulating the ambient light and relieving areas of shadow. They are available in different sizes and colours. A gold version will help add warmth to the subject.

4 Flash light

Flash light

Light is crucial to photography, so what do you do when the ambient light is insufficient – or if the subject is not lit to its best potential? The quantity of light isn't always ideal and is rarely perfect, so how do you overcome the limitations and inconsistency of light? The answer is to control light levels by adding your own light source – in the form of flash light.

Whilst it is true that, used incorrectly, flash can prove destructive – casting ugly highlights, washing out colour and creating an unnatural look – applied well, it will hugely benefit your photography.

By enhancing or overriding the natural light, a photographer has greater control over light and, therefore, it is possible to achieve better images than had you simply accepted and used the existing conditions. Flash will allow you to capture shots that wouldn't otherwise be possible. However, the addition of artificial (flash) light presents photographers with a new set of challenges. By introducing flash, some of the basic parameters of exposure are altered. For example, shutter time is largely dictated by the camera's sync speed (see page 139) and the speed of the emitted flash effectively works as the shutter speed. As a result, it is the lens aperture, together with the flash-to-subject distance, which are the overriding controls of flash exposure.

Flash photography can appear quite daunting and complex at first. There are many new terms to grow familiar with – for example, fill-in, high- and low-speed sync and front- and rear-curtain flash. Even if you don't own a dedicated speedlight, most consumer DSLRs are designed with a small built-in unit, which is capable of surprisingly good results. To enable you to use flash correctly and creatively, a good understanding of the 'basics' is important. This chapter is designed to help you master flash and understand flash exposure.

TTL flash metering

Achieving correctly exposed results using flash is made easier today, thanks to sophistication and accuracy of TTL flash metering – where the camera and flash 'communicate' to achieve the correct level of illumination. This technology was first introduced by Nikon over 20 years ago. However, previous to this a flash unit would always discharge at full power – leaving the photographer to calculate flash exposure, depending on the aperture and the camera-to-subject distance.

TTL flash metering works by the unit only emitting the correct amount of light for the exposure settings selected and the prevailing shooting conditions. In basic terms, when you take a picture using TTL flash metering, the flash emitted strikes the subject then bounces back to the camera, exposing the image sensor. This light is measured by a sensor in the camera and, once it determines that sufficient light has amassed to form a correct exposure, the flash burst is terminated. Remarkably, all this occurs within a fraction of a second – at the speed of light.

Thanks to this technology, it is possible to pop-up your camera's integral unit, or attach a dedicated speedlight, and immediately begin shooting acceptably good flash images. However, as with non-flash TTL metering (see page 18), it is designed to render your subject mid-tone and – as previously discussed – this will not always record darker and lighter subjects faithfully. Therefore, whilst TTL metering is capable of excellent results, it cannot be relied upon in every instance. As with non-flash TTL metering, exposure compensation – or flash bracketing – may well be necessary to achieve the results you desire.

▶ **Barn owl**

Arguably, the most common exposure problem is a simple lack of light, preventing us from taking the image we want. When natural light is insufficient, flash is the answer. Thanks to the sophistication and accuracy of TTL metering, achieving correctly exposed pictures using flash is easier than ever before.

Nikon D70, 105mm, 1/200sec at f/8,
ISO 200 and SB800 speedlight.

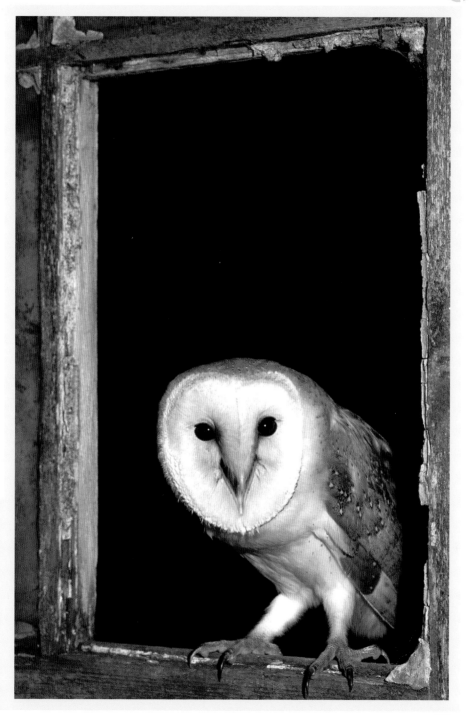

Flash basics

Flash light can be a powerful and essential tool. However, to make the best use of it, it is important to be familiar with the terms associated with using flash. For example, a unit's guide number refers to its maximum operating distance, so to ensure you always stay within its effective working distance, it is important to be aware of this number. Also the effect of the 'inverse square law', and the unit's recycling time, will dictate its reach and performance.

▼ *External speedlight*
This speedlight is typical of today's breed of sophisticated flashguns. With a high guide number of 38 (m/ISO 100), it boasts a good operating range. It also has a recycle time of just 2.7 seconds when its quick recycle pack is attached.

Guide numbers

The guide number (GN) of a flash unit is given by the manufacturer and indicates its power and operating distance. The number can be used to calculate the relevant aperture or – more commonly – the distance that the flash can effectively travel. The number is normally stated in feet or meters for a sensitivity rating equivalent to the camera's lowest ISO – normally ISO 100 or 200. The guide number can be used in two equations:

f-stop = GN/distance
distance = GN/f-stop

For example, if the guide number of a pop-up flash is 18 (ISO m/ISO 200), the effective operating distance for that particular flash unit can be quickly calculated by dividing the number by the f-stop selected. Therefore, if an aperture of f/4 is set, the effective range of the flash will be:

distance = 18/4 = 4.5m

The coverage of an external speedlight will exceed that of a pop-up unit, so it has a larger guide number. When buying a flash, it is worthwhile investing in a unit with the largest guide number you can afford, as this will provide the longest operating distance.

Flash recycle time

This is the length of time it takes for a flash unit to recharge its capacitors – and be ready for use – after being fired. Typically, this will only be a matter of seconds, but recycling time will be lengthened when the flash is fired at full capacity or when batteries are becoming exhausted. A quick recycling time is important when you need to shoot a number of frames in quick succession. The recycling time of some external speedlights can be shortened by attaching compatible power packs, which hold extra batteries and are designed to speed up recycling time – by as much as half – between bursts.

Exposure tip

Remember, a guide number is exactly that – a guide. It is not a power output value. Each manufacturer has a different interpretation to what constitutes acceptable exposure for the operating range. Some are more optimistic than others, so do your own tests to check the unit's effectiveness over varying distances.

▶ *Heather*

Due to flash fall-off – a result of the 'inverse square law' – a subject lit by flash will often have an artificially dark – or even black – background. This can betray the use of flash light, but in this instance it has helped emphasize the subject against a simple, non-conflicting backdrop.

- -

Nikon D200, 150mm, 1/250sec at f/4, ISO 100, SB800 speedlight and tripod.

- -

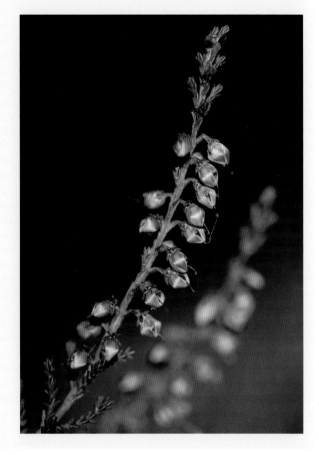

The inverse square law

When using flash it is useful to keep in mind the limitations imposed by the 'inverse square law'. This is a mathematical law, describing light fall-off owing to distance travelled. Simply put, it means that at a constant output the illuminating power of the flash will be the inverse square of the distance. This means that if you double the distance from a light source, the illumination is quartered – not halved as you might first think. For example, if you had two objects, one of which is 6½ft (2m) from a light source and the other 13ft (4m) from it, the object 13ft (4m) away will receive only a quarter of the light received by the nearer object. An object 26ft (8m) away would receive only a sixteenth as much light. This rate of fall-off is due to the way light spreads as it travels progressively further from its source.

All light sources follow this rule and it is the reason why foreground objects are much more brightly illuminated by a camera-mounted flash unit than distant objects. A modern flash unit is highly sophisticated and will try to compensate for fall-off, but its power (guide number) may limit the extent to which it can do so.

Built-in flash

Practically all digital SLR and compact cameras boast a built-in, pop-up flash unit. They are designed to provide illumination in situations where there isn't sufficient ambient light to correctly expose your subject. If the camera is set to automatic the unit will pop-up and fire when the exposure meter deems it necessary. This is usually when the shutter speed drops below a safe speed to handhold the camera without the risk of shake – for example 1/30sec. However, your integral unit can be useful in a wide variety of situations – to relieve ugly shadows or add a catchlight to your subject's eyes. Therefore, it is often only when you override the automatic settings that you will enjoy your built-in unit's full creative and corrective potential.

Many photographers overlook their camera's pop-up flash. However, it can prove a useful and convenient tool. Although not as powerful or flexible as an external speedlight, an integral unit will typically boast a GN of between 10 and 18 – powerful enough for illuminating most nearby subjects. It can be used when ambient light is inadequate; to add fill-in flash when backlighting is excessive; or to relieve ugly, dark shadows – regardless of whether you are shooting indoors or out. It is capable of producing excellent results, particularly when used in conjunction with flash exposure compensation (see page 134). However, to make the most of your camera's pop-up unit, and to ensure you use it appropriately, it is important to be aware of its limitations.

Compared to an external speedlight, which often boast a GN of 30 or more, they lack power. Therefore, there is little point trying to use one to illuminate distant objects as the flash will 'fall off' before reaching the subject. Depending on the

ISO you employ, they are normally best used with subjects within a 13ft (4m) range. Also, their position is fixed, so the flash burst can't be directed away from the subject in order to bounce the light off a ceiling or wall to soften its effect. Lastly, a built in flash can exaggerate the effect of red-eye (see page 141). This is because the flash is near to the optical axis of the camera and, as a result, the light strikes the subject's eyes at a similar angle to which the reflected light is entering the camera. It is the reasons above that lead photographers who regularly rely on flash to invest in a dedicated flashgun. However, if your budget won't stretch to the cost of a separate unit, or you rarely use flash at all, your camera's pop-up flash will prove useful and capable.

One of the biggest advantages of an integral flash is that it can be quickly activated whenever required, without the need to attach a separate unit or adding extra weight to your kit bag. Normally, it is possible to pop up the flash via a small button near the pentaprism – indicated by a lightning flash symbol. Lifting the flash will activate the unit and it will quickly charge and fire the next time the shutter is released. The unit is designed to work seamlessly with the camera's exposure metering, focusing and zoom systems, so the results are often accurate and pleasing.

Most camera's have a range of flash modes, typically: front curtain sync (see page 138), red-eye reduction (see page 141) and slow sync (see page 137). Exposure compensation can also be applied, adding to the pop-up unit's versatility. In my experience, integral units are also very useful for adding a small reflection of light to a subject's eyes. This is commonly known as a 'catchlight' and adds life and depth to portraits of people and animals. Whilst catchlights often appear naturally, when necessary, they can be created using your pop-up flash – applying a stop or two of negative flash exposure compensation to ensure that the results look natural.

Exposure tip *In your camera's fully automatic mode, the integral flash will pop up whenever the exposure meter deems there is insufficient light. However, a camera cannot recognize situations where a flash isn't required – for example, when shooting a sunset. In situations like this, flash is redundant, so switch to a different mode or switch the flash off.*

▶ Built-in flash

Most consumer digital SLR cameras boast a built-in pop-up flash, which can prove effective and useful in a wide range of shooting situations.

▼ Evie

A camera's speedlight is useful in a wide variety of shooting situations. In this instance, I used a small burst from the camera's pop-up flash to add catchlights to my daughter's eyes in this portrait shot. It gives the image more life and depth.

Nikon D300, 150mm, 1/300sec at f4, ISO200, pop-up flash and handheld.

External flash

An external speedlight offers far more versatility and power than the camera's built-in unit – proving a good investment for regular users of flash. There is a wide choice, varying in design, strength, sophistication and cost. The majority are auto-electronic systems, which operate by exchanging information with the camera via a proprietary digital data line. They are designed to operate in synchronization with the camera's internal metering – producing correctly exposed flash images with the minimum of fuss.

There are many advantages of using external flash, opposed to an integral unit. They are designed with a higher GN, enabling photographers to illuminate subjects from further away. Many speedlights boast a flash head that can swivel from side-to-side and be raised and lowered to offer more control over the flash's direction and enabling photographers to 'bounce' flash (see page 140). Some have a zoom head, which is designed to expand the flash beam when there is a wide angle of view, and narrow it at longer focal lengths in order to increase its useful range whilst maintaining coverage. Often they are designed with an integral diffuser panel that can be

pulled down in front of the flash head to diffuse the light emitted – particularly useful when shooting nearby subjects. Their flash recycle time is faster and using an external flash limits the effect of red-eye (see page 141), as the light source is further away from the subject's eyes. The majority of flashguns also feature an LCD panel, where settings can be easily altered and are displayed, and they boast an AF assist illuminator, which is activated in low light to project a patterned beam to aid the camera's auto-focusing and accurately lock onto the subject.

External flash units connect to the camera via the hotshoe mount, although they can be used off-camera – in order to simulate a more natural angle of light, for example – via a connecting cable or as a slave unit triggered by light. Although you can set flash output manually, the camera's automatic and TTL modes tend to be extremely reliable, ending the flash burst when the correct level of exposure has been reached. However, no form of metering is infallible. Flash output is affected by the reflectivity and tonal value of your scene or subject, so, just as with normal metering, your camera will attempt to record the subject as an average tone. Therefore, when photographing very light or dark subjects you may need to dial in positive or negative flash compensation (see page 134) to achieve a correct exposure.

◀ *Camera-mounted flash*
There is a wide choice of external units available to buy – ranging in strength, versatility, sophistication and cost. Dedicated units are best, so try to buy a speedlight produced by the manufacturer of your camera.

▶ *LCD display*
External units offer far greater versatility and control. Settings can be quickly altered via the unit's control panel, and the present settings are displayed in the speedlight's LCD.

Painting with light

This is a method involving a long exposure – of up to a minute or more – in near or total darkness. Then, whilst the shutter is open, the photographer manually illuminates the subject using an external flash – or torchlight. The resulting images have a surreal, mystical feel to them, created by the uneven illumination of the artificial light source combined with any remaining ambient light.

If taking pictures outdoors, it is best to shoot around an hour after sunset, when there is still some colour in the sky. There is no set rule regarding the length of exposure required. Due to its nature, this is a technique which is impossible to meter for with any great accuracy. Begin by using a 30-second exposure combined with a small aperture, although you may find that the best results are achieved at a minute or longer.

To create exposure times this long, it will be necessary to employ your camera's bulb setting (see page 52). With your camera set up on a tripod, release the shutter using either a remote release or the self-timer. By doing so, you can be in position ready to begin 'painting'. Although a torch can be used, a flashgun is a better method to illuminate larger objects. You will need to manually fire the flash – on full, by pressing the test button – repeatedly to create the effect. Walk around the subject directing the flash burst towards the areas you want lit. You can emphasize certain regions by giving them repeated flashes. It is important to keep moving as you 'paint' – otherwise you will be recorded in the picture. Practising the technique will teach you which exposures work best and how you should light the scene. However, you will never get the same result twice.

▼ Folly

Ruined buildings, mine shafts, gravestones and follies are among the subjects that can look striking photographed in darkness and then 'painted with light'.

Nikon D200, 10–200mm (at 14mm), 30secs at f/22, ISO 200, SB800 speedlight and tripod.

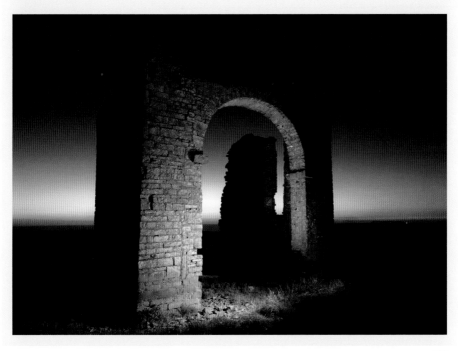

Macro flash

Close-up photography presents flash photographers with a fresh set of challenges. When working so close to the subject, the illumination from an everyday speedlight can prove too powerful, even if negative exposure compensation is applied. As a result, lighting can look harsh and unnatural. Another problem is that the burst from a camera-mounted flash can 'miss' or only partly expose subjects positioned near to the camera lens due to its (relatively) high, fixed position. The best way for close-up enthusiasts to artificially illuminate miniature subjects is to attach a dedicated macro flash. There are two main types of macro flash; ring/macro flash or twin flash.

Ring/macro flash

Unlike a conventional flashgun, a ring/macro flash is circular, attaching directly to the front of the lens via an adapter, while the control unit sits on the camera's hotshoe. This design enables the flash to effectively expose close subjects from all directions at once, providing even, shadowless light. However, in truth, the resulting light can look quite flat and unnatural, which is disappointing for creative

photography. To overcome this, many ring/macro flashes boast more than one flash tube, which can be controlled independently. This allows photographers to vary the output ratio between them and create more natural, three dimensional-looking results. Alternatively, you can improvise by using black tape to mask parts of the ring to vary the flash output.

Twin flash

Twin flash units work using a similar principle to a ring/macro flash. Instead of a ring, they consist of two individual flash heads that are mounted on an adapter ring attached to the front of the lens. The flash output can be varied between the heads to solve the problem of the flat, even light that is commonly associated with macro flash. However, they also have the added flexibility of being able to be moved and positioned independently. They can even be removed from the mounting ring altogether and be handheld or attached to, for example, a tripod leg. The heads can be fired together or individually, providing even greater flexibility and creative possibilities. They're relatively lightweight and compact and are arguably the most versatile form of flash available. However, they produce twin catchlights, which can look unnatural. Due to the fact that macro flashes are intended to illuminate close-up subjects, they normally have a small GN and are most effective within a range of 3ft (1m).

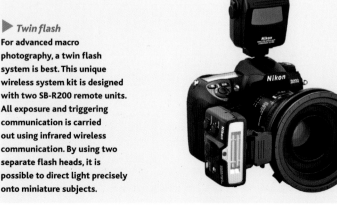

▶ *Twin flash*
For advanced macro photography, a twin flash system is best. This unique wireless system kit is designed with two SB-R200 remote units. All exposure and triggering communication is carried out using infrared wireless communication. By using two separate flash heads, it is possible to direct light precisely onto miniature subjects.

Ring/macro flashes can also be used for portrait and fashion photography. Not only do they help remove shadows, which otherwise can be unflattering and emphasize wrinkles, but the unique way that ring/macro flashes render light can give models a 'glowing' appearance.

▶ Macro flash

Ring/macro flashes are designed to produce even, shadowless light to illuminate close-up subjects. They are ideally suited to macro enthusiasts, although, being a specialized piece of kit, can prove quite costly.

▼ Common darter

Light is often severely restricted when shooting in such close proximity to the subject – particularly when photographing natural history. Macro flash units are specifically designed to illuminate small subjects. By varying the output of a twin flash unit, natural looking results are possible to achieve.

- -

Nikon D200, 150mm, 1/250sec at f/4, ISO100, SB R1C1 and tripod.

- -

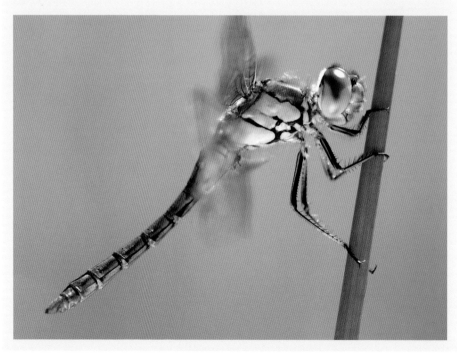

Fill-in flash

When using flash, it doesn't have to be the primary light source for exposure. 'Fill-in' or 'fill' flash is a technique where a flash burst is used to supplement the existing light – typically to brighten deep areas of shadow outdoors on sunny days. Whilst it is easy to presume that flash is only useful in low light conditions, in reality it is an essential tool in a variety of photographic situations – for example, to relieve dark shadows in bright light, to reduce harsh contrast and to brighten dull images.

Arguably, fill-in flash is the most important flash technique to be familiar with, giving images more life, yet retaining a natural feel. You could consider it to be like a form of portable reflector – shining a little extra light into certain regions. Fill flash is popular with portrait photographers working in daylight – particular when the sun is directly overhead, which casts ugly shadows under the model's nose, lips and eye sockets. However, it is useful in any situation where shadow is obscuring subject detail, or when the background is significantly brighter than the foreground. To give you an example, if photographing a portrait of someone wearing a hat outside, say at a wedding, the rim will likely create a distracting shadow directly across the subject's eyes. Fill flash will help you even out the exposure across your subject's face, without overexposing the rest of the frame.

Before modern electronics existed, calculating fill flash manually could prove complex, requiring balancing the flash and existing light to give a daylight-to-flash ratio of approximately 1:4. Today, it is straightforward, with the camera and dedicated speedlight communicating with one another in order to adjust flash output to achieve a natural balance

between the main subject and the background. Essentially, using fill flash doesn't alter exposure settings – its role is to relieve areas of shadow that would otherwise appear too dark in the final image. The aperture and shutter speed are set to correctly expose the background, while the flash is fired to illuminate the foreground subject. Therefore, meter as you would normally, with exposure time being dictated by the amount of light already present within the scene.

To help you decide whether fill flash is appropriate or not, ask yourself the following questions – is my subject (or part of it) in shade, or, is there more light behind the main subject than in front of it? If the answer to either of these is yes, then you need to consider whether you are near enough to the subject for the flash burst to be effective. Presuming that you are, attach a dedicated external speedlight or pop up your camera's built-in unit. The majority of speedlights have a specific fill-in mode, designed to emit just enough flashlight to relieve the shadows. However, monitor the results carefully, as you may want to alter the camera's automatic settings to ensure the best results. Fill-in flash often looks most natural when the output is approximately a stop darker than the ambient light. If the flash-to-daylight ratio is too even, or if the flash begins to overpower the existing light, the overall balance looks false and betrays the use of flash. By using the camera's flash compensation function – or by dialling in positive or negative compensation on the speedlight itself – it is possible to increase or decrease the burst emitted to create just the result you desire. By adjusting the output of the flash unit in this way, you are effectively altering the flash-to-daylight ratio. Generally speaking, photographs taken in bright light require more fill-flash to relieve the shadow areas than images taken in shade or on an overcast day.

Exposure tip

Fill-in flash isn't just useful for portraits. Close-up and flower photographers will often employ a small burst of flash to open up shadow detail and it is also useful for images of architectural detail.

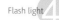

▼ *Fill-in flash*

Fill-in flash is useful to relieve harsh shadows, particularly when shooting portraits on sunny days, when overhead sunlight can create ugly shadows underneath facial features. Here, the first image (1) was taken without flash, whilst for the subsequent frame (2) a burst of fill-in flash was used.

Nikon D300, 24–85mm (28mm) 1/250sec at f/7.1, ISO 100, SB800, handheld.

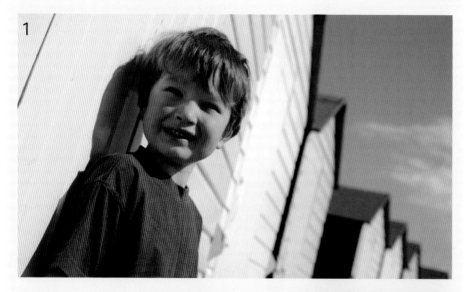

Flash exposure compensation

Although TTL flash metering is reliable in the majority of shooting situations, it can still be deceived. As with normal TTL metering (see page 18), your camera attempts to record subjects as mid-tone. Therefore, if you are using automatic TTL flash, the camera will effectively underexpose light subjects and overexpose dark subjects in order to render them with average tonality. The simplest way to correct this is to apply flash exposure compensation.

Flash exposure compensation is similar in principle to exposure compensation (see page 60). It is a common feature on DSLRs and should be applied if the flash level automatically set by your camera proves incorrect. When flash exposure compensation is applied, no changes are made to aperture, shutter speed or ISO – only the level of flash emitted is altered. Positive compensation (+) increases the burst – making the subject appear brighter – whilst negative compensation (-) reduces flash output – making the subject darker and also reducing highlights and reflections.

Due to the way cameras attempt to render subjects as mid-tone – underexposing light subjects and overexposing dark ones – you actually need to

apply positive compensation when photographing light or white subjects, and a negative amount when shooting subjects darker in tone. For example, if you are photographing a white flower, or a bride in her wedding dress against a light coloured wall, you would actually need to increase the flash burst – contrary to what your instincts might tell you. Naturally, the amount of compensation you need to apply will depend on the tonality of the scene or subject. Most digital SLRs will allow you to set a flash compensation value of between -3EV (darker) and +1EV (lighter) in increments of 1/3EV. Experience will help you identify just how much compensation is required in any given situation, but at first you may need to experiment or even 'bracket' flash output to achieve the correct level of exposure.

Flash exposure compensation allows you to control the balance between flash and ambient light. Therefore, it is a function that can be used creatively as well as for corrective purposes. Using flash compensation you can exert more creative influence on your images. The more the flash burst dominates the ambient light, the more artificial the effect is. Therefore, for subtle results, employ negative compensation, and for more dramatic effects apply a positive amount. As you use flash more, and grow familiar with its effects, the sooner you will begin to intuitively recognize just when positive or negative compensation is required.

▼ - 2EV

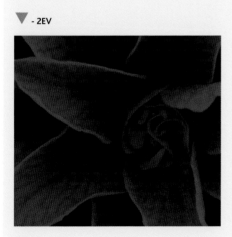

▼ - 1EV

Flash compensation shouldn't be confused with exposure compensation. Exposure compensation alters the exposure for ambient and flash light, whilst flash compensation doesn't alter how the existing light is recorded – just the output of the flash.

Exposure tip

Flash bracketing

Flash bracketing is recommended in tricky lighting situations, where it is difficult to set exposure confidently and there is not time to scrutinize results on the camera's LCD and adjust the settings accordingly. It works in a similar way to normal bracketing (see page 60) – just the flash output is altered with each subsequent frame, opposed to the exposure value. The majority of DSLRs are designed with a specific flash bracketing facility, where you can select the number of shots in the sequence and also the flash exposure increment. Some cameras will allow you to shoot a sequence of up to nine frames – automatically adjusting flash intensity after each shot. However, in most situations a series of three images – one taken with negative compensation, another with no compensation applied and a third with a positive amount – will suffice.

Bracketing is a particularly useful feature if you are a beginner to flash photography, helping you find the most pleasing combination of ambient and flash light.

▼ *Flash bracketing*
You can increase or reduce the light emitted by your speedlight by setting either positive or negative compensation. It can be worthwhile bracketing flash output to ensure you achieve just the effect you desire.

Nikon D300, 150mm, 1/180sec
at f/18, ISO 200, Nikon SB800 and tripod.

▼ **0EV**

▼ **+1EV**

Flash modes

Digital cameras offer a choice of flash modes, designed to suit different subjects and shooting situations. They enable photographers to capture more creative and imaginative results than may have been possible by simply relying on standard auto-flash mode.

High-speed sync

High-speed synchronization or focal-plane (FP) flash is when the speedlight's output is pulsed at an extremely high rate to simulate a continuous burst. In this mode, it is possible to synchronize flash exposure with shutter speeds faster than the normal limits of the camera's X-sync speed. Although not all DSLRs offer this function, this mode is useful in a variety of situations. For example, if you want to employ a burst of fill-in flash (see page 132) to relieve harsh shadows, but also want to select a large aperture to throw the background out of focus. The wide aperture will let in more light, but you can't increase shutter speed to allow for this without exceeding the camera's flash sync. High-speed sync is the solution, allowing the desired faster shutter speed to be selected. The drawback of using this type of pulsed light is that the effective range of the speedlight is reduced by as much as a third. Also, despite its name, the continuous nature of pulsing light isn't able to freeze movement in the same way a single, powerful burst can.

▼ *Flower*
Focal-plane flash is ideally suited to situations where you wish to employ a faster shutter speed than the camera's flash sync will allow. In this instance, I wanted to select a large aperture to create a narrow depth of field, but as a result of setting an f-number of f/4, the shutter speed exceeded the flash sync. However, by using high-speed sync, I was able to employ a small 'kiss' of flash, which I required to relieve the shadows.

Nikon D200, 150mm, 1/400sec at f/4, ISO 100, SB800 speedlight and tripod.

The trick, when using any mode of flash, is to ensure that the artificial burst doesn't overpower your subject. For this reason it is often worth applying a small degree of negative exposure compensation, in the region of a 2/3 of stop.

Exposure tip

Slow-sync

Slow sync is a technique where the flash is fired in combination with a slow exposure and is most commonly used at night. The flash burst correctly illuminates the foreground subject, whilst the long shutter speed enables the sensor to record ambient light and detail in the background. Also known as 'dragging the shutter', this form of mixing flash and existing light can create some striking results – particularly if there is subject movement, which will create light trails and ghosting – whilst still retaining the mood of the setting. You should meter for the scene as you would normally, selecting your camera's

slow-sync mode – or camera's 'night portrait' pre-programmed exposure mode, if it has one – in order to expose the foreground subject correctly. Study the results, and apply flash compensation if you feel it is needed. As this technique relies on using a shutter speed of several seconds or longer, the use of a sturdy tripod is essential to keep the camera still during exposure. It is also worthwhile using a remote release, or your camera's self-timer function, to ensure that you don't create any camera movement when releasing the shutter.

▼ *Slow-sync*

Slow sync flash is ideal in situations where you wish to record the ambient light, but need a burst of flash to expose a foreground subject. Here, I employed slow-sync flash to illuminate a statue, whilst the long exposure correctly exposed the background and captured the trails of passing cars.

Nikon D300, 12–24mm (at 12mm), 20secs at f/20, ISO 100, SB800 speedlight and tripod.

Front- and rear-curtain flash

The point at which the flash triggers during exposure can have a big impact on the final result. If it fires at the beginning of the exposure (front-curtain sync) any subsequent motion will appear to be in-front of the subject; whilst if it flashes just before the shutter closes again (rear-curtain sync) the motion will appear to trail the subject. Therefore, before you begin taking pictures, you need to decide which flash effect will suit your subject or scene best.

Front- and rear-curtain sync

The majority of DSLR cameras have a focal-plane shutter, designed with two curtains – a front and rear curtain. The front curtain opens to begin exposure, whilst the rear curtain slides closed to end

it. Front- and rear-curtain sync – also known as first- and second-curtain synchronization – allows you to select whether the flash is fired at the beginning or end of the exposure.

In front-curtain sync mode, the flash is triggered the instant the shutter is fully open, freezing any subject motion at the beginning of the exposure. This is suitable in most situations and is often the camera's default setting. However, during longer exposures of moving subjects, a light trail will be recorded in-front of your flash illuminated subject – creating the impression that the subject is moving backwards. This effect can look rather odd. Therefore, in situations like this, it is normally best to select rear-curtain sync instead. This mode fires the flash at the end of exposure, just before the shutter closes. As a result, the light trails appear to follow the moving, flash-exposed subject, creating more natural-looking images.

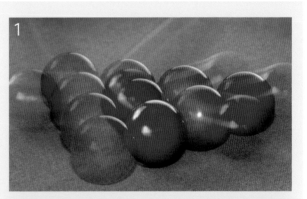

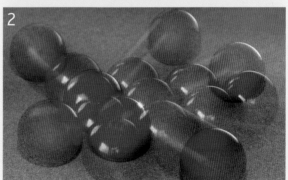

▶ *Front- and rear-curtain sync*
When using the default setting of front curtain flash to photograph moving subjects, the motion trail appears to be in front of the subject (1), which can look odd. By selecting rear-curtain sync, the light trail, or ghosting, will appear to follow the subject (2) and appear more natural.

Nikon D70, 105mm, 1sec at f/18, ISO 200, SB800 speedlight, tripod.

Flash sync speed

The duration of a flash burst is only a matter of milliseconds, so timing is crucial. It must occur when the shutter is fully open – if the flash is triggered whilst the shutter is in the process of opening or closing, then the resulting image will only be partly exposed. This is due to the design of a shutter mechanism. The shutters incorporated in SLR cameras are equipped with a pair of moving curtains. They move vertically across the image area, as opposed to horizontally, as the distance is less to travel. At fast shutter speeds the opening is actually a slit between the two curtains – travelling the height of the image area. However, this presents a problem when using flash, as if only a narrow slit is exposed at the moment the flash fires it is not possible to illuminate the entire image area. An electronic flash burst is always much briefer than the camera's fastest shutter speed. Therefore, full synchronization – where the flash burst will expose the entire image area of the sensor – is only possible within a limited shutter speed range. You will be overridden by the camera if you try to select a shutter speed that exceeds this range. The maximum synchronization speed is commonly known as the 'flash sync' or 'X-sync'. Some cameras are faster than others, but typically the flash sync speed is upwards of 1/125sec.

▶ *Postman*
Using flash to photograph moving subjects can create some striking, surreal effects. This image of a postman starting his round was created by using a burst of rear-curtain sync.

Nikon D70, 18–70mm (at 18mm),
1sec at f/5, ISO 200, SB800
speedlight and tripod.

Bounce flash

Direct flash, where the flash head is aimed directly at the subject, can create quite harsh, unflattering light. Flash is a relatively small light source, so it creates quite hard-edged shadows that draw attention to the use of flash light. One way to soften the light of on-camera flash is to spread it over a larger area. The most effective and simple way to do this is to 'bounce' the light.

Bounce flash is a technique where the flash head is intentionally positioned to provide indirect light onto the subject. It is best to 'bounce' the light off a large white surface, like a wall, ceiling or large portable reflector, otherwise the bounced light will adopt the colour characteristics of the surface it strikes. Not only is bounced light more diffused and flattering, but it reduces distracting hotspots and, if you are shooting portraits, eliminates the risk of red-eye as the flash light is not directed on the subject-to-lens axis.

In order to bounce flash, you need an external speedlight designed with a head which tilts and swivels – your integral unit won't work as its position is fixed. Naturally, the direction in which you bounce the light will have a bearing on the end result, and will be dictated by the position of the nearest, most convenient surface.

Bouncing flash off a ceiling

Tilt the flash head towards the ceiling, at a 75–90-degree angle. It will act like a giant reflector, bouncing light downward to evenly expose your subject. However, the disadvantage of this method is that if you are shooting portraits, you may notice some shadow beneath the eyes, nose and lips due to the way the subject is effectively lit from above.

Reverse bouncing

This method involves directing the flash head at a 45–75-degree angle backwards over your shoulder, to bounce light off both the ceiling and wall behind you. This will give you a greater level of diffusion and the light reflecting off the wall will relieve any shadow that may be caused by the light reflected downward from the ceiling. However, a lot of light is lost when doing this.

Bouncing flash off a wall

This form of side bouncing involves swivelling the flash head 90 degrees sideways towards the nearest wall. The wall acts like a large softbox. This form of bounced light appears more directional, creating areas of shadow and light, and therefore gives images more depth.

▶ *Bounced flash*
More natural results are possible by bouncing the flash off a nearby white wall or ceiling. You will diffuse the flash light and soften the hard shadow. Here, (1) was shot using direct flash, while (2) was taken by bouncing the burst off the ceiling.

Nikon D300, 150mm, 1/125sec at f/11, ISO 200, SB800 speedlight and tripod.

▼ Baby girl

Bounced flash is ideal when shooting family portraits indoors. The resulting light will look far more natural and help disguise the use of an artificial flash burst.

Nikon D200, 105mm, 1/180sec
at f/5.6, ISO 100, SB800 speedlight.

There are a number of flash accessories available, which are specifically designed to bounce or diffuse the typically harsh lighting of direct flash (see page 126).

Exposure tip

Exposure

The drawback of bouncing flash is that a certain amount of light is scattered or absorbed – typically, around two stops. Also, the light has to travel further in order to reach the subject, reducing the effective range of your speedlight. For the best results, you need to be within just a few metres of the surface you intend bouncing from. However, unless you are using your flash manually, there is no need to worry about compensating exposure time. The camera is measuring the light entering through the lens, so accounts for the extra distance the flash has to travel and also for the light which is lost. Therefore, in auto or TTL mode, dedicated units will automatically adjust flash output – presuming that you stay within the flashgun's effective range, with an appropriate ISO and aperture selection.

Red-eye

Most snappers are familiar with the effect of red-eye. It is a phenomenon where people's eyes appear red in photographs where flash is the principal light source. This is caused by the artificial burst reflecting off blood vessels at the back of the subject's retina. The effect of red-eye also affects certain animals, and, whilst it can be corrected using post capture software, it is best to avoid it in the first place. There are various ways to limit its effect. Placing the flash away from the camera's optical axis will ensure that the artificial burst strikes the eye at an oblique angle. Therefore, if possible,

avoid using your camera's integral flash and instead use an external speedlight. Also, bounce the flash if possible, so that only diffused light enters the eye. To help minimize the risk of red-eye, most digital cameras – compact and SLR – feature a built-in red-eye reduction facility. Normally, this works by emitting a series of short, low power pre-flashes in order to contract the iris. Failing this, some cameras have the facility to correct red-eye in camera, although, generally speaking, this isn't as reliable as using the red-eye removal function built in to many photo editing programs.

Flash accessories

As mentioned previously in this chapter, one of the drawbacks of using flashlight is that it can cast hard shadows, drawing attention to the use of flash and looking artificial. Whilst it may be possible to bounce the flash and diffuse it this way, this is not always an option. Thankfully, there is a wide range of useful flash accessories available to buy – designed to help your flash exposures look more natural and intended to help you realize the full creative potential of your speedlight.

Diffusers

Although many modern speedlights are designed with an integral, flip-down diffuser panel, it is still worthwhile investing in a dedicated diffuser. They greatly help to reduce the bursts' intensity, softening shadows, reducing the risk of red-eye and creating more natural-looking results overall. They are available in a wide range of designs; however, each is intended to do the same job – fitting over the flash head to make the output appear less intense. The most popular type is a push-on diffuser. This is a hard plastic diffuser which is available to fit different speedlights. You can now also buy a version which is compatible with a DSLR's pop-up unit.

Another popular type of diffuser is a mini softbox design. Again, it fits directly to the flash head, but the larger design gives a wider, softer and more even diffusion.

The drawback of using any type of diffuser is that, due to the way they absorb light, they reduce the effective range of the flash. As a result, they are best used when shooting relatively close to the subject – for example indoors or in a studio environment.

▼ *Diffuser*
A diffuser is an essential flash accessory, which works by softening the intensity and harshness of the flash burst. They are available in a wide variety of designs – it is even possible to buy versions that are compatible with your camera's pop-up unit.

▼ *Softbox diffuser*
Mini softbox type diffusers are designed for hotshoe mounted flash. They help eliminate red-eye and soften harsh light. They are quick and easy to use and require no additional adaptor or bracket.

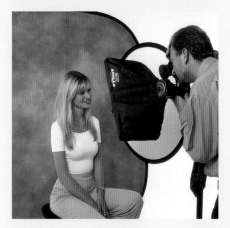

It is possible to buy coloured 'gels', which attach to the flash head in order to alter the colour of the light emitted. They can be used for either colour correction or to create dramatic colouring effects for creative purposes.

Exposure tip

Extenders

Flash extenders are designed to increase a flash's range. They concentrate the burst of artificial light via a precision fresnel lens – a concept designed originally for lighthouses – effectively gaining two or three stops of light. They attach directly to a flash head and are best combined with longer focal lengths – upwards of 300mm. Therefore, they are most popular with sports and wildlife photographers who have to shoot subjects from further away.

Presuming you are using TTL metering, there is no need to adjust your exposure settings when using an extender as the camera will do this automatically. However, always ensure that there is a clear, visual path between the flash and the subject you are photographing, as anything in between is likely to appear grossly overexposed – receiving too much light – due to the inverse square law (see page 125).

Flash brackets and arms

Although flash can provide very natural-looking lighting, particularly when it is diffused in some way, it can also create harsh-looking light. One way to rectify this is to alter the position and angle of the flash, which can reduce or exaggerate the shade, depending on the effect you require. To minimize shadow, by casting below the subject, the flash is best mounted above and directly behind the optical axis. However, this can create a very flat-looking quality of light. Often, it is better to position the flash to the side of the lens. By doing so, shadows are cast in one direction, creating more depth and life. Hotshoe-mounted flash can prove severely limited when you require this type of creative control over the direction and effect it gives. To overcome these limitations, it is possible to mount your flash off-camera using a dedicated flash arm or bracket. There is a wide range available; designs and flexibility vary depending on the make or model.

▶ *Flash bracket*
Compared to having your speedlight hotshoe mounted, flash brackets and arms provide far greater lighting flexibility. They allow you to be more creative in the way you position and direct your burst of artificial light. For example, this flash bracket allows you to position your speedlight in an infinite number of positions.

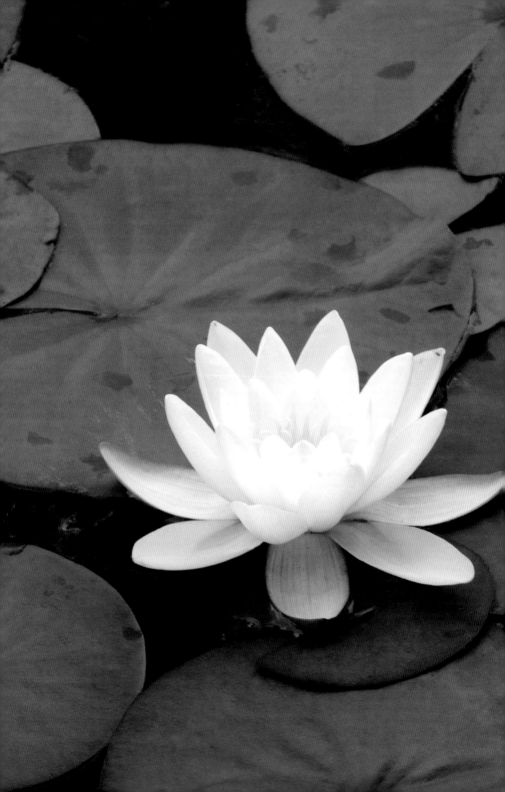

5 Filters

Filters

Whilst it is true that digital capture has negated the need for some traditional, in-camera filters, they remain an essential creative and corrective tool for digital photographers. A camera's white balance setting may be a far more convenient method of correcting the light's colour temperature than attaching a colour balancing filter, but the role and necessity of many other filter types remains unaltered. For example, the affects of a polarizer (see page 154–157) or neutral-density filters (see page 150–151) are impossible to mimic post capture. Essentially, filters are designed to manage light; therefore digital photographers need to be aware of their effect on exposure before they begin using them. There are a wide range of different types available, but this chapter is dedicated to the filters most relevant and useful to photographers today.

The advent of digital has affected the sale of filters, with many photographers believing that their effects can be added post capture instead. While some can be replicated using imaging software like Photoshop, there are benefits to filtering the light at the time of exposure and in-camera filtration shouldn't be overlooked. Filters are particularly useful for photographing landscapes, but can benefit all forms of photography. Personally, I always keep a polarizer, neutral-density and graduated neutral-density filter in my camera bag.

The effect of using filters can be very seductive. However, it is important not to rely too heavily on them. It can be easy to begin using them simply through habit – attaching a filter in the wrong situation or when it isn't really needed. This will have the opposite effect to what you intend – degrading, rather then enhancing a photo. It is important to remember that sometimes it is best not to attach a filter at all. They cannot miraculously transform a bad image into a good one – the light, composition and conditions need to be suitable first. However, used correctly and intelligently, they will enhance your photography.

Filter factor

Due to their design, many filter types reduce the amount of light reaching the sensor. This is known as the 'filter factor' – a measurement indicating the degree of light that will be absorbed. The higher the 'filter factor' the greater the light loss and if the exposure settings are not adjusted accordingly, the resulting photograph will be underexposed (see page 34). TTL metering measures the actual light entering the lens. Therefore it will adjust for the filter factor automatically. However, it is still useful to be aware of the effect filters are having on exposure.

The 'filter factor' should be stated either on the filter, its mount or packaging. The table below lists the amount of light that a handful of the most popular filter types absorb.

Filter:	Filter factor:	Exposure increase:
Polarizer	4x	2 stops
ND 0.1	1.3x	1/3 stop
ND 0.3	2x	1 stop
ND 0.6	4x	2 stops
ND 0.9	8x	3 stops
ND grads	1x	None
Skylight/UV	1x	None
Soft focus	1x	None
Close-up	1x	None

▶ *The effect of filtration*
**Digital capture may have
negated the need for some
filter types, but filters remain
an essential tool for creative
photographers. The following
images help illustrate how they
can be used to enhance a scene –
for the first image (1) no filters
were attached, whilst for the
second shot (2) a polarizer and
an 0.9 ND grad were used.**

Nikon D300, 12–24mm (at 14mm),
2secs at f/20, ISO 100, polarizer,
0.9 ND grad and tripod (2 only).

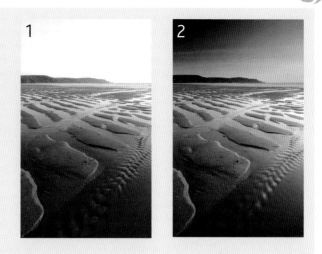

Vignetting

Vignetting is a common and frustrating filter-related problem. It occurs when the light is obstructed from reaching the edges of the frame during exposure. The result is a photograph with visible darkening at the corners. Commonly, vignetting is the result of using a polarizer with a deep mount, or stacking two or more screw-in filters together, in combination with a wide focal length. However, it can also occur if a filter holder (see page 148) is positioned at an angle, instead of straight. Super wide-angle lenses are particularly prone to this problem and vignetting will almost certainly occur when combining filters with a focal length below 18mm. You might think that the effect would be obvious when you look through the viewfinder. However, it can easily go undetected, due to the fact that many digital SLR viewfinders only display around 88–97% of the total image area. The solution is to buy filters with ultra thin mounts and avoid using two or more screw-in filters at one time. Also, scrutinize your results via image playback, zooming into the picture's corners to check for darkening. It is sometimes possible to remove the effects of vignetting post capture, using the Clone or Heal tool in Photoshop.

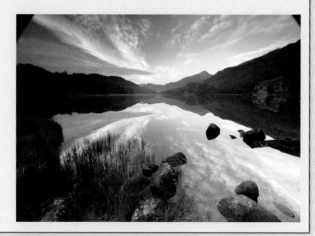

▶ *Vignetting*
**Darkening of the corners of the
frame is a common problem
when using ultra wide-angle
lenses in combination with
filters and filter holders.**

Slot-in or screw-in filters?

Filters are available in two distinct types; screw- or slot-in. Screw-in filters are circular in design and attach directly to the front of the lens via its filter thread. Slot-in filters are square or rectangular pieces of glass – or optical resin – which attach to the lens via a dedicated filter holder. Photographers new to using filters might assume that you either opt for one filter type or the other. However, both systems have individual benefits and drawbacks. Therefore, regular filter users will often employ a hybrid system, using a combination of both traditional screw-in-type filters and a modular slot-in system.

Screw-in filters

Circular screw-in filters are produced in specific filter threads – for example, 52mm, 58mm, 67mm and 77mm are all popular sizes. Therefore, it is important to buy filters that match the thread size of your lens. This isn't a problem if all the focal lengths in your system happen to share the same filter thread. However, the likelihood is that they will have a variety of fits, resulting in a compatibility problem. Whilst you could buy a set of filters for each thread size, this isn't economical or practical. Instead, step-rings offer a simple solution. They are designed to adapt a filter to a lens, when the two have differing diameters. For instance, if you had a 67mm screw-in filter, but wanted to attach it to a 58mm lens, the appropriate step-down ring would allow you to do this. Step-down rings are a cost-effective way to expand the compatibility of larger filters. However, step-up rings are normally best avoided, as they enhance the likelihood of vignetting (see page 147).

If you decide to invest in a system of circular filters and step-rings, remember you will need to buy a set of filters that fit the largest diameter lens in your current system. This could be up to 77mm or 82mm in size. Not only will the initial outlay prove costly, but filters of this diameter will prove bulky in your camera bag. Instead, many rely on the versatility of using a slot-in system, buying only two or three essential screw-in filters.

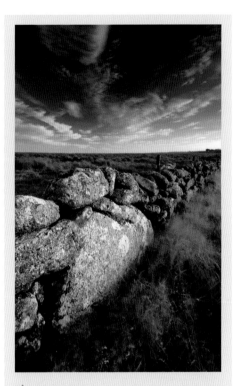

▲ **Stone wall**
Like many photographers, I use a hybrid system, employing both screw- and slot-in filters. In this instance, I combined a circular polarizer with a neutral-density slot-in-type filter. The polarizing filter helped saturate the blue sky, whilst the ND lengthened shutter time to intentionally blur the swaying grasses in the foreground.

Nikon D200, 10–20mm (at 14mm),
2sec at f/22, ISO 100 and tripod.

Slot-in filters

The advantage of using a slot-in system is that you can use the same filters and holder on all the lenses in your set-up. This is possible via adaptor rings, which are inexpensive and available to fit different thread fits. The adaptor rings attach directly to the holder, but can be removed quickly should you need to swap the holder and filters from one lens to another. Also, due to the holder's design, it is possible to employ two or three filters together without increasing the risk of vignetting. Holders are normally designed with three filter slots, making it possible to combine technical and creative filters together to achieve different effects.

Without doubt, a slot-in system is the most cost-effective, compatible and versatile method to apply in-camera filtration – simply speaking, it is the

best long-term investment for regular filter users. Not only is a slot-in system expandable, but filters can be slid into position and removed quickly – vital if the light, or conditions, are quickly changing. There is a variety of systems on the market, by popular filter brands like Cokin, Lee and Hitech. Typically, they are available in three progressive sizes – 67mm 84/85mm and 100mm – designed to cater for different budgets and capabilities.

It is best to opt for the largest filter system that you can justify buying, as smaller holders will not be compatible with larger diameter lenses and the risk of vignetting is greatly increased when using wide focal lengths. A 100mm system is a good long-term investment for landscape photographers.

▼ *Filter system*

At the hub of a slot-in system, is the holder. Normally it will have two or three slots, allowing you to employ a combination of filters. An adaptor ring is needed to attach the holder to the thread fit of the lens. Some holders are adapted to also hold a circular polarizer.

▼ *Screw-in filters*

Screw-in filters are available in a variety of sizes and types. Whilst they might not offer photographers the same level of flexibility as a slot-in system, with the addition of step-rings they can be used with different diameter lenses.

Neutral-density (ND) filters

Neutral-density (ND) filters are one of the most important and regularly used filter types. They are designed to reduce the amount of light entering the camera and reaching the sensor. By doing so, they can be employed to artificially lengthen exposure time. This can be useful in situations where there is too much light and you wish to employ a narrower aperture than the light or camera capabilities will allow. However, ND filters are more commonly used to lengthen shutter time to emphasize subject movement, creating the impression of movement for artistic effect.

ND filters have a neutral grey coating which is designed to absorb all the colours in the visible spectrum in equal amounts. By doing so, they do not create a colour cast of any kind – altering only the brightness of light, not its colour. They are produced in a range of densities, to suit different conditions and purposes and in both slot- and screw-in types.

Their strength is printed on the filter, or mount – the darker their shade of grey, the greater their absorption of light. A density of 0.1 represents a light loss of 1/3 stop. They can be bought individually or in a set – typically comprising of a 0.3 (1-stop), 0.6 (2-stop) and 0.9 (3-stop) strengths. If required, two or more can be combined to manufacture an even greater light loss. However, a 0.6 ND – equivalent to a 2-stop reduction in light – is normally adequate in most situations where you wish to artificially lengthen shutter time. For instance, it will allow

▼ *Blurred water*
In order to generate a shutter speed long enough to create this moody-looking shot of the rising tide and silhouetted rocks, I attached a 0.9ND filter to absorb the ambient light. Whilst the effect is highly subjective, personally I like the atmospheric looking results.

Nikon D200, 18–70mm (at 50mm), 10secs at f/18, ISO 100, 0.9 ND filter and tripod.

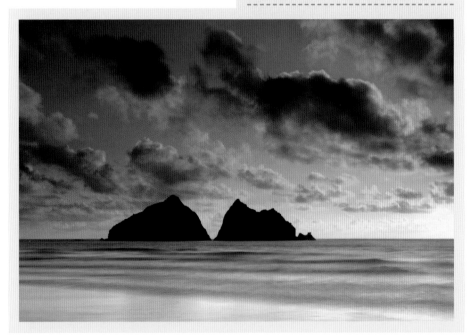

ND filters significantly darken the camera's viewfinder, making composition and focusing tricky. Therefore, only attach the filter after you have arranged your shot – remembering to adjust your exposure settings before releasing the shutter.

Exposure tip

a shutter time of one second, opposed to one of 1/4sec, or the use of an f-stop two stops wider; a significant shift, which has the potential to vastly alter the appearance of the resulting shot.

Intentionally emphasizing movement is a powerful aesthetic tool (see page 70). Traditionally, ND filters are most popularly used to create lengthy exposures to blur the movement of running water, for example a waterfall or rising tide. This is a favourite technique among many outdoor photographers, as the water adopts a milky white ethereal-looking blur, which can help produce atmospheric-looking results. However, ND filters can also be used to creatively blur – among other things – the movement of people, flowers, or wildlife.

No other filter type has a greater effect on exposure than neutral-densities. However, presuming you are using your camera's internal TTL meter, you will not need to make any manual adjustments – the

meter will automatically adjust for the filter factor (see page 56) of the filter attached. If you are using a non-TTL meter, then remember to adjust the reading by the strength of the filter in use.

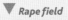

▼ Rape field

By artificially lengthening exposure time, ND filters are capable of dramatically altering the appearance of moving subjects. For image 2, I attached a 0.9 ND filter – equivalent to three stops of light – to enable me to emphasize the movement of a crop of swaying rape.

Nikon D200, 10–20mm (at 14mm), 1sec at f/22, ISO 100, 0.9 ND filter and tripod (2 only).

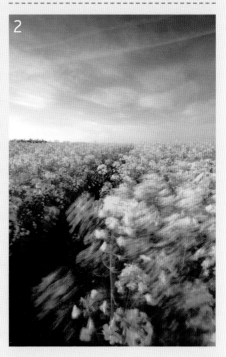

5

Graduated neutral-density (ND) filters

Have your scenic photographs ever suffered from washed-out skies, or dark, underexposed foregrounds? It is a common headache for landscape photographers caused by the difference in brightness between the land and brighter sky. Depending on the light, this imbalance can be equal to two or three stops. The most popular solution, in order to lower the contrast between sky and land, is to attach a graduated neutral-density filter.

Graduated ND filters are half-clear, half-coated, with a transitional zone where they meet. They work using the same principle as an ordinary neutral-density, with the coated area absorbing light. However, when using an ND grad, it is possible to block light from only a portion of the image-space, as opposed to all of it. This is ideally suited to shooting scenics where the sky is typically brighter than the land below. This contrast in light will often exceed the camera's dynamic range (see page 32). Therefore, if you meter to correctly expose the sky, the foreground will be too dark; whilst if you expose for the land, the sky will be overexposed and devoid of detail. An ND grad can be positioned to balance this contrast in light – helping to achieve a correctly exposed image overall.

Like ND filters, grads are available in a variety of densities to suit different lighting conditions and in both screw- and slot-in types. However, I

▼ 0.3 (1 stop)

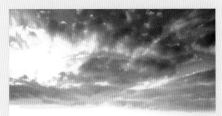

▲ *Hard grad ND set*
'Hard' ND grads are best suited to scenes with a relatively straight horizon, where the transitional zone – between the neutral density coating and clear area of the filter – can be accurately aligned with the skyline.

▶ *Graduated ND comparison*
When shooting landscapes, the foreground will normally be darker than the sky. The most popular method to balance the light – and achieve a correct exposure overall – is to employ graduated ND filtration. Graduated ND filters are available in a variety of strengths, to suit different lighting situations with 0.1 being equivalent to 1/3 stop. Sets are available in 0.3 (1-stop), 0.6 (2-stop) and 0.9 (3-stop) strengths – their effect can be seen in this progressive sequence.

Nikon D200, 10–20mm (13mm) 1/2sec at f/14, ISO 100, polarizer and tripod.

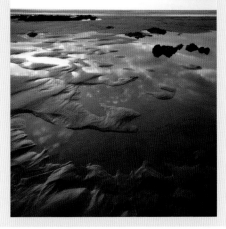

wouldn't recommend using circular, screw-in ND grads. This is because, once screwed onto the lens, the position of the transitional zone is fixed and cannot be altered. This dictates where you place the horizon in your photograph, greatly restricting your options. Instead, it is better to opt for a slot-in ND grad. In conjunction with a filter holder, they can be slid up or down into position so that the graduated zone is precisely aligned with your horizon. A word of warning though; accurate placement is essential – push the filter too far down in the holder and the coated area will overlap the foreground, artificially darkening the landscape and degrading the shot.

It is also possible to buy graduated coloured filters. They are available in a wide array of colours, including blue, grey, tobacco and coral. They can create some striking effects, but are generally less popular today, as their effect can look very artificial. Also, they can be simulated in Photoshop using the Gradient tool.

Soft- or hard-edged?

ND grads are available in two types – hard- and soft-edged. 'Soft' ND filters have a feathered edge, providing a gentle transition from the coated portion of the filter to the clear zone, whilst a 'hard' ND has a more sudden transition.

Soft grads are better suited to shooting landscapes with broken horizons as they don't noticeably darken objects breaking the horizon, like buildings or trees. However, only around a third of the filter is coated with its full density before fading to transparent. This can be a problem, as usually the brightest part of the sky will be just above the horizon where a soft grad is at its weakest. Therefore – to avoid this strip of horizon from overexposing – it may be necessary to align the filter lower in the holder, overlapping the ground, which is undesirable. In contrast, 'hard' grads are designed so the full strength of their specified density is spread over a greater proportion of the coated area. While this makes them less forgiving should the filter be poorly aligned with the horizon, they do allow you to reduce the brightness of the sky with greater accuracy than a soft grad.

▼ 0.6 (2 stops)

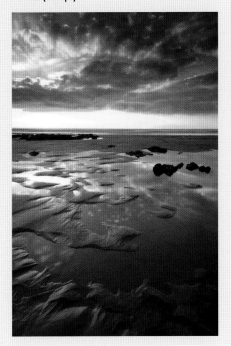

▼ 0.9 (3 stops)

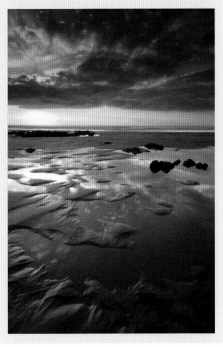

Polarizing filters

If you can only find room for one filter in your camera bag, make it a polarizer – no other filter will have a greater impact on your photography. They are designed to eliminate glare, reduce reflections and enhance colour saturation – effects which are impossible to replicate post capture. Simply speaking, whatever subjects you enjoy shooting, a polarizer is a must-have tool.

To appreciate how a polarizer works, it is first necessary to have a basic understanding of how light travels. Light is transmitted in waves, the wavelengths of which determine the way we perceive colour. They don't just travel up and down in one plane; the vibrations exist in all possible planes through 360 degrees. When they strike a surface, a percentage of wavelengths are reflected, whilst others are absorbed. It is these that define the colour of the surface. For example, a blue-coloured object will reflect blue wavelengths of light, while absorbing others. It is for this reason that foliage is green, as it absorbs all wavelengths of light other than those forming the green part of the visible spectrum.

Polarized light is different. It is the result of wavelengths being reflected or scattered and only travels in a single direction. It is these wavelengths that cause glare and reflections, reducing the intensity of a surface's colour. It is prevalent, for example, in light reflected from non-metallic surfaces, like water and in light from blue sky at 90 degrees to the sun. A polarizing filter is designed to restore contrast and colour saturation by blocking polarized light from entering the lens and reaching the image sensor.

A polarizing filter is constructed from a thin foil of polarizing material, sandwiched between two circular pieces of optical glass. Unlike other filters, the front of its mount can be rotated. Doing so affects the angle of polarization, which alters the degree of polarized light that can pass through the filter. The direction that wavelengths of polarized light travel in is inconsistent, but the point of optimal contrast can soon be determined by simply twisting the filter in its mount whilst looking through the camera's viewfinder. As you do so, you will see reflections come and go and the intensity of colours strengthen and fade. The strength of this effect depends on the angle of the camera in relation to the sun. Some surfaces remain unaffected by the polarizing effect – for example, metallic objects, like polished steel and chrome plate do not reflect polarized light patterns.

A polarizer has a 4x filter factor (see page 146) – equivalent to two stops of light. Therefore, attaching one will effect exposure time. Your camera's TTL metering will automatically adjust for this, but remember that the shutter time will be lengthened as a result.

Linear or circular – what is the difference?

Polarizing filters are available in two types – linear and circular. This can prove confusing if you are new to using filters, with photographers being unsure which to buy. Although both types are physically circular in shape and look identical, the design of the linear type will affect the metering accuracy of auto-focus cameras, as they polarize some light internally. If this light is also polarized by a filter, a false meter reading will result. To correct this, circular polarizers are constructed with a wave-retardation plate – one-quarter of a wavelength thick. This allows the wavelengths passing through the filter to rotate and appear un-polarized to the camera's metering system. Therefore, digital photographers need to opt for the circular type to ensure their camera's metering remains accurate.

◄ *Sign*

The difference between a polarized and non-polarized photograph can be dramatic. It will often bring an image to life, cutting through haze and improving clarity and subject definition. In this instance, the photograph without a polarizer (1) is rather dull and nondescript. In contrast, the subsequent shot (2) – taken with polarizer attached – is vibrant, with the contrast between the colourful sign and the sky behind far more dramatic.

Nikon D300, 18–70mm (at 40mm), ISO 200, 1/40sec at f/8, polarizer, handheld (2 only).

▼ *Oxeye daisies*

If you wish to capture eye-catching images with strong, vibrant colours, attach a polarizer. Subjects captured against a clear, blue sky will stand out. Here, a polarized sky provided the perfect backdrop for a group of oxeye daisies.

Pentax K100D, 50mm macro, 1/300 at f/8, ISO 200, polarizing filter and handheld.

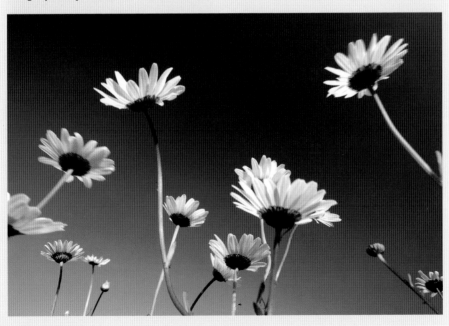

Using polarizing filters

Polarizers are synonymous with vibrant blue skies. Our atmosphere contains air molecules and tiny suspended particles – smaller than a wavelength of light – both of which scatter light. This scattered light is polarized, which is why polarizing filters work so effectively to intensify the colour of skies. However, the strength of the effect will vary depending on the angle of the camera in relation to the sun. The sun contains most polarized light in the areas that are at 90 degrees to it. Therefore, to achieve the most obvious result, position the camera at right angles to the sun – known as 'Brewster's angle'. The polarizing effect appears at its most pronounced during morning and evening, when the sun is lower in the sky. However, the filter will have little or no effect on hazy, cloudy skies.

Although many photographers invest in a polarizing filter simply for its ability to deepen blue skies, they have many uses aside. Due to the way they reduce glare reflecting from foliage, they are useful when taking countryside images, restoring colour and contrast. They are also useful when shooting floral close-ups, revealing their true colour. The polarizing effect is particularly noticeable if foliage is damp, as wet leaves and petals reflect more stray light. A polarizer will cut through this sheen – so attach one next time you shoot foliage after a downpour.

A polarizer can also be employed to reduce, or eliminate, reflections. Therefore, if you wish to photograph a subject underneath the water – fish and coral in a rock-pool for example – a polarizer will weaken the reflections on the water's surface to reveal what is below. Equally, they can be used

▼ *Water lily*

Polarizers cut through the glare reflecting from foliage, especially when wet. Picture (1) was shot without filtration, whilst a polarizer was attached before capturing the second frame (2).

Nikon D200, 100–300mm (at 200mm), 1/8sec at f/9, ISO 100, polarizer and tripod (2 only).

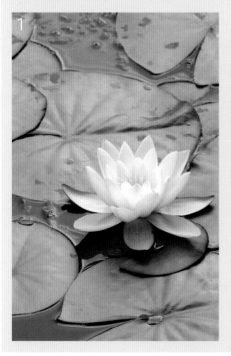

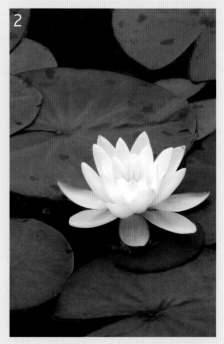

Polarizing problems

As useful as polarizing filters are, one or two problems can occur when using them. Thankfully, once you are aware of this, they are relatively easy to avoid. The most common polarizer-related problem is over-polarization. While a deep blue sky might look seductive, it is possible to overdo the effect. It is important to remember the most flattering effect isn't necessarily achieved at full polarization and at the optimal point the effect can be too strong. This can render skies unnaturally dark, or even black. Over-polarization is most likely when photographing a blue sky overhead at high altitudes. Often the effect will be obvious through the viewfinder, but review images via your camera's image playback.

Another relatively common problem is uneven polarization. This is when the polarizing effect is uneven across the sky. Short focal lengths below 24mm are most prone to this, as they capture such a broad expanse of sky. As a result, when taking pictures at certain angles to the sun, you may find the colour of the sky will be irregular, being dark in some areas, but lighter in others. Either employ a longer focal length, or adjust your shooting position, to correct the problem.

Finally, the risk of vignetting (see page 147) is enhanced when using a polarizer. This is because, being constructed with two pieces of glass, the mount can be quite deep. Thankfully, many filter brands now market ultra-slim polarizers to minimize the occurrence of vignetting.

to diminish distracting reflections from glass, making polarizers well suited to photographing modern buildings and urban landscapes. However, it should be emphasized that eliminating reflections is not always desirable. Whilst some reflections can prove ugly and distracting, others enhance a photograph – for example a mountain range reflected in a still loch. In situations like this, the reflections form an integral part of the composition. This isn't to say you shouldn't still attach a polarizer. By removing the sheen on the water's surface, they can actually intensify reflections. Regulate the effect by slowly rotating the filter until you get the result you want.

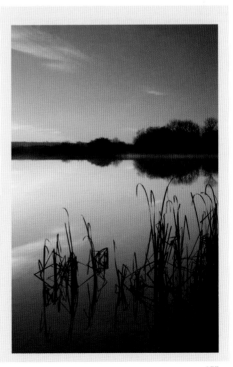

▶ *Lake view*
Polarizers can be used to enhance reflections. Here, I attached a polarizer and, whilst looking through the viewfinder, slowly rotated it until the sheen on the water's surface was removed. As a result, the reflections were intensified, enhancing the impact of this photograph.

Sony Alpha 700, 16–80mm (at 30mm), 1/6sec at f/20, ISO 100, polarizer, 0.6ND grad and tripod.

Soft focus filters

Digital technology, combined with the quality of modern optics, enables photographers to capture images which are bitingly sharp. So, why would you want to attach a misty piece of glass or plastic in front of the lens? The answer is simple – mood. By disguising hard edges and obscuring fine detail, soft focus filters can add atmosphere and a feeling of romance to your images.

Soft focus filters are designed to give light an attractive, dreamy quality. Traditionally, they are best combined with portraits and nude studies – with a subtle degree of diffusion helping to produce evocative looking results. However, combined with suitable light, they can also enhance still life and scenic images.

They are available in both screw- and slot-in types and also in a range of strengths. Filter brands have a variety of different titles for them, including 'soft', 'diffuser', 'mist', 'halo' and 'dream' filter. However, they are all designed to distort light and, by doing so, lower image contrast. Although they are available in different grades, it is tricky to recommend a specific strength, as it will greatly depend on the subject and the look you desire. It is a very subjective effect, so it is best to experiment.

Soft focus filters work by causing rays of light to refract or bend – so that they don't combine together on the sensor plane. This results in a soft image. However, the effect isn't the same as if the lens was out of focus and they are not intended to degrade image quality. Instead, they are designed to subtly alter mood by softening fine detail. They do this by creating the impression that your subject is overlaid with a gentle and attractive diffusion. However, key detail and the subject's overall shape and form remain recognizable.

Mimicking a soft focus filter effect

There are several different ways to create in-camera diffusion. Smearing Vaseline on a clear, inexpensive filter is a popular method – as is stretching a stocking over the camera lens. However, in this digital age, many photographers prefer the convenience and precision of adding a soft focus effect post capture.

There are several Photoshop tools capable of doing this, but the most popular method is via the Blur filters. Gaussian Blur produces the most natural-looking results. First, make a duplicate layer. Then, with this layer highlighted, click Filter > Blur > Gaussian Blur. A preview box with Radius slider will appear. The further you drag the slider to the right, the more blurred the layer image becomes. To create the soft focus effect, the blurred layer needs to be combined with the sharp original. To do this, change the blending mode of the duplicate layer via the drop-down menu in the layers palette. If necessary, it is possible to reduce the strength of the blurred layer, by clicking opacity in the layers palette and dragging the slider left. When happy with the effect, merge the layers and save using a different file name to the original.

The strength and direction of light also has a bearing on the filter's effect. The ethereal glow they are capable of creating is due to the way they 'bleed' the highlights of an image into the shadow areas. This type of effect is particular well suited to backlit subjects (see page 105) and can create striking results – especially when combined with soft early morning or late evening light.

Not only can the strength of the softening effect be varied by using different grades of filter, but it can also be altered simply through exposure. The larger the aperture the greater the level of diffusion. For example, at a lens's maximum aperture of, say f/2.8 or f/4, you will enjoy the full strength of the filter attached. However, at smaller apertures, the level of diffusion will progressively lessen. Naturally, this is something you must take into account when deciding which filter and aperture combination is best to use.

Exposure tip

It is possible to mimic the effect of a soft focus filter by simply breathing on the lens. This will create a fine mist of condensation that diffuses the image.

▲ **Evie**

Soft focus filters are a favourite accessory among portrait photographers, flattering skin tones and disguising any imperfections or blemishes.

- -

Nikon D60, 150mm, 1/320sec at f/4, ISO 100, handheld and fill flash.

- -

▼ **Bluebells**

A level of diffusion can create an ethereal, atmospheric or even dreamy-looking effect, particularly when combined with backlighting. In this instance, a soft focus filter effect was applied post capture using Gaussian Blur.

- -

Nikon D200, 18–70mm (at 46mm), 1/2sec at f/14, ISO 100, polarizer and tripod.

- -

Black and white contrast filters

Whilst colour images rely on colour contrast for much of their impact, black and white photographs depend on tonal contrast. However, many colours can appear very similar to one another when recorded in greyscale. For this reason, black and white photographers will often employ brightly coloured filters to render a specific colour as a lighter or darker tone, providing separation.

At first, using colour filters for black and white photography seems like a very odd concept. However, they enhance tonal contrast by absorbing wavelengths of colour different to their own hue and are an essential aid for black and white photographers – particularly before the advent of digital photography.

To appreciate their effect, you need to understand that a complementary relationship exists between the additive (red, green and blue) and subtractive (cyan, magenta and yellow) primary colours. Therefore, a colour filter will absorb the light that is the most complementary to that particular colour – whilst allowing similar colours of light to pass largely unaltered. The denser the filter, the greater the level of absorption. So, if you wish to obstruct a particular colour, to adjust tonal contrast, you need to attach a filter that is its complement.

For example, red is complementary of green, so not only will it lighten reds, but it will darken greens and blues – enriching foliage and darkening skies. The contrasty results can look eye-catching, with white clouds standing out far more dramatically than had the shot been unfiltered.

Due to the way they are able to weaken or intensify the density of the grey tones representing individual colours within a photo, strong coloured filters have been used in black and white photography for years.

The five most commonly used colour contrast filters are: yellow, green, orange, red and blue. Each filter is designed to lighten its own colour, whilst darkening its complementary.

The majority of digital cameras can be programmed to capture images in greyscale and, in this mode, they will react to contrast filters in a similar way to traditional black and white film. However, a colour image contains more information than one captured in greyscale, so a better option is to shoot in colour originally, and later convert the file to black and white (see page 180).

Tonal contrast remains just as important to digital images that are later converted into black and white. However, if you cannot justify buying a set of black and white contrast filters, it is possible to simulate their effect post capture using the Channel Mixer in Photoshop.

▶ *Complementary colours*
This colour wheel helps illustrate the relationship of complementary colours. The colour directly opposite is its complement. For example, an orange filter will absorb shades of blue and green, making them appear darker, whilst lightening colours similar to its own.

Blue filter

▲ Black and white contrast filters

To create an obvious effect, black and white contrast filters need to absorb a large quantity of a particular colour of light. It is for this reason that they are so boldly coloured.

Green filter

▶ Comparison

Look at this comparison sequence. The first image (1), using a blue filter, lacks impact as the filter has weakened the intensity of the sky. A slight improvement is seen when a green filter is attached instead (2). However – in this instance – the most striking result is when a red filter is employed (3). The blue sky turns almost inky black due to the way it obstructs the blue wavelengths of light and tonal contrast is improved overall.

Red filter

The factor of a black and white contrast filter will depend on its colour and density, but is typically between 2x–8x. The level of exposure compensation needed should be stated on the filter's box or mount. Your camera's TTL metering will adjust for this automatically. However, remember exposure time will be lengthened as a result of using one.

Exposure tip

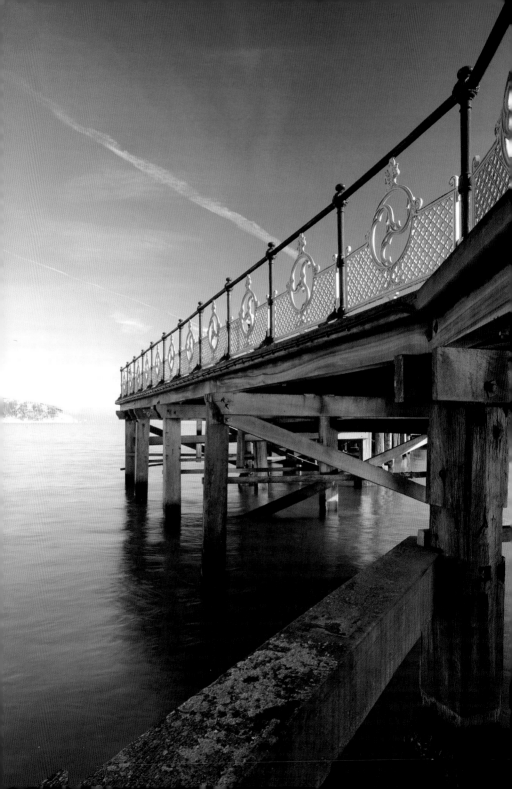

6 Exposure in the digital darkroom

Exposure in the digital darkroom

Releasing the shutter and capturing a picture is just the beginning – an image still needs processing before it is ready to be published or printed. Presuming the exposure was correct at the time of capture, images shot in Jpeg should require little work. However, if you shoot in Raw, your photographs are effectively unprocessed data, requiring your input. This is why it is important to be familiar with essential digital darkroom tools and techniques; otherwise you will never realize your photographs' full potential. This is often only mimicking darkroom techniques that have been popular for years.

After downloading the images onto your computer's hard-drive, it is time to select the photographs you wish to process. Having read this handbook, hopefully you will achieve the exposure you desire in-camera. However, the vast majority of images will still need – and benefit from – a few 'tweaks' to exposure post capture. For example, Curves or Levels are essential tools for adjusting contrast, whilst you may wish to boast colour saturation via the Hue/Saturation tool. Dual processing Raw files

is a relatively new technique which will help you to maximize tonality, whilst high dynamic range (HDR) photography is a fun and interesting technique designed to overcome the natural dynamic range limitations of a digital chip.

Post processing is a huge topic which is impossible to do justice to in a single chapter. Therefore, the following pages are purely dedicated to techniques designed to help ensure a correctly exposed end result. I have been very selective, trying to only include helpful tools that will complement the previous chapters and improve your images.

Software

Using appropriate image editing software to edit and process your files is important. Although digital cameras are normally bundled with a dedicated software package, the majority of enthusiasts prefer using a universal program. Whilst this may prove an extra cost, their power and range of capabilities is unrivalled. Adobe Photoshop is widely recognized as the industry standard, but just so you are aware of the options available, I have briefly outlined a handful of the most useful and popular software packages available to buy.

▶ *Digital processing*
If you don't process your images, you may never reveal their full impact and potential. For example, image (1) is an unprocessed file, without any adjustments made to contrast or saturation. Image (2) is the same frame, but after a few simple 'tweaks' had been made using levels and hue/saturation. The difference between the two images is significant.

Nikon D300, 12–24mm (at 20mm), 1/50sec at f/13sec, ISO 200, 0.6 ND grad and tripod.

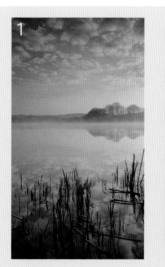
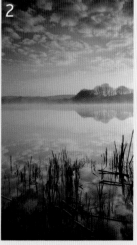

Some popular software packages

Adobe Photoshop Creative Suite	Photoshop CS is the most popular and widely used imaging program. Quite simply, it is the ultimate image-manipulation package, providing one application for managing, adjusting and presenting large volumes of digital files. However, many photographers will never require, or fully utilize, its full capabilities, making a limited version a more practical and economical option.
Adobe Photoshop Elements	This is a stripped-down version of the full CS package. It is a fraction of the cost, yet still possesses the key editing tools and boasts enough features to satisfy the vast majority of photographers. It is a digital photographer's essential toolbox.
Adobe Photoshop Lightroom	This is a workflow package designed to help photographers organize and archive large numbers of images. Essentially aimed at professionals and enthusiasts, it allows you to fine tune your photographs with precise, easy-to-use tools – correcting white balance, exposure, tone curves, lens distortion and colour casts.
Phase One Capture One	Capture One is Raw workflow software. It is the perfect choice for high volume photography, being designed to handle many images at a time. Renowned for its excellent image quality, Capture One has unlimited batch capability, multiple output files from each conversion, IPTC/EXIF (meta data) support among many other essential features. It is available in full or limited edition (LE) versions.
Apple Aperture	This innovative package offers next-generation Raw processing for producing images of the highest quality. It boasts quick preview mode for rapid-fire photo browsing, image adjustment controls such as Recovery, Definition, Vibrancy and Soft-edged Retouch brush for removing unwanted elements from photographs. It also has iPhoto library facilities. However, it is only available for Apple Macintosh computers.
Corel Paintshop Pro	Paint Shop Pro is an inexpensive alternative to Photoshop. It provides a depth of functionality allowing photographers to download, view, sort and quickly process their digital photographs. This is easy-to-use, powerful and affordable software.

Calibration

Having taken a technically good image, which is correctly exposed and using an appropriate white balance setting, you naturally expect a perfect likeness when you view the image on your computer's monitor and print the result on your home printer (page 186). Unfortunately, it is rarely that straightforward. Digital cameras, monitors and even printers all see colour differently. As a result, the file produced by your camera will probably appear different when displayed on your screen and again when printed. Calibration and profiling are the answer.

If you wish to post process your digital images with confidence and produce faithful, high-quality prints, you need to do two things: calibrate your monitor and profile your photo printer. Only by calibrating your monitor can you be sure that what you see on screen is how the image really looks. Typically, the majority of monitors display a colour cast of some type out of the box. Whilst this may only be a slight colour shift, it still means that the colours in your photographs will not look authentic. You may automatically try to correct this using image editing software – possibly mistaking the cast as a problem relating to white balance. However, by doing so, you are actually introducing a colour imbalance, so when you finally print the image the colours look nothing like they did when you took the picture originally. By calibrating your monitor, you can feel assured that the colours you see on screen are a true representative of your digital images. This will allow you to adjust colour and white balance – when necessary – with confidence.

Many photographers avoid calibrating their monitor, believing it is a complex and technical process. However, it is not as daunting as you might think. Whilst some monitors actually include calibration software, photographers are advised to invest in a dedicated calibration kit. GretagMacbeth and ColorVision are among the leading manufacturers, making calibration simple; just follow the on-screen instructions, position the monitor sensor and the accompanying software does the rest – creating an ICC profile and completing calibration within a few minutes. Before finally printing the image, you should profile your printer (see page 186).

▶ *Calibration devices*
The ColorVision Spyder is one of the most popular and easy-to-use calibration devices on the market. The Spyder sensor can be used to calibrate all CRT, LCD and laptop displays.

If you don't have dedicated software, an alternative is to calibrate your monitor using Adobe Gamma – a utility installed alongside Photoshop on Windows PCs. Although less accurate, it is preferable to not calibrating your monitor. Click My Computer > Control Panel > Adobe Gamma and follow the on-screen instructions.

Exposure tip

ICC profiles

The International Color Consortium (ICC) was formed in 1993 by Adobe, Agfa, Apple, Kodak, Microsoft, Silicon Graphics, Sun Microsystems and Taligent in order to create a universal colour management system that could be applied to all operating systems and software packages. ICC profiles are the language of colour. They are required due to the way hardware devices – like digital cameras, monitors and printers – display colour differently.

In simple terms, an ICC profile is a file that communicates to other hardware how that particular device reproduces colour. They can be created for three types of device – a display device (monitor), an input device (digital camera or scanner), or an output device (printer). By using a profile that accurately characterizes a particular device, you get the best results in a colour-managed workflow.

ICC profiles can be either generic or custom. Generic profiles are created by the device manufacturer, using profiling software and instruments to examine the colour characteristics of a group of the same devices under specified conditions. Therefore, the generic profile that accompanies that device is not actually specific to it or its working conditions. In contrast, custom profiles describe a specific device under set working conditions, making them even more accurate.

▼ *Lips*

To ensure the colours you view on screen remain punchy and reproduce faithfully when printed, it is important to calibrate your monitor and profile your printer.

Raw conversion

Why shoot in Raw format when Jpegs require far less post production and time? There is a simple answer. When you capture a Jpeg or Tiff in-camera, the Raw information is processed for you – the camera applying the shooting parameters in order to produce a 'finished article'. Whilst this might be the easiest, most convenient option, you are effectively allowing the camera to make a series of important, interpretive decisions on your behalf. The camera is also discarding important picture information that cannot be retrieved. In contrast, by shooting in Raw, you are effectively capturing a 'digital negative' containing untouched, 'raw' pixel information direct from the image sensor. This allows you to precisely control how the final converted Jpeg, Tiff or PSD is generated.

When you release the shutter, exposing a digital image, naturally you want to maximize the amount of information recorded. Of particular importance is the range of tones and colours captured. Also, you need to ensure that the highlights don't burn out, whilst recording as much information as possible in the shadow areas. The majority of digital SLRs capture either 12 or 14 bits of data in order to do this. If the camera records 12 bits of data then each pixel can record 4,096 levels of brightness, whilst 14-bit digital cameras can capture 16,384 different brightness levels. However, a photograph captured in Jpeg is converted in-camera to 8-bit mode, reducing the levels of brightness to 256. By retaining the full bit depth of the data recorded, Raw capture enables photographers to extract shadow and highlight detail, during conversion, which otherwise would have been lost. Higher bit depth also reduces an image's susceptibility to posterization.

Raw conversion software

A Raw file is effectively unprocessed digital data until it is converted. Therefore, unlike a Jpeg, it cannot be opened and viewed without using appropriate software. Raw formats differ between camera manufacturers, so dedicated software has to be used. Digital cameras are bundled with propriety programs, but their capabilities vary tremendously – some being highly sophisticated, whilst others are relatively basic. As a result, many photographers prefer to convert their Raw images using third-party software. Adobe, Apple, Phase One, DxO and even Google market Raw conversion software that allows you to download, browse, correct and process your Raw files with the minimum of fuss.

A Raw file has a high degree of exposure latitude compared to transparency film, lessening the need to bracket and allowing photographers to achieve the maximum exposure possible without losing highlight detail – commonly known as exposing to the right (see page 36). In addition, many of the camera settings applied to the Raw data can be undone and altered during conversion. Unlike a file captured in Jpeg or Tiff, the shooting parameters are not applied directly to the image. Instead, they are kept as an external parameter set, which is accessed each time the Raw file is viewed. As a result, parameters like white balance, levels, sharpening, colour and saturation can be quickly and easily adjusted – normally via an array of sliders, or similar post processing tools. After just a few clicks, your converted Raw image will be ready to be saved as the file type of your choice.

Raw exposure

Thanks to the relatively wide latitude of Raw, it is possible to alter exposure – within the sensor's dynamic range – post capture. Exposing to the

Exposure tip

Regularly downloading images directly from your camera may ultimately damage its delicate components due to wear and tear caused by inserting and removing the connection cable. Instead, it is better to invest in a dedicated card reader.

▶ *Dartmoor tree*
**If a Raw image boasts a good
range of tones and colours,
it will need minimal work
at the conversion stage. I'm
a traditionalist at heart, so
my intention is to produce a
final image that is an accurate
representative of the scene
or subject I photographed
originally – I'm not a believer
of making adjustments just
for the sake of it.**

Nikon D300, 10–20mm (at 12mm)
1/2sec at f/18, ISO 100, polarizer
and tripod.

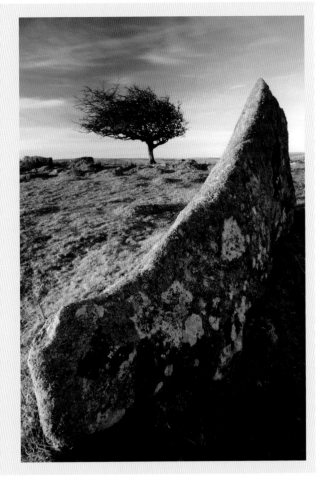

right is a good example of how photographers can manipulate this latitude, but this degree of flexibility is also useful in situations where a photographer has made an exposure error. Presuming the highlight or shadow areas aren't actually clipped, the image can be retrieved by lightening or darkening the picture to achieve a correctly exposed result. Normally, this is a relatively simple procedure using either a dedicated 'exposure' slider, built in to the Raw conversion software, or by using the Levels or Curves tool – a more precise and sophisticated method.

However, although Raw files are relatively forgiving, this shouldn't promote complacency or laziness when setting exposure in-camera. It remains important to always strive to achieve the exposure

you desire at the point of releasing the shutter – a Raw file's latitude should simply be considered as a 'safety blanket'. I think it is important to underline this; otherwise you could mistakenly get the impression that it is possible to 'get away' with poor technique when shooting in Raw. Good technique remains essential, as image quality will be compromised if exposure is poor. For example, if you need to greatly increase exposure (brighten the image), the visibility of any signal noise in dark areas of the frame will be exaggerated, whilst overexposed images will have burned-out highlights devoid of detail. This is why an image's histogram (see page 28) is an essential aid to Raw shooters.

▶ Raw conversion

During the Raw conversion stage, it is possible to adjust exposure – for either correction purposes or to create a more visually pleasing result. Typically, this is done via a dedicated exposure slider – built in to the software – or through altering the tonal curve.

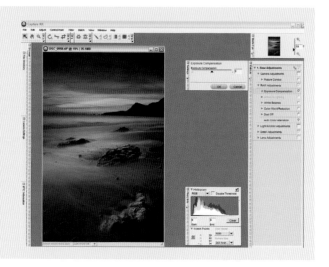

Photographers can use a Raw image's exposure latitude in a variety of ways to ensure the final image is exposed as they wish. One method is to double process the same Raw file and then merge the two images in order to enjoy the file's full tonal range.

Raw images boast wide exposure latitude, meaning a small degree of error can normally be corrected when the Raw file is converted. However, this should not be seen as an excuse to grow lazy when setting exposure – a photographer should still strive to achieve the level of exposure they desire in-camera.

Double-processing Raw for better tonality

Image sensors can perceive a contrast ratio of around 40:1. Whilst this might be better than film, compared to our eyesight – which can appreciate a ratio of around 800:1 – the tonal information a digital camera records is relatively limited. However, there is a technique that will help maximize a Raw file's tonality known as double-processing. It involves processing the same Raw file twice – once for the highlights and once for the shadows. You then merge the two images to realize the full extent of the original's tonal range. At first, this may seem like a potentially long and laborious process, resulting in yet more time stuck in front of a computer.

However, it is not a Raw conversion technique that needs applying to each and every image – just contrasty shots that would benefit from being intentionally processed to bring out better detail in both the highlight and shadow areas.

Either using the editing software supplied with your camera, or third-party software like Photoshop, open your Raw image. First, process the file for the highlights. Make sure you hold all the detail and colour in the brightest regions of the photo when you adjust the exposure slider. The remainder of the image will look underexposed, but don't let this worry you. When finished, save this file. Next, open up the same Raw file again and process it a second time, but exposed correctly for the shadow areas. Open up the shadows and lighten the image overall. If detail in the brightest areas of the frame begin to look 'washed out', don't worry – this will be remedied when the two processed images are merged. Save this image using a different file name – otherwise you will overwrite the first image.

Now, merge the two differently exposed images using the method outlined on page 184. Since the two images originate from identical files, they will align exactly. The resulting photograph will demonstrate a far greater tonal range than had you processed the file once. Finally, adjust contrast using levels or curves if required.

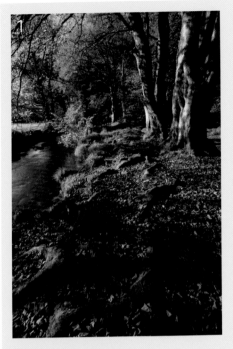

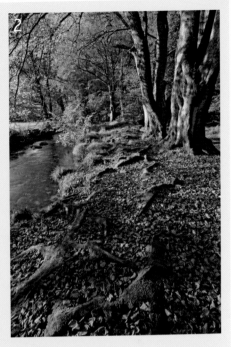

▲ *Autumnal woodland*

These two images of autumnal woodland are dramatically different, but are, in fact, from the same Raw file. Image (1) was converted normally, but the high level of contrast made it impossible for me to brighten the shadow areas without also washing out the highlights. Therefore, I decided to convert the same Raw file twice – once for the highlights and again for the shadows. I then merged them to realize the full extent of the original's tonality (2).

Nikon D200, 10–20mm (11mm), 1/2sec at f/20, ISO 100, polarizer and tripod.

Having made the necessary adjustments to your Raw file, the converted image needs to be saved as a different file format. Most photographers prefer archiving their images as lossless Tiffs – outputting the image as a 16-bit file to maximize the information retained. Alternatively, save images as 8-bit files if you wish to keep the final image at a more manageable file size.

Exposure tip

Levels

Levels is an image editing tool – found in programs like Photoshop and Raw conversion software – that enables photographers to re-map the pixel values by stretching and moving the brightness levels of the image's tonal range. By doing so, brightness and contrast can be altered in order to enhance the image. Quite simply, Levels is one of the most useful and widely used photo editing tools.

Every picture, and its corresponding histogram, is unique. Therefore, they need adjusting individually – there is no single way to collectively alter levels for all of your photographs. However, a good understanding of how best to adjust levels is important, helping you to better represent the tonal range in the final image.

Click Image > Adjustments > Levels. Within the displayed levels dialogue box is the active image's histogram. Beneath it are three sliders – the main components of the Levels tool. The pointer to the far right represents white (255); the one to the far left, black (0); and the middle arrow is mid-tone (128). Most images look best when they use a full range of tones – from black to white. Therefore, a histogram with gaps between the right and left limits of the horizontal axis will often look dull. By moving the sliders it is possible to remove the gaps and extend the histogram to fill the entire tonal range.

▼ Levels dialogue box

Levels is one of the most useful post-processing tools. Click Image>Adjustments>Levels to open the levels dialogue box in Photoshop. By adjusting the black, mid-tone and white sliders, underneath the image's histogram, it is possible to adjust contrast by re-mapping the pixel values.

Eyedropper

The Eyedropper tool – to the bottom right of the Levels dialogue box – allows you to precisely set the black and white points. Click on a specific location within the image using the black eyedropper and all pixels with a value below or equal to the selected tone will be re-mapped as black. Using the white eyedropper, all pixels above or equal to the selected tone will be re-mapped as white. However, it often isn't as easy to achieve the effect you want using this method – you don't know, until you click on a given point, whether the result will 'clip' the histogram. The middle eyedropper allows you to select the grey point – all pixels are then adjusted accordingly. This is a tool that can be used to neutralize colour casts.

A good starting point is to move the black point slider (far left) right to just before where the histogram begins – the image will grow darker. Next drag the white point slider (far right) left to the point just after where the histogram ends – the image will lighten. Be careful doing this; drag it too far to the left and you risk burning out the highlights. You have now set both the black and white points. However, the image may still not look right; if the effect appears too strong, adjust the sliders accordingly.

The mid-tone slider compresses or stretches the images tones. Dragging the slider left will brighten the image – by stretching out the shadows and compressing the highlights – whilst moving the slider right will do the opposite. Therefore, the mid-tone slider's main use is to brighten or darken the mid-tones within an image.

Levels is a very intuitive and visual tool. The amount of 'tweaking' required will greatly depend on the subject matter and the effect you want. Be careful not to increase contrast too much – the effect can look artificial and you risk clipping the histogram. Therefore, always adjust levels with the preview box checked so that you can view the results instantly.

▶ Re-mapping the pixel value

Using the Levels tool, it is possible to alter an image's contrast and brightness. When I opened this shot in Photoshop it was obvious that the original file lacked contrast (1). This was confirmed when I viewed the image's histogram in the Levels dialogue box, which showed a peak in the middle of the graph. To stretch the tonal range, I dragged the left (black) slider to where the histogram began and the right (white) slider to where it finished (2). The final image, with levels adjusted, boasts far more contrast and impact (3).

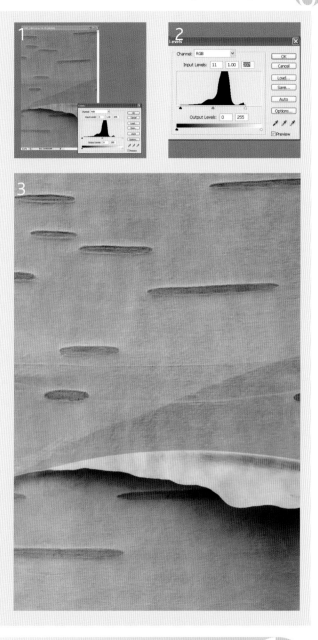

The drop-down menu from the Channels box allows you to select individual or all (RGB) colour channels for adjustment. Using this option, you can re-map pixels of a single colour only, if required.

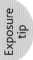

Exposure tip

Curves

The Curves tool works in a very similar way to Levels. It allows photographers to adjust the tonal range of images lacking contrast, by re-mapping the black and white points. However, it does so without the aid of a histogram – instead it takes the form of a grid with a line running from bottom left to top right. By clicking and dragging the line – cutting diagonally at a 45-degree angle – into different positions you can alter the image's tonal range and control contrast overall.

It is fair to say that Curves is a more complex and daunting tool to use and, for basic adjustments to shadows and highlights, it is probably best to opt for Levels. However, it is a more powerful and flexible tool for stretching and compressing tones. Whilst Levels only has a black, white and mid-point control, a tonal 'curve' is controlled by selecting up to sixteen anchor points.

When you open the Curves dialogue box, the levels relationship between pixels is plotted as a graph. The bottom left corner represents black (0); the top right corner white (255); and mid-point mid-tones (128). The horizontal axis of the graph represents the original brightness values of the pixels (Input levels); the vertical axis represents the new brightness levels (Output levels). The default diagonal line represents every pixel in the corresponding image, but at this stage no pixels have been re-mapped, so all pixels have the same Input and Output values. By dragging the ends of the line in you are able to adjust the black and white points. Making the line steeper increases contrast, while making it flatter will reduce it. You can also create anchor points by clicking on any point along the line. Then, by either dragging them up or down, you can create your customized

'curve'. By moving a point up the grid, pixels of that tone within the image will become lighter; drag them downward and they will become darker.

By placing Curves points along the line you can anchor areas of the image – such as the highlights or shadows – so that any adjustments you make mainly affect the pixels beyond the anchor points. Often, three anchor points – one each for the shadows, mid-tones and highlights – is all that is required, in addition to the black and white points. Smooth curves usually produce the best, most natural-looking results. A simple change in the curve can have a dramatic affect on the image, so always ensure the preview box is checked, allowing you to view adjustments as they are made.

▼ *Curves dialogue box*

Curves is one of the most useful photo editing tools. Using Photoshop, click Image>Adjustments>Curves to open the dialogue box. The default diagonal line is straight – the 'curve' is created by dragging the line into a different position to alter the images contrast and brightness.

▶ *Adjusting contrast*

Using Curves, it is possible to alter an image's contrast and brightness with greater precision than any other photo editing tool (1).

Two of the most common and useful Curve types, for altering contrast, are the 'S-curve' and 'inverted S-curve'. An S-curve adds contrast to the mid-tones at the expense of shadows and highlights (2), whilst the inverted S-curve will do the opposite (3).

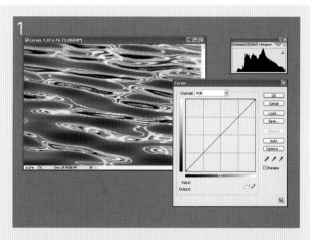

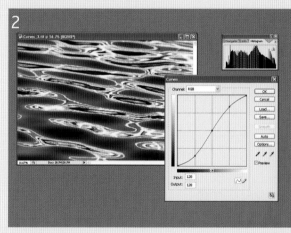

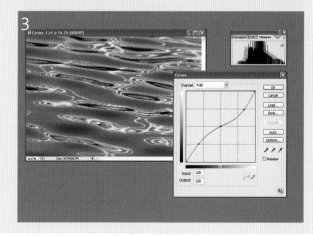

The dodge and burn tools

Dodging (lightening) and burning (darkening) are well-practised darkroom techniques, employed to selectively lighten or darken specific regions of an image that would benefit from more or less exposure. The Dodge and Burn tools are Photoshop's attempt at mimicking their effect and – applied appropriately and with care – are capable of enhancing your digital images.

Whilst Levels or Curves are essential tools for altering an image's overall brightness, there will be times when you only wish to adjust very specific areas. There are a couple of different ways to do this – for example, by selecting the area and then tweaking brightness. However, the Dodge and Burn tools – grouped together with the Sponge tool – in the Photoshop Toolbox are the preferred method of many professional image editors.

▼ *Dodge and Burn tools*
The Dodge and Burn tools are grouped together – along with the Sponge tool. The icon of the tool last used, will be the one displayed in the Toolbox.

Dodge tool

Once you have selected the Dodge tool from the Toolbox, you can customize the settings via the options bar. Here, you can alter the Brush size, to suit the area you will be working on; Range, where you decide which tones will be affected by your edit; Exposure, which dictates how fast the image is lightened when you apply the tool; and finally the Airbrush button, which you should click if you want the tool to continue to work whilst the left mouse button remains pressed, even when the cursor is not moving.

Running the Dodge brush over the image, causes all the pixels over which it passes to become lighter – according to the parameters you select. Via the Range setting, you can choose to lighten highlights, mid-tones, or shadows, but the tool does not work on all three at once. Instead, each must be worked on individually if desired. The Exposure slider is a key control, determining how fast the image is lightened. Set to 100% – or close to it – pixels are brightened impractically fast and it is tricky to make your adjustment strokes look smooth or natural. In fact, at higher settings, this tool can make a mess of your images. Instead, it is best to select an Exposure setting of no more than 10%.

The Dodge tool is effective when you 'left click' the mouse button, but it does not do any additional work until you move it – unless you have selected the airbrush option. However, repeated strokes over the same area do have a cumulative effect. Therefore, try not to overlap your strokes, or these areas will be brighter, creating a 'streaky' look.

Finally, if you click Edit > Fade when you have finished using the tool, you can alter the opacity of the strokes you have just applied for added precision.

Burn tool

The Burn tool works in a very similar way to the Dodge tool, but the brush darkens the pixels that it is dragged over, as opposed to lightening them. The Burn tool can often be used in conjunction with the Dodge brush and they can complement each other well when working on high-contrast images where a few subtle, selective 'tweaks' will benefit the overall look of the image.

The brush size you select will not only be dictated by the area you wish to Dodge or Burn, but also the picture's resolution. For example, a brush tip of 100 pixels used on a small image would make a relatively large stroke, but on a large file, of say 20 or 30 megabytes, the effect would appear far smaller.

Exposure tip

Whilst the Burn tool cannot restore detail in highlights that are blown – as no detail is actually recorded – it can help reduce the impact of distracting areas of brightness that are maybe verging on being overexposed. When you select the Burn tool, you have the same Brush, Range and Exposure options to select from in the options bar

as you would if using the Dodge tool. Again, reduce the 'Exposure' setting to around 10%, as this will allow you to darken the pixels you deem too bright with control. Be aware that, 'burning' can give the impression of deepening the colours, so apply the brush with precision and ensure the transition is natural and smooth.

▶ Pier

When I photographed this pier, the range of brightness was too great for my camera to record faithfully. I exposed for the highlights, but this left the wooden beam underexposed (1). To fix this, I dodged the beam, using a brush size of 75 pixels and an exposure setting of 10%. This brought out the detail and colour of the beam, enhancing the image's contrast. The distant

chalk cliffs were verging on overexposure so I used the burn tool to subtly darken them to be less distracting (2). Compare the results and you can see how the Dodge and Burn tools can enhance your images (3).

Nikon D300, 10–20mm (at 14mm), ISO200, 1/5sec at f/13, polarizer and tripod.

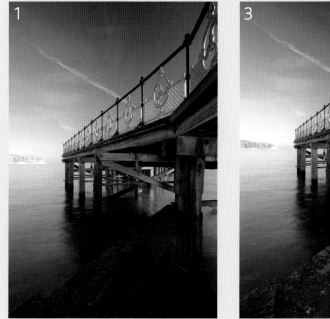

Colour and saturation

Colour is one of a photograph's most important and influential ingredients, greatly dictating its feel and appearance. For example, a colour cast can – intentionally or mistakenly – create the impression of warmth or coldness; whilst saturated colour will add to an image's impact. However, a sensor will not always record colour faithfully or with the vividness of the original scene. Alternatively, you may want to intentionally add a cast or saturate colour for creative effect. It is for this reason that 'tweaking' colour – to either restore or enhance it – is a common and useful post-capture technique.

Colour casts

There are several photo editing tools that can be used to adjust colour. Levels (see page 172) and curves (see page 174) are best known for their ability to alter contrast and brightness, but by selecting individual colours from their drop-down Channel menu, it is possible to either enhance or correct colour.

One of the most common reasons for adjusting colour is due to incorrect white balance. Whilst it is normally easiest to adjust white balance using the editing software supplied with your camera, levels or curves will do the job equally well. However, to confidently correct or add a colour cast, you need at least a basic understanding of the relationship between additive (red, green and blue) and subtractive (cyan, magenta and yellow) colours. Subtracting red will result in more cyan; subtracting green, will achieve more magenta and subtracting blue will result in more yellow and vice versa. Therefore, to add warmth, or correct a cold colour cast, it is necessary to add more yellow, magenta or red – or, in other words, less blue, green and cyan. The opposite applies if you wish to add a cool hue, or correct a warm colour cast.

Saturating colour

Saturated colours add impact and life to a photo. A polarizing filter (see page 154) will help do this in-camera, but photographers will often wish to give their images added punch by enriching the colour post capture.

Saturation is a measure of a colour's purity and whilst subtle adjustments can prove highly beneficial, too much saturation will create artificial looking results – so don't be seduced by the attractive look of strong colours on your computer monitor. One of the most useful post-processing tools for adjusting saturation is the Hue/Saturation control in Photoshop. Open the dialogue box by clicking Image > Adjustment > Hue/Saturation. You will be presented with three sliders:

Colour balance

Colour Balance (Image > Adjustments > Colour Balance) is a basic, but useful tool for removing or adding colour. Within the Colour Balance dialogue box are three sliders for adding or subtracting colour from the image: cyan and red; magenta and green and yellow and blue. The colours work in tandem; adding from one colour, will subtract from the other. The values for the subtractive colours – cyan, magenta and yellow – are expressed in negative numbers. You can select which area of the image your settings will be applied to – Shadows, Midtones or Highlights – under the Tone Balance control. The combination of settings, and degree of adjustment, will depend on the strength and look of the effect you want. Ensure the Preserve Luminosity box is checked to maintain the original's brightness.

Hue

By dragging the Hue slider left or right, you alter the colour of the entire image. By doing so, you are cycling through the spectrum and re-mapping colour. This is illustrated via the two bars at the bottom of the dialogue box. The top bar represents the colours of the original and never changes, whilst the one below moves in relation to it – displaying the new arrangement. Large colour shifts will create bizarre, surreal-looking results. However, subtle adjustments can enhance the natural look of the image's colours.

Saturation

This reflects the depth of the colour. Moving the slider to the right will intensify the image's colours – or the selected colour, via the drop-down Edit menu – whilst dragging it to the left will reduce saturation. In fact, push the slider fully to the left and the image will appear black and white; drag it too far to the right, and colour will look completely artificial. The saturation slider can be used to emphasize certain colours – or parts of the image.

Lightness

This is the least useful of the three controls. Adjusting the lightness slider will not alter the images hue or saturation. Therefore, colours remain identifiable. Instead, moving the slider left will darken the image, whilst pushing it right will lighten it.

▲ Feathers

Whilst happy with this photograph of a pheasant's feathers, the colours looked subdued (1). To enrich them, I increased saturation by +20 using Hue/Saturation. The result has far more impact than the original and I have still retained a natural look (2).

Nikon D200, 150mm, 1/80sec at f/14, ISO 100 and tripod.

Summary

The effect of adjusting hue/saturation is best judged visually – rather than entering a set value. Therefore, it is essential to check the preview box so that you can regulate the effect of your changes.

Black and white conversion

Digital capture has made black and white photography more accessible then ever before. Converting colour images into mono is quick and simple. As a result, a new generation of photographers – who might have otherwise overlooked mono – are being introduced to this powerful and dramatic medium.

With so much technology invested in producing digital sensors which are capable of reproducing colour with stunning accuracy, you might wonder why anyone would want to produce a mono image. However, black and white photography has passed the test of time and – combined with a suitable scene or subject – can convey more drama and mood than its colour equivalent. Removing colour helps eliminate distractions and places extra emphasis on the subject's shape and form and also the composition and light.

Many digital cameras will allow you to capture greyscale images in-camera. However, more detail and information is recorded in colour so, to maximize image quality, it is best to continue shooting in colour and convert at the post-processing stage. Also, whilst you can convert a colour image to black and white, you can't convert a black and white image to colour – therefore, shooting in colour originally gives you more options.

Naturally, not all images suit conversion to mono and, by removing colour, you can just as easily lessen a picture's impact as enhance it. It is for this reason that you should select images with care and consideration. Traditionally portrait and scenic images look most dramatic in mono, but practically any subject matter can potentially convert well.

Without colour contrast to enhance a picture's impact, good composition is vital. Strong lighting is an important ingredient, creating drama, bold shadows and helping to define shapes. Also, black and white images rely on tonal contrast for impact, so this is another key consideration when making your selection. When using photo editing programs like Photoshop, there are several different ways to transform colour files into black and white. However, some tools are better than others:

Desaturate

Click Image > Adjustments > Desaturate. This is a quick method, but some hues don't convert well when desaturated, which can affect contrast. However, colour information is still retained, which can be helpful if you wish to tone the image later.

Greyscale

Click Image > Mode > Greyscale. A dialogue box will appear with the message: Discard Colour Information? Simply click OK to convert the image to greyscale. The results from this method are better. The image is permanently altered, so remember to copy the original before saving. Often it will be necessary to adjust contrast using levels or curves.

Channel mixer

Click Image > Adjustments > Channel Mixer. This is the most sophisticated, but involved method. Using the channel mixer, it is possible to mix the colour channels to alter the image's tonal range and contrast. This can be done by adjusting the red, green and blue sliders. Try to keep the combined total of the three mixer settings to 100%.

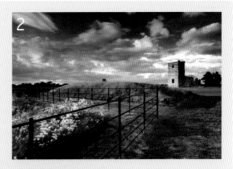

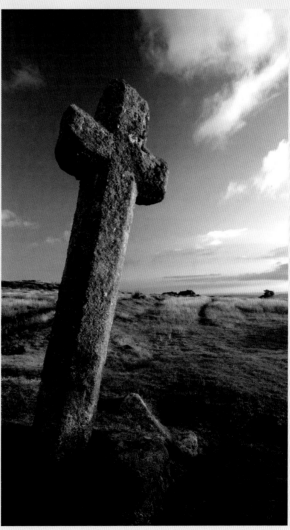

▲ *Church ruin*

Mono is a great medium
for conveying mood and
atmosphere. Storm clouds
and buildings are well suited
to black and white, so when
I processed the original colour
Raw file (1), I thought this shot
would also look striking in mono
(2). I used the channel mixer
to convert the picture, before
tweaking contrast using levels.

Nikon D200, 10–20mm (at 11mm)
8secs at f/20, polarizer, 0.9ND
filter and tripod.

▶ *Granite cross*

The simplicity of black and
white can create striking,
evocative images. However, it is
best to shoot in colour originally
and later convert using photo
editing software.

Nikon D200, 10–20mm,
(at 12mm), 1/30sec at f/11,
ISO100 and handheld.

High dynamic range photography

High dynamic range or HDR photography has exploded in popularity over the past couple of years. HDR imaging is a software technique where the photographer merges a bracketed sequence of exposures to overcome the dynamic range limitations of traditional single-shot photography (see page 32). The final results display remarkable detail throughout the image, from dark shadows to bright highlights, effectively exaggerating a camera's normal dynamic range.

The intention of HDR imaging is to faithfully represent the wide range of intensity levels found in high-contrast photographs. Therefore, scenes boasting extreme levels of light are best suited to this technique. Having identified a suitable scene – a cityscape at night, for example – you need to shoot a bracketed sequence of images. Naturally, a sturdy tripod is essential to do this, as the images must be identical in order to align precisely when merged. Many digital cameras have an auto bracketing sequence. If possible, set it to shoot a sequence of five exposures set at -2, -1, 0, +1, +2. Alternatively, you can create your bracketed

1 **To convert your bracketed sequence of exposures into a single image, open the HDR tool by clicking File > Automate > Merge to HDR and load all the photographs in your sequence. In this instance, I loaded five images taken of a Cornish lighthouse at dawn. This process is quite memory intensive, so it may take a few moments for the images to load.**

2 **Once processing has stopped, the HDR photo – and the images' combined histogram – will be displayed. Photoshop estimates the white point, but this value will often clip the highlights, so move the white point slider to the rightmost edge of the histogram to reveal all highlight detail. Once you click OK, Photoshop will output a 32-bit HDR file. The image will look quite dull at this stage, partly due to a monitor's limitation to properly display this bit depth of information. Your HDR 'negative' must be developed and reduced to a smaller bit depth, before it is complete.**

1

2

Typically, dramatic differences in colour and texture work well in HDR. Therefore, look for subjects boasting a wide range of colour and also good contrast between natural and/or man-made textures.

Exposure tip

sequence by manually adjusting the shutter speed – aperture and ISO should remain constant. Still subjects work best, as movement, like pedestrians and moving cars, will be 'ghosted' – although sometimes this will actually add to the effect. Merging your bracketed sequence to create your HDR image is a relatively simple process using appropriate software. Photoshop, Photomatix and Lightroom are among the programs that simplify the technique, doing much of the hard work for you.

Whilst HDR images can look artificial and surreal, the results are often stunning. They record the full range of colour and contrast that our eyes can see, but which an image sensor can't capture in a single exposure. This is a relatively in-depth technique, which is impossible to do justice to in a couple of pages. More advanced HDR techniques are easily found on the internet, but to get you started, below is a basic tutorial using the built-in HDR facility in Photoshop CS2.

3 **You now need to tone map your image.** Do this by converting your HDR photo to an 8-bit image by clicking Image > Mode > 8bits/channel. This will open the HDR conversion dialogue box. From the drop-down menu, select Local Adaptation – this offers greater control compared to the other three options: Exposure and Gamma, Highlight Compression and Equalize Histogram. Using the curves control, adjust the tonal curve to best suit the image. Click OK when finished and Photoshop will convert the file to an 8-bit file.

4 **Finally, you may wish to 'tweak' contrast using** either levels (see page 172) or curves (see page 174) and also adjust hue/saturation (see page 178) to maximize the image's impact. The result will be an eye-catching image that would be impossible to achieve using a single aperture and shutter-speed exposure.

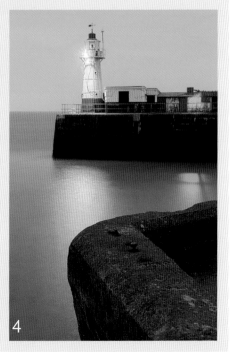

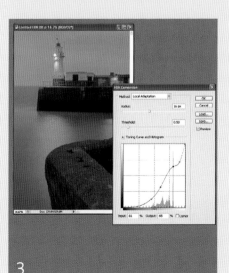

Merging two different exposures

As stated in previous pages, the contrast between highlight and shadow areas of an image will often stretch beyond the sensor's dynamic range. This is a regular problem for scenic photographers, with the sky often being a couple of stops brighter than the landscape below. Graduated neutral-density filters (see page 152) are designed to correct this light imbalance, but they are less practical if the horizon is broken. For example, if there is a tree or building breaking the skyline, this object will also be artificially darkened by the ND coating. In situations like this, it is better to take two exposures – one correctly exposed for the sky and the other for the foreground – and merge them later using image editing software. In order to do this, the composition for both exposures needs to be identical. Therefore, a sturdy tripod is essential to make sure the camera keeps in a fixed position.

Specific plug-ins are available to make the merging process simpler, but personally I rely on a blending technique involving a Layer Mask in Photoshop. The two exposures are blended to form one image with detail in both the highlights and shadows. To prevent artefacts arising during the blending process – along sharp edges between shadows and highlights – the Layer Mask is softened using a small amount of Gaussian Blur. The following step-by-step tutorial shows you how to apply the technique to your own images.

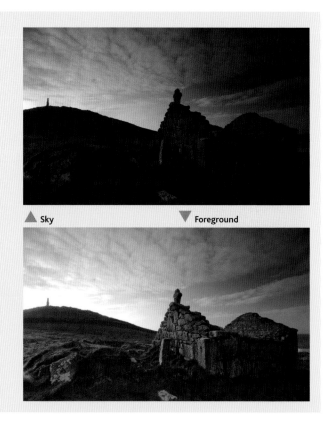

▲ Sky　　　　　　　　　▼ Foreground

When I photographed this small ruined chapel, I knew traditional filtration methods wouldn't work to balance the large contrast in light between sky and foreground, due to the broken, uneven skyline.

Therefore, I took two exposures, the first correctly metered for the sky and the second for the land. I later imported the two images into Photoshop, naming the images 'Sky' and 'Foreground' – to indicate their correct exposure.

1 With the two images placed alongside each other in Photoshop, click on Sky and press CTRL + A to select the whole image – indicated by a segmented line running along the edges of the image. Now press CTRL + C to copy the selected file.

2 Next, select foreground and, by pressing CTRL + V, paste Sky onto it. The Sky image is no longer needed, so close this file. In the Layers palette, you will notice that the foreground file is indicated as the background layer and your pasted shot as layer 1.

3 Now, add a layer mask by clicking on the Add Layer Mask icon at the bottom of the layers palette – a white circle within a grey rectangle. A white rectangle will appear next to layer 1 in the Layers palette.

4 Click on the background layer to select it. Press CTRL + A to select the image, followed by CTRL + C to copy it to the clipboard. Finally, hold down the ALT key and click on the white layer mask thumbnail in the Layer 1 palette. The image will turn white.

5 Press CTRL + V to paste the contents of the clipboard onto the white layer mask. The image will transform into a black and white mask – colour is retained within the layers.

6 Click Filter > Blur > Gaussian Blur. This will open the Gaussian Blur dialogue box. Set the radius in the region of 25–40pixels.Click OK to apply the blur, providing a gradual transitional zone.

7 Next, click on the Background Layer to blend the two images together. Finally, flatten/merge Layers and, if desired, fine tune the image's tonal range using curves or levels. The result is an image that gives the impression of being accurately exposed for both highlights and shadows.

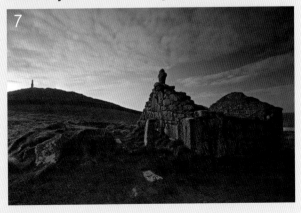

Printing

Having captured a stunning digital image, it would be a waste to keep it hidden away on your computer's hard-drive. Beautiful photography should be shared and enjoyed by others, which is why the majority of photographers take pictures with the intention of ultimately printing their best – either to frame, exhibit or to enter into competitions.

Thanks to the sophistication of today's breed of home printers, it is possible to produce prints of true photo quality without the need, or added cost, of getting them printed at a professional lab. Even budget photo printers are capable of excellent results, despite their relatively low price tag. However, if you intend making a large number of prints it is worthwhile investing in the best quality printer you can justify, and opting for a version that prints up to A3 size. This will give you greater flexibility with the range of sizes you can print and, with the resolution of digital cameras growing ever higher, it is possible to create large prints without making any compromise to print quality.

Whilst only a few years ago there were concerns regarding the projected lifespan of digital photo prints, the latest inks are far more stable than older ink sets. Ink is undeniably expensive, but generally speaking, it is best to opt for the printer's own inks, rather than a cheaper, third party-made compatible. There are a wide range of papers available, in a variety of finishes. Personally, I prefer a matt-finish paper, but it is personal taste. Independent makers of photo paper, like Harman – the revived Ilford photo paper company – and Hahnemuhle are popular and, although they can prove more costly, produce excellent prints.

Profiling

To ensure the final printed image remains faithful to your original digital file, you should – in addition to properly calibrating your monitor (see page 166) – profile your printer. Basically, this is software that optimizes your printer driver settings to achieve optimum tone separation and ink delivery.

If you are using inks and paper produced by the same manufacturer as the printer, profiling may not be essential. However, if you are using, for example, an Epson printer, with an independent make of inks and printing on, say, Hahnemuhle or Harman paper, profiling is recommended. It is normally possible to download ICC profiles (see page 167) from the maker's websites. Alternatively, you can have a custom profile made for you for certain ink and paper combinations. Custom profiles are relatively cheap, especially compared to the potential cost of wasted photo paper and inks if profiling is incorrect.

▼ *Printer*

There are now many high quality, affordable photo printers available to buy, offering flexibility, long-lasting images and high-speed operation.

Dpi (dots per inch)

Dots per inch, or dpi, refers to a printer measurement and shouldn't be confused with pixels per inch (ppi). Simply, a printer prints dots and a monitor displays pixels. The dpi measurement of a printer often needs to be considerably higher than the ppi of a monitor in order to produce similar-quality output. This is due to the limited range of colours for each dot typically available on a printer.

Remember that dpi is not the resolution of the image or the monitor; it is the measurement of how many dots of ink the printer can place within an inch. In theory, a printer with a higher dpi will produce a higher quality print. Today, even so called budget printers are capable of excellent results, typically boasting a high dpi upwards of 1440. Inkjet is the most widely used type of home printer, working by squirting tiny droplets of ink.

1 To create a print, open the image in the appropriate software – I prefer using Photoshop. Click Image > Image Size to open the image size dialogue box. Ideally, resolution should be set to 300ppi for optimum quality. The dimensions shown in the Image Size window are the maximum dimensions you should output to. If the image is printed much bigger without interpolation, quality will suffer. In this instance, the dimensions at 300ppi are approximately 9½in x 14¼in (24 x 36cm).

2 Next, click File > Print with preview. The dialog box displays a variety of print options, including Color Management and Output options. Having made your selections, close the box and click File > Print. Check other settings, like Media Type and, if you have a custom profile, apply these settings. Ensure the appropriate paper type is loaded before finally printing.

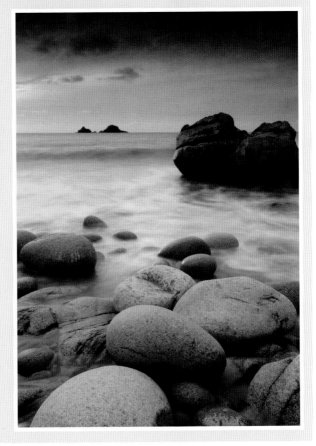

▶ *Porth Nanvan*
Your best images should be enjoyed and shared with others. Your print is the last stage of taking a great 'exposure'.

A thin, white border is a simple but effective way to help your images stand out. Therefore, slightly reduce the scale of your image to leave a border of equal width surrounding your photo. A thin border is also useful should you wish to mount the image for display or framing – negating the need to crop into the image-space itself.

Exposure tip

Glossary

AE-L (autoexposure lock): A camera control that locks in the exposure value, allowing an image to be recomposed.

Angle of view: The area of a scene that a lens takes in, measured in degrees.

Aperture: The opening in a camera lens through which light passes to expose the image sensor. The relative size of the aperture is denoted by f-numbers.

Autoexposure: A camera system where exposure is calculated automatically by the camera.

Bracketing: Taking a series of identical compositions, changing only the exposure value, usually in half or one f-stop (+/–) increments.

Camera shake: Movement of the camera during exposure that, particularly at slow shutter speeds, can lead to blurred images. Often caused by an unsteady hold or support.

CCD (charged-coupled device): One of the most common types of image sensor incorporated in digital cameras.

Centre weighted metering: A way of determining the exposure of a photograph, placing emphasis on the lightmeter reading from the centre of the frame.

CMOS (complementary oxide semi-conductor): A microchip consisting of a grid of millions of light-sensitive cells – the more sensors, the greater the number of pixels and the higher the resolution of the final image.

Colour temperature: The colour of a light source expressed in degrees Kelvin (k).

Compression: The process by which digital files are reduced in size.

Contrast: The range between the highlight and shadow areas of an image, or a marked difference in illumination between colours or adjacent areas.

Depth of field (DOF): The amount of an image that appears acceptably sharp. This is controlled by the aperture – the smaller the aperture, the greater the depth of field.

dpi (dots per inch): Measure of the resolution of a printer or a scanner. The more dots per inch, the higher the resolution.

Dynamic range: The ability of the camera's sensor to capture a full range of shadows and highlights.

Evaluative metering: A metering system whereby light reflected from several subject areas is calculated based on algorithms.

Exposure: The amount of light allowed to strike and expose the image sensor, controlled by aperture, shutter speed and ISO sensitivity. Also the act of taking a photograph, as in 'making an exposure'.

Exposure compensation: A control that allows intentional over- or underexposure.

Fill-in flash: Flash combined with daylight in an exposure. Used with naturally backlit or harshly side-lit or top-lit subjects to prevent silhouettes forming, or to add extra light to the shadow areas of a well-lit scene.

Filter: A piece of coloured, or coated, glass or plastic placed in front of the lens for creative or corrective use.

F-stop/number: Number assigned to a particular lens aperture. Wide apertures are denoted by small numbers such as f/2.8; and small apertures by large numbers such as f/22.

Focal length: The distance, usually in millimetres, from the optical centre point of a lens element to its focal point, which signifies its power.

GN (guide number): Used to determine a flashgun's output. GN = subject distance x aperture.

Highlights: The brightest areas of an image.

Histogram: A graph used to represent the distribution of tones in an image.

Hotshoe: An accessory shoe with electrical contacts that allows synchronization between the camera and a flashgun.

Incident-light reading: Meter reading based on the light falling on the subject.

ISO (International Standards Organization): The sensitivity of the image sensor measured in terms equivalent to the ISO rating of a film.

Jpeg (Joint Photographic Experts Group): A popular image file type, compressed to reduce file size.

LCD (liquid crystal display): The flat screen on the back of a digital camera that allows the user to play back and review digital images and shooting information.

Macro: A term used to describe close-up photography and the close-focusing ability of a lens.

Megapixel: One million pixels equals one megapixel.

Metering: Using a camera or handheld light-meter to determine the amount of light coming from a scene and calculate the required exposure.

Metering pattern: The system used by the camera to calculate the exposure.

Monochrome: Image compromising only of grey tones, from black to white.

Multiplication factor: The amount the focal length of a lens will be magnified when attached to a camera with a cropped-type sensor – smaller than 35mm.

Noise: Coloured image interference caused by stray electrical signals.

Overexposure: A condition when too much light reaches the sensor. Detail is lost in the highlights.

Pixel: Abbreviation of 'picture element'. Pixels are the smallest bits of information that combine to form a digital image.

Post processing: The use of software to make adjustments to a digital file on a computer.

Raw: A versatile and widely used digital file format where the shooting parameters are attached to the file, not applied.

Resolution: The number of pixels used to either capture an image or display it, usually expressed in ppi. The higher the resolution, the finer the detail.

Saturation: The intensity of the colours in an image.

Shadow areas: The darkest areas of the exposure.

Shutter: The mechanism that controls the amount of light reaching the sensor by opening and closing when the shutter release is activated.

Shutter speed: The shutter speed determines the duration of exposure.

SLR (single lens reflex): A camera type that allows the user to view the scene through the lens, using a reflex mirror.

Spot metering: A metering system that places importance on the intensity of light reflected by a very small percentage of the frame.

Telephoto lens: A lens with a large focal length and a narrow angle of view

TIFF (Tagged-Image File Format): A universal file format supported by virtually all image editing applications. TIFFS are uncompressed digital files.

TTL (through the lens) metering: A metering system built into the camera that measures light passing through the lens at the time of shooting.

Underexposure: A condition in which too little light reaches the sensor. There is too much detail lost in the shadow areas of the exposure.

Viewfinder: An optical system used for composing and sometimes focusing the subject.

Vignetting: Darkening of the corners of an image, due to an obstruction – usually caused by a filter(s) or hood.

White balance: A function that allows the correct colour balance to be recorded for any given lighting situation.

Wide-angle lens: A lens with a short focal length.

Useful websites

Calibration

Datacolor: **www.datacolor.com**

Xrite: **www.xrite.com**

Photographers

Ross Hoddinott: **www.rosshoddinott.co.uk**

Photographic equipment

Bogen Imaging: **www.bogenimaging.co.uk**

Canon: **www.canon.com**

Cokin: **www.cokin.com**

Lastolite: **www.lastolite.com**

Lee Filters: **www.leefilters.com**

Lexar: **www.lexar.com**

Lumiquest: **www.lumiquest.com**

Nikon: **www.nikon.com**

Novoflex: **www.novoflex.com**

Olympus: **www.olympus.com**

Pentax: **www.pentaximaging.com**

Sigma: **www.sigmaphoto.com**

Sony: **www.sony.com**

Sto-fen: **www.stofen.com**

Tamron: **www.tamron.com**

Wimberley: **www.tripodhead.com**

Photography workshops

Dawn 2 Dusk: **www.dawn2duskphotography.com**

Printing

Epson: **www.epson.com**

Hahnemuehle: **www.hahnemuehle.de**

Harman: **www.harman-inkjet.com**

Publisher

Photographers' Institute Press: **www.pipress.com**

Software

Adobe: **www.adobe.com**

Apple: **www.apple.com/aperture**

Corel: **www.corel.com**

DxO: **www.dxo.com**

Phase One: **www.phaseone.com**

Useful reading

Digital Photography Review: **www.dpreview.com**

Digital SLR photography: **www.digitalslrphoto.com**

Ephotozine: **www.ephotozine.com**

Acknowledgements

Writing any book is a time-consuming – and sometimes stressful – project. Although it is my name on the cover, this book wouldn't be possible without the hard work of everyone at Photographers' Institute Press. A big 'thank you' to Gerrie Purcell, Chloë Alexander and particularly to Virginia Brehaut – my editor for this publication who has been so patient and helpful. Also, thank you James Beattie, who originally approached me with the idea for this title. Thank you to Canon, ColorVision, Cokin, Epson, Hoya, Lastolite, Lee Filters, Lumiquest, Nikon, Sekonic and Wimberley for supplying product images, and to Ollie Blayney for allowing me to use a couple of his striking portrait images in this book.

This biggest 'thank you' is reserved for my wonderful family. Their love, support and encouragement is unfailing. I'm fortunate that my mum and dad aren't just great parents, but wonderful friends too. Thank you for everything you do. My wife, Fliss, is simply the most wonderful person I've ever met. She is so understanding of the demands of my profession. She is my best friend and the most wonderful mother to our beautiful daughters. Thank you Fliss... I love you.

Index

To place an order, or to request a catalogue, contact:
Photographers' Institute Press
Castle Place, 166 High Street, Lewes, East Sussex, BN7 1XU United Kingdom
Tel: +44 (0) 1273 488005 Fax: +44 (0) 1273 402866
Website: www.pipress.com
Orders by credit card are accepted